THE WHITE RE

32

C000117752

Sadie Coles HQ

Seth Price

Opening April 2022
62 Kingly Street, London, W1B 5QN

Caterina, Granta subscriber
Photographed in Brussels, 2021
Subscribe today for £32

GRANTA

Stephen Shore
Modern Instances
The Craft of Photography. A Memoir.

An essential handbook for anyone interested in learning more about mastering one's craft and the distinct threads that come together to inform a creative voice, written by one of the world's most prolific artists.

MACK
FEBRUARY 2022

THE ROSES OF TYERS ST.

VAUXHALL PLEASURE GARDENS

THE WHITE REVIEW

SUBSCRIBE INTERNATIONALLY

THEWHITEREVIEW.ORG/SUBSCRIBE

Cold Enough for Snow by Jessica Au
is published by Fitzcarraldo Editions
on 23 February 2022.

'Rarely have I been so moved, reading
a book: I love the quiet beauty of
Cold Enough for Snow and how,
within its calm simplicity, Jessica Au
camouflages incredible power.'
— Édouard Louis,
author of *The End of Eddy*

Fitzcarraldo Editions

Published by The White Review, February 2022 Edition of 1,200 Typeset in Nouveau Blanche Printed in Lithuania
ISBN No. 978-1-9160351-5-7 The White Review is a registered charity (number 1148690)

The White Review, 8–12 Creekside, London SE8 3DX www.thewhitereview.org

EDITORIAL

'All of our myths come out of looking at the stars and finding a metaphor for them', says Ocean Vuong, interviewed in *The White Review* No. 32. Speaking about Asian American literature, Vuong explains how the oral tradition has shaped his writing, and discusses myth-making as a powerful tool to help imagine, and build, alternate futures.

New legends, and the reinvigoration of the old, appear throughout this issue as a means of countering stereotype, critiquing the present and passing knowledge on.

Rebecca Liu's essay 'So You Have an Asian Mother' contends with the representation of the Asian mother in fiction by examining the 'tiger mom' trope. Familial myth underpins Shane Jones's story 'Young Forest', which immerses the reader in a brother's psychological quest to rescue a sibling who has escaped into the woods. In 'The Understory', an extract from a forthcoming novel by Saneh Sangsuk, translated from Thai by Mui Poopoksakul, a monk relays legends to villagers around a fire. His stories are ornamented and crafted through retellings; they alter with each repetition, haunted by the decline of the forest and changes inflicted on rural communities, reaching for a new moral each time.

For their experimental translation project 'Ovid Void', Maria Stepanova and Eugene Ostashevsky return to Ovid's poetry of exile, written after the Roman poet was banished to modern-day Romania. Stepanova began 'paraphrasing' Ovid's melancholy verses in Russian while snowed-in at a winter cabin. Ostashevsky continued the process, adapting Stepanova's translations into English. As the material passes through hands and languages, it speaks to many of the concerns of the day: isolation, censorship, climatic change.

'The Chicken' by RZ Baschir, winner of The White Review Short Story Prize 2021, sponsored by RCW, is a dark folktale in which women are treated as sexual livestock. Irenosen Okojie's surreal fiction also twists and shifts the world as we know it; in an interview she discusses migration, memory and her determination to seek new literary forms. Replete with time-travelling monks and women who transform into liquorice, Okojie's stories, like Baschir's, are unsettling folktales about modern life.

Issue 32 also includes poetry by Raymond de Borja, James Giddings and Kandace Siobhan Walker, the winner of The White Review Poet's Prize 2020, in partnership with CHEERIO. The artist Zach Blas discusses the weaponisation of technology and our willing exposure to systems of domination, Polly Barton writes an ode to the Japanese new-wave pop star and 'insect woman' Jun Togawa, and Lili Hamlyn examines the drive for immortality by way of cryogenics and posthumous sperm retrieval.

Interviewed for issue 32, the artist Lubaina Himid speaks of the women of African descent who populate her paintings, the architects and city planners that are 'deciding where the parks and lakes will be, where girls will be able to play outside'. One such painting, *Three Architects* (2019), depicting Black inventors, is the cover of the issue. Three figures are seen designing architectural maquettes in a workshop – boats, houses on stilts, structures for the future. Through their collaborative work they appear to pass on knowledge and shape the world to come.

THE CHICKEN
RZ BASCHIR

FICTION

I've always lived with Aunt and Uncle. They're the only sisterfuckers I've ever had, and I've always lived with them. The house is cold and skinny and my bedroom is right at the top, on the fourth floor, in the space underneath the roof. If I stand in the middle I'm alright, but since I turned 11 a few years ago, I've had to bend my knees to stand in the spaces where the ceiling swoops down and the mice scuttle. I spend most of my time here in my bedroom when I'm not at School. I draw pictures or write things down. Downstairs, Aunt smokes from her hookah pipe and listens to sad love songs from the cassette with a large 'S' painted on it in blue nail varnish. Uncle is asleep. He wakes up when the sky gets dark, and washes his face till his eyes turn red and water drips from his long feathery hair. Then he comes downstairs and sits on the edge of the sofa, breathing heavily, making a noise like there's something wet and green lodged in his throat. He waits for Aunt to bring him his special drink of chilled chicken's blood and rose water, served in a tall glass covered in faded gold flowers. He gulps it, feathery head thrown back, then smacks the glass on the table, clears his throat, puts on his stinking leather jacket, and leaves for his shift at Paris Sweets and Restaurant, where he cooks and sweats in the small, dark kitchen all night, over pots that would crush him if they could. I don't drink the chicken's blood, but I do eat the flesh when Aunt cooks it. She cooks it in all sorts of ways, with butter and spices, turns it into this or that, a pastry or a soup or a jelly. Uncle doesn't eat the flesh, Aunt says his throat closes up around food. It's the chicken's blood that keeps him going, that, and the smells of cooking, is all he needs. He's not had any solid food for so long now that he looks grey. Or like he's in constant pain. Even I could take him if I wanted to. Sometimes I do want to. I imagine him on the floor with me standing over him, the way Aunt stands over me sometimes, forehead covered in sweat, eyes bulging. Next to me and Aunt, he's nothing. Me and Aunt are soft and round from the chickens we eat every day. We grow rounder all the time, around our chins and legs especially. I think we're proud of it. Aunt's proud of her chest, and she says her belly is something to show off, not hide. 'We're not hungry,' Aunt says. That's for sure. I eat so much I sometimes vomit in my mouth and then I swallow it back down. Aunt says my lower legs look like sisterfucking chicken drumsticks and when she hits me on the head or the back or the thigh or wherever it is, playfully or when she's really lost it, she says she needs to go harder so I can feel it through the layers of fat on me. Even though Aunt says we should show off our bellies and our chins, I sometimes feel like we shouldn't. Then I think I shouldn't eat. But then I think, why not? And there's never a good enough answer to that question, so I carry on. And Aunt makes all sorts of things out of chicken: curries, pâtés, pastries, kebabs, cakes, pies. Every dish begins with her killing a chicken with a knife, cutting its head off, draining its blood into a baby blue plastic tub for Uncle's drink, and then pulling its body apart into little piles of dark red organs, white bubbles of fat, and plasticky parcels of meat. The muscles. The chicken's breasts and thighs. Aunt scrapes the balls of fat and bits of gristle,

pink and white and red strings of sinew, a sort of glue that holds all the different bits of the chicken together when it's alive, off the chopping board, into a carrier bag lining the bin, where the bits all sort of speckle the inside, stick to the plastic and graze my hands every time I go to put something in the sisterfucking bin. The offal, the shiny maroon pile, she fries in butter and garlic till it turns from dark browns and reds to bruised greys and blues. To the pink meat, she might add chilli, salt, and yoghurt, then tuck it in the fridge next to milk bottles full of chicken blood. The milk bottles we get from the milkman, the chickens, because we have to have fresh blood for Uncle (or he'll die), we get from The Chicken Man, and not the butchers like other people do. He usually comes on Sundays. The sisterfucker's short, and wears a stained blue butcher's jacket that comes down to his calves, and a knitted white skull cap that sits on his head like a cobweb. He parks his van in the curve of the cul-de-sac, surrounded by the tall houses on our street in a squashed half-moon. He beeps his horn a few times, then tumbles out and cracks the back of the van half open so you can see three rows of chickens, grey-faced and screaming in thin, wiry cages, their pointed faces stabbing out of the dark, the stench of their shit spreading across the street and reaching my eyes at the front door, making them water, so I rub them, and I stand and watch Aunt as she makes her way over to the van, touching her breasts to feel for her purse. 'Oof! That's the smell of real food,' she says, scrunching up her nose and laughing. She winds a bright yellow scarf around her large head, and holds it in place by sliding some of the fabric between her pursed lips. She nods her head at The Chicken Man in greeting.

'How many?'

'Give me 10.'

'I would give you 100, right here, right now.'

'That so. Well, maybe later you can, but not right here janu.'

She feels around her breasts for some coins, and The Chicken Man watches her, before slowly turning to pull the birds from the hatches. 'My birds,' he calls them. 'My girls.' Aunt's a big girl. Always has been, even before we started eating the chickens. She has bouncing breasts and lips stained purple with tobacco smoke. She wears a gold glittering thing in her left nostril and its tiny beads move every time she speaks. Her hair is curly when she combs it on Fridays, but usually it's tied into a thick black plait that sits straight, right down her back, along her spine or the crease between the fat. Aunt and The Chicken Man have what she calls 'a special deal'. He gives her cheap birds, and she cooks them for him when Uncle is at Paris. Twice a week, The Chicken Man arrives at our house sweating, red in the face, delighted with himself, the sisterfucker,

hungry. He leaves grease stains on the shiny red settee and smokes thin, knobbly little cigarettes that he makes himself while Aunt barks at him from the kitchen where she prepares the birds. The birds would kill Uncle if he took a single bite out of them, I always think. I think how funny it is that they would kill Uncle, but we'd die if we didn't eat them. How is it that he can't eat the meat, but can drink the blood, and I'd be sick if I had to drink the blood, but I can eat the meat? The Chicken Man has both, the meat washed down with a couple of shot glasses of blood. He mixes it with some kind of clear spirit he carries in a small flask in the inside pocket of his jacket. His grunts of laughter and pleasure, sucking sounds from ripping chicken meat off bones, burping, licking, and farting, reach me in my room upstairs. When I am told to go downstairs and clear the table, there's nothing left on the plates. Then he looks at me as if it's the first time he's seeing me, mouth slightly slack, eyes slightly glazed. He says, 'Got a lot of meat on her, this one, bet she's delicious! What do you say?' The mad bastard. Aunt gets angry then and slams a plate of green chicken custard in front of him. Aunt really is a fantastic cook. She can make anything with chicken, things that are salty, or things that are sweet and hot. The Chicken Man eats everything she puts in front of him, the way he sees it, he's doing us a favour by collecting the birds for us from The Factories (even if they are free), and then another favour by making sure none of our meat goes to waste by eating what Uncle can't. 'If Uncle, that poor sisterfucker, can't eat it, it doesn't look like you two little ladies are going to finish 10 chickens between you a week, what do you say?' Aunt and I look like we eat 10 chickens each a week. But Aunt always giggles when he says this. 'What do you say?' 'What do you say?' This is something he says all the time, without expecting Aunt to say a thing. 'These cigarettes are top class, what do you say?' 'This girl is a gone case, what do you say?' he says every time he sees me, eyes shining. He brushes against me when I put dishes on the table in front of him. I feel something inside me shrink whenever he looks at me. 'Number One, eh, what do you say? Number One isn't it?' he always says, looking at me and the plates of chicken, and licking his lips and looking at Aunt, as she feels around for the coins in her bra and hands a couple of silvers to him. She smiles, head cocked to one side. Then she slowly turns her back to him and approaches me with five screaming birds in each hand.

'Where does he get the birds from?' I ask, like always.

'I told you, my pussy,' she replies, also like always. I look at her. 'Where do you think he gets them from? A farm of course.' Then, getting pissed, 'I swear to god, this one's a real idiot. Poor fucker whoever ends up with her.' She always says that.

She squeezes past me with the chickens, all real mad bastards, lunging and flapping to escape. 'Close the sisterfucking front door!' She shouts. And then she lets

the birds fall to the ground, scramble around, all of them with patchy white-grey feathers covering their thin shoulders and leaky eyes. Aunt grabs a sharp little knife from the table, and pinching a chicken at random, pulls its wings up into the air till the weight of its body exposes the creamy sinew attaching wing to body, then she slashes it with the knife so that it can't fly away. As I watch she says, 'What are you looking at? Sisterfucking grab them and bring them to me.' And so I grab at the one she's just slashed and chuck it in the back garden, and grab another and pass it to Aunt. I like the feeling of their ribs and chest heaving in my hands, even though I'm scared of them and they're all mad bastards and look like they would claw my eyes out if their own weren't so watery and filled with pus. This is how we spend Sunday mornings, me grabbing and passing chickens to Aunt, and Aunt slashing the skin under the chicken's wings, not enough to cut them off completely, but just enough to stop the mad bastards from flying away, though it has happened before, that Aunt gets excited and cuts too hard, and severs the wing completely, and that kills the chicken there and then, but we just carry on, bending to wipe its acidic shit off the floor before it hardens on the linoleum, slitting the throats of two or three more chickens, chucking their hard, pointy legs out into the yard for the other chickens to fight over, then collecting blood from the dripping necks of the ones we've killed in a pink plastic tub in the sink, then slopping it into old milk bottles and storing it in the fridge. I didn't used to think chickens could fly, because I never saw one fly. When I was younger I asked Aunt if chickens fly, and she used the knife to cut my plait off my head and threw it on the floor where the chickens pecked at it and covered it in their shit, so I cried and cried then eventually threw it in the bin where it gradually disappeared under little red and pink and white and purple mounds of fat and gristle and skin and feathers. Aunt told me she cut their wings whether they could fly or not, so whether or not they could fly was irrelevant. I think this means they can fly, or that Aunt is scared of them flying. Aunt has her ways of doing things. The house always smells like chicken or chicken's blood, or cigarettes and the soft smells of sweat and spices. The sweat and the spices are from Uncle's leather jacket. And I always think those smells for him are like food for us. He eats the smells and drinks the blood. His jacket hangs stinking on the wall when he isn't wearing it. When he wears it, it's because he's going to work, at Paris, Paris Sweets and Restaurant, where he cooks but never eats, because he lives off the smell of cooking and a pint of chicken blood a day. 'He needs the drink to keep it up, that man needs chicken's blood to help him fucking sit up, he's all dry and empty inside. Asthma, you see, that's what his problem is, he's dry as chapatti flour inside. Doesn't produce blood of his own no more, the chicken's blood's all he's got in all that dry old body of his. Gives him some strength, the strength to wipe his own arse at least. He's dry as chapatti flour inside, dry as ashes, with all that coughing and wheezing he does, dried in the nuts as well thank fuck! He can't get even get it up most weeks without a cup or two of that blood thank god, thank god I've been spared

his smelly sticky sickly spill between my legs.' Aunt thinks of me as her sister sometimes, she says, and then she tells me things she forgets later on, when she gets mad angry and bashes my face against the metal pole that runs along the stairs, or, if she can't grab me quickly enough, chases me up to my room and holds a pair of scissors, or a length of metal rope we use to hang net curtains, or a rolling pin, or whatever it is she has to hand, and beats me with it till I can't breathe. Always I think, 'She's gonna kill me, she's gonna kill me, she's gonna kill me.' But I never die. I just cry for a bit, wipe my tears and carry on like before, never remembering not to chew loudly, or not to ask stupid questions, always lazy, always forgetful, sometimes still pissing myself. Aunt says I'm shameless and even a good beating can't teach me anything but I don't agree. The beatings do teach me some things. I feel calm and empty after them, I don't like to write or draw then. I just sit in a ball under the covers and sort of sleep. Aunt listens to the radio, or her favourite cassette, and she delicately guts and cleans the chicken meat, cutting the innards, and separating them into piles of white, and brown, and pink. Milk bottles filled with blood stand in the sink. The chickens fight each other in the garden, peck at the legs of the dead, strewn across the slabs. The chickens talk to each other about their fear of Aunt's blade, their hopes that when it happens it'll be quick. I watch them and think I can understand what they're saying. Something about a factory, something about the wood, something about wires digging into their feet. They turn the dead legs, the legs that are left on the slabs in front of them, if they're not carried off by the rats, they turn them, and show each other the scars in the flesh. They talk to each other like Aunt talks to me sometimes, when she says she thinks of me as a sister. Sometimes, Aunt tells me, when they were first wed Uncle would drink her blood. He liked to watch himself get red and slick with it, then he'd go down on her and lick her dry she said. Now he only drinks chicken's blood the sisterfucker. He has watery little eyes, and black flickery hair, and never ever speaks to me or Aunt. Aunt is scary because she randomly gets angry and beats me up. But at least I know that when she's looking at me, eyes narrowed, head shaking, all she's thinking is: 'A real poor sisterfucker whoever ends up with you,' because that's what she says. But Uncle never says anything. He breathes noisily, like there's something wet and green stuck in his throat. He's got hairy hands, and pink skin. And I never see him touch anything but that chicken blood before leaving for Paris. At Paris, the main room is covered in a dark red damask wallpaper, and dim, cosy lights made out of paper semi-circles are attached to the wall. Ten little round tables covered in white cloths are set out, five a side, which leaves a gap just wide enough for the skinny old waiter to walk through to the back where a counter displaying sweets sits in a beautiful glass tank. In it are gem-like barfis, gulab jamuns, fancy scrolls of orange jalebi, and bricks of gajar halva. Curious white people walk over to it with wrinkled faces, and nervously giggle over them. Boss, the owner of Paris, sits next to the counter and below a huge black and white print of the Eiffel Tower covered in flowery

writing. He mutters an encouraging 'very good', or 'first class' to whatever item customers pick out, staring all the while at the long, bare legs, and soft, yielding breasts of the white women. Downstairs, the kitchen is lit by a single, bare bulb that hangs from the ceiling. The space is too small for the five men who are jammed inside. They listen to songs about men leaving the village, about a mother with a quivering chin as she waves goodbye, or the shade of the mango tree in the summer and the shape of the woman who sleeps beneath it. The walls are wet with steam and the smell of cardamom mingles with sweat and cigarette smoke and spices. Uncle is quiet, but purposeful in this environment. The other men are bigger than him, and around them he looks even more lost and fragile than he does in the house, or on the street. He stays in the kitchen till every last customer leaves, and then comes home early in the morning, and the chickens in the back garden begin to wake up, ruffling their feathers, pecking at each other, Uncle brings rounds of naan and greasy foil boxes of coloured pilau rice home with him, and leaves them in a bag on the kitchen floor. I eat the naan, if they're still soft, with some jam or butter, standing over the sink, looking into the garden at the huddle of chickens who sit on the grey slabs like sunken clouds, leaking into one another, shivering in the cold. I wash my mouth out with water, run my finger along my teeth, and leave for School. Aunt says School is only compulsory for girls who don't bleed. When I do, she'll tell the School I'm sick and can't attend any more, and then Uncle will find me a Man to live with and I'll become an Aunt myself if I find a 'little chick' to look after, like Aunt and Uncle found me. Aunt said she found me in the bins behind the community hall. That's where a lot of girls are found. Crying and puking. She said I was covered in shit and shivering, so she picked me up and took me home and fed me sugared water on a little cloth rag that I grabbed and sucked on till I could walk and talk. She told the Authorities and they gave her 50 quid a week for taking me in, she says. Money that stopped a few years ago, she says, pointedly. She doesn't get the point of School she says, given that I can walk and talk just fine, I can read things the Authorities send to the house, and translate for her when a man or a woman from the Authorities comes knocking on the door, and ask questions about this or that, like, 'Where's your Uncle?' In those situations, I have to say 'he's gone out', never ever that he's asleep, never that he's in the loo, or that he's at Paris, Aunt says. He is never out, he is always asleep. But I can't say that for some reason, that's not good. Uncle's are supposed to be out, not sleeping. If I slip up, it means I'm creating problems for Aunt. So I just do what Aunt says. Aunt doesn't like to see me reading or writing in the house. So I do it in my room, or I just do it when I'm at School. School is three rooms at the back of a tall red building that looks like it used to be a church, but is now used for weddings and occasionally cooking classes and activities for Uncles who don't go to work. I have to walk for 40 minutes to get there and sometimes still get sisterfucking lost. I walk through four or five streets, and then some woods, and then an underpass that runs under the main roads. It's a route

I know, but sometimes I get confused in the woods because the trees all look the same. And then I sit there, wherever I am, and cry until someone approaches that I can tag along with, which is what usually happens after a few minutes. And then I pinch my wet nose on the sleeve of my jumper, and turn it up so that the snot is contained within a sort of pocket. I wear the School colours of purple and grey, a scratchy purple jumper with a yellow line around the V of the neck, over a grey shirt and pinafore dress with glossy plastic buttons all down the front. Sometimes, if she's awake, or in a good mood, Aunt pulls and scrapes my hair back, slicks it down with oil, and ties it into a thick plait that glistens all down my back and sits in a puddle in the back of my seat. I don't think it's the best style to wear my hair given the way it highlights my chins. Without the feathering of hair around my face my chins are fully exposed, wobbling, instead of blending into my neck and chest the way that they do when my hair is down. At School, I sit next to Selma. She has flaky skin and cracks around her powdery mouth. Occasionally, she turns to me and says 'What's she on about?', nodding her head towards Mrs McCain, our sisterfucking gremlin of a teacher. I say, 'Nonsense, probably, knowing her, stupid bitch'. At lunch I eat lukewarm peas and machine-diced carrots with fish fingers and beans. For dessert I have a jam and cornflake tart. The pale blue plates look like little moons on the red and yellow circular tables in the hall. They're like planets I think, or like egg yolks and blood. And the plates, are they moons or eggs? All sticky and soft, or all talcum powder and stone? I touch my plate, its edges are covered in sticky fingerprints of jam. I eat slowly, and listen to the blah blah blah of conversations happening around me. They say bleeding hurts. But they also say that it's the cut that heals itself. It can't kill you. Cuts always heal themselves. Usually what happens with cuts is they sort of go all jammy and itchy before new skin is made to cover up the hole, it starts with a yellow filmy layer, which keeps growing on top of itself, pulling at the good skin all around the hole, and then the yellow stuff dries up and hardens until the hole is patched, then there's a sort of ring around it, around the new skin there's an outline, and this new bit of skin doesn't have the same lines or texture as the old skin. And I think, is that what will happen down there when I bleed? I think about a chicken's neck congealing like that, healing, creating layers of new skin and bone, and muscle and gristle, and feathers and leaky eyes, till the mad bastard can squawk again, run on its severed legs, flap its almost severed wings. Things are like that I think, they need time. Just a bit of time, and things grow, change, bleed, heal. But maybe cut wings can't heal, maybe the cut is too sisterfucking sly, under the wing, invisible to the eye. Maybe it heals but heals as a knot, tying the chicken to the ground. These are the things I think about when I get lost on the way to School. The other thing I always think about is the Man. Maybe Aunt and Uncle have already picked the Man for me. I think about that a lot. And I wonder then if I'll buy a chicken for this Man, and who will cook it. A thing has started with me recently, where if I touch the space between my legs, I can feel feathers. Or not

feathers, because feathers makes it sound like it's soft. It's sort of like little spikes poking through my skin, but they're hard at the bottom and then softer at the top. I can feel them underneath my arms too. Spiky, sharp little points that break my skin. I can't see anything in the day, but at night, when the mice scuttle around on the floor, and The Chicken Man is downstairs with Aunt, I touch myself between my legs to feel calm. I feel the feathers down there and I smell The Chicken Man's smell: chicken shit and sweat and cigarettes. If I stop breathing, I can hear the sounds of moaning coming from somewhere inside me, or, I think, holding my breath, is it coming from downstairs? I'm not sure because I'm too scared to check. Then, I feel that space between my legs under the sheets, and I can feel spikes, I can see them almost, bony feathers just breaking the skin, and yes, I can see them, pushing from inside me, into the darkness of the air above my sheets, and out, up over the bed, like strange flowers, stretching towards the grey light of the moon. In the morning, I have found feathers in the sheets, and then, looking between my legs, I see I'm as bald as a stinking plucked chicken. Or as bald as the men who hit Uncle once. Big, angry, pink men with bald heads, or heads covered in a short blonde fuzz, followed Uncle down the street once. When he turned back to look at them, they punched him and punched him till he bled from his temple and the side of his mouth. Since then, he leaves Paris only when the streets are properly quiet, just before dawn, and walks home with quick little steps, gripping a blade in his pocket. Then he stays sleeping all day in his room until it's time for his next shift. His skin is grey and his eyes are small and watery. He has an oniony metallic smell that hangs around the landing after he's come in. It's a bit like blood which makes sense because he loves blood. Loved drinking Aunt's blood one time, she said. At one time in their relationship that's what he'd do, drink her blood. In the end he must have drank her dry, and that's why now, she serves him chicken's blood, mixed with rose water, in a tall glass covered in faded gold flowers. I hardly ever sit in the same room as him. When he walks into the room downstairs sometimes, and I haven't been paying attention, just been lost in my own head thinking about this or that, and not realised the sound of his breathing wasn't my breathing but his breathing then I realise too late, only after he's walked in, being in the same room as him makes me want to be sick. I can feel him looking at me, and I think, maybe he wants to say something, but no, he never talks, what he wants is to drink my sisterfucking blood I think. That's it. And I stare and stare at my feet. And I think, if I don't make a noise or say anything, he'll go soon. When I hear him come home in the morning, the slam of the door, and then the rattle of his breath, I wait for him to go up to his room, then I sneak into the kitchen to eat the juicy tubes of kebab meat he's bought home, wrapped in foil parcels. I look out of the window above the sink, into the back garden, at the birds all sitting together, the floor around them littered with chicken feet and bits of corn. I think about chucking them a bit of naan or kebab, but before I know it, I've eaten it all while I've been thinking and it's gone. Today, I feel something

warm between my legs and I think I'm pissing myself again. I run up the stairs, feeling a sharp pain now, not piss, not like piss usually feels. Breathing heavily, still chewing on the kebab meat, mouth open, I lock myself in the bathroom, pull down my trousers, and see something pushing against my knickers. I can't breathe. I pull my knickers down and feathers burst around my legs. White and long, like flat, white fingers clawing at me, tickling me, sisterfucking clawing at me till I bleed. Because there it is, a stain, a blood stain in my knickers and on the floor. And I don't know what to do, but I wipe the floor with some paper, shove some tissue paper into my undies, and pray and keep thinking I hope no one can smell the blood on me I hope no one can smell the blood on me please I pray that no one can smell the blood on me that no one can smell it that no one can smell it that no one can smell it that no one can smell it. I put on my uniform and walk until I reach the woods, thinking I'll go to School anyway, but then the ache in my stomach means I have to stop. So I sit down and sort of lean forward a bit, making noises, moaning. And when I look up, my hands have disappeared under feathers, long white feathers. And my clothes fall off my body. My neck is covered with soft white feathers, and it blends into my chest, into the little boobies that were just starting to form out of the fat on my body. All of me is tight, compact, held together by sinews and stickiness, all pink and white strings. I stretch my wings and try to jump into the air, but nothing happens. I dive my face into the ground, pecking at nothing. My neck jerks forward, and then back again, and then forward. I stay in the woods until it gets dark, and I cry, but make no sound and can't crumple my face or anything. Only my cloudy eyes water, and I know I'm crying because I can feel it all tight in my heart. If Aunt sees me, she will cut my head off. She will slice chunks off me, and put some in the bin, and some in a pie. Uncle will drink my blood mixed with rose water, out of a tall glass covered in faded gold flowers. I don't move. I stay here, in the woods, and keep away from the other sisterfucking birds who squawk and fly up into the air and back onto the ground and look at me like they want to kill me too. The first night is hard because I've never been a chicken before. Or maybe, I've always been a chicken. But I can't think too much, my brain is shrinking. I feel things still. But they're sharp and flat. I'm hungry. I'm scared. I'm sleepy. Images flash into my head: legs strewn across the garden floor, the smell of meat, still warm after death. The Chicken Man appears in my head again and again. 'What do you say?' He says, again and again and again. 'What do you say?' It's dark. I'm tired and I stop crying. I close my leaking eyes, and then I feel sort of calm and empty and lay there quietly.

IF DEAD, COOL WITH ICE
LILI HAMLYN

ESSAY

A middle-aged man in a suit stands in a surgical environment. His hand rests on a four-sided cot, which contains a medical mannequin, blanketed in silicone prop ice. The dummy's arms are raised and cuffed to the automated CPR machine that sits, immobile, on its chest. There's a ventilator in the dummy's mouth and a blue mask over its face. The man, Max More, is the ambassador and President Emeritus of Alcor Life Extension Foundation, a cryonics organisation based in Scottsdale, Arizona. The image is taken from Alcor's live online tour.

Cryonics is the practice of freezing human corpses in the hope that reanimation will be possible at an indeterminate, sufficiently technologically advanced point in the future. Traditionally, this has been the terrain of pop-cultural mythology (Walt Disney, contrary to popular belief, was not cryogenically frozen) and speculative fiction, most notably Don DeLillo's *Zero K* (2016). Alcor, where the genuine cryopreservations take place, was founded by Linda and Fred Chamberlain in 1972 and has over 1,300 members worldwide. The facility – the Scottsdale location chosen for its good weather, airport access, low crime rate and minimal natural disaster risk – currently holds 181 cryopreserved 'patients'. They admit anyone who'll pay, with the exception of Ebola victims, whom they're legally prevented from cryopreserving. Outside the 'patient care bay', where the frozen bodies are kept behind steel-reinforced walls and bullet-proof glass, the walls are dotted with headshots of their better-known patients: Fred Chamberlain; the Chinese science fiction writer, Du Hong; a 3-year-old who died of paediatric brain cancer; Kim Suozzi, a 23-year-old who crowdfunded her cryopreservation on Reddit; Hal Finney, the first man ever to receive a Bitcoin; and the baseball star Ted Williams.

Max More joined Alcor at 22 and calls himself a futurist. He claims that most Alcor patients, despite their different backgrounds, tend to have three things in common: they're highly educated, harbour a keen sense of adventure and are optimistic about the future. More worries that science fiction has given too many of us an unjustly dystopian view of what's to come. 'A lot of people don't want to come back because they don't have much imagination,' he says. More's worldview is founded on an unwavering belief in progress; thanks to human innovation, things will just keep getting better. The future is a site of hope whereas it's the past, according to More, that 'was terrible'. 'We had slaves,' he adds.

I'd always assumed that cryonics would be shrouded in cultish secrecy, hidden away from the layperson's gaze. Yet a large part of Alcor's mission is educating the general public about the virtues of cryonics. They offer free weekly Zoom tours, which are presented as a no-strings-attached opportunity to see what it's all about. Out of curiosity – and frankly a sense of voyeurism – I signed up, expecting to lurk, muted and with my camera off, while sci-fi nuts and death deniers asked unhinged questions about how to triumph over death and live forever. Instead, I was the only attendee. Spending an hour – in virtual space – speaking with cryonicists was somewhat mesmerising. You find yourself being lulled by their logic, guided to a precipice. You peek over the edge, into a space in which this thing makes sense, where death isn't the end but just a temporary pause before a second life.

Alcor relies on a variety of comparisons and justifications to forestall scepticism. The moon landing, as an impossible-seeming thing which happened, is a favourite of theirs. On Alcor's website, I find a series of historic quotations about the unfeasibility of space travel. Underneath is their bombastic response, misattributed to Mahatma Gandhi, 'First they ignore you, then they laugh at you, then they fight you, then you win.' In a video, a self-satisfied Max More points out that in 1890 no one would have believed a man could walk on the moon. The message, I gather, is that a failure of imagination will embarrass you in the end. Alcor use somewhat more applicable comparisons too, which they refer to as 'proof of concept'. During the tour, Linda Chamberlain speaks of successful experiments in the cryopreservation of rabbit kidneys. She lifts her hand, moves it to her webcam, and points at the joint of one finger to illustrate the size. She tells me that in 10 to 20 years scientists will be able to reanimate a mouse. There's no reason to think this claim is based on anything but hope. Though cryopreservation is an active field of scientific research, the current focus of this work is not on the preservation or reanimation of whole organisms. Instead, scientists are attempting to find methods of preserving cell and tissue samples – in particular adult stem cells for medical treatment and tissue samples for pharmacological research – which don't cause significant cell damage. Cryopreservation is also used in ovarian autotransplantation, an experimental fertility treatment in which a patient's ovarian tissues are removed before cancer treatment and then reinserted once the treatment is over to restore fertility and/ or menstruation (as of 2015, 42 healthy babies have been born to mothers who'd undergone the treatment). There is some hope that cryopreservation may eventually be used to create organ banks of hearts and kidneys for transplant but neither organ has been consistently recovered following freezing.

Max More talks about electric signals whirring through the neurological pathways of defrosted monkey brains and how, in 1984, Alcor conducted a series of experiments on dogs. The dogs were completely exsanguinated and their body temperature was lowered to 4°C. Alcor claims that some of the dogs survived after being in this state for up to four hours but the publication of the study was blocked by the Society of Cryobiology due to ethical concerns. In June 2021, scientists revived bdelloid rotifers, microscopic worm-like creatures which had been buried in permafrost for over 24,000 years, but their biology is more resilient and far less complex than a dog's. Most significantly, Alcor cites the cryopreservation of human gametes and embryos as evidence that cryonics will work. More says there are 'millions of people walking around who were cryopreserved. They were just embryos at the time.' But the difference in scale is monumental: the most advanced embryo which IVF doctors cryopreserve contains 120 cells; the human body contains around 30 trillion.

*

In 2016, I cared for my mother as she was dying of breast cancer. I felt I was, in a way, actively participating in her dying. For a time, it was most of my life. Following her death, in the early throes of grief, a long-held fascination with what we could broadly refer to as death denial became more urgent or acute, and I began to probe the outer edges of the phenomenon. I was less interested in our quotidian failures to cope with or confront mortality – how so many of us can't talk about death,

or to a dying person – than with the extreme lengths some take to avoid the only inevitable part of life, its end. This research is what led me to cryonics, as well as the pop-cultural fixation with pseudocide (faking one's own death), the contemporary proliferation of wellness-adjacent psychic mediums, mind uploading and the boundless conspiracies that dead celebrities are not in fact dead. I also began to research posthumous sperm retrieval, a fringe but scientifically viable medical procedure in which spermatozoa are extracted from an individual following their death for the purpose of future, posthumous conception. Cryonics and posthumous sperm retrieval stand out to me, at least within this framework of death denial, as being somewhat akin. They aren't ineffable belief systems or whacky theories but material realities. Some version of them does take place.

Posthumous sperm retrieval was first performed by Dr Cappy Rothman in 1980, but the first child to be conceived using posthumously procured sperm wasn't born until 1999. The practice is illegal in France, Germany, Sweden, Canada, Taiwan and parts of Australia. In the UK, explicit written consent from the deceased is required; in Israel implied consent will suffice. There is no direct legislation in the US. It's left instead to individual hospitals to create their own protocols, though a 2018 study showed that just over a quarter of hospitals surveyed had done so. Amongst those that did, common policies included limiting who can request sperm, whether written or implied consent is needed and instituting a mandatory 'bereavement period' between sperm extraction and any attempts at fertilisation.

The procedure is most often requested in situations where an otherwise healthy young man dies unexpectedly following an accident or short illness. As a result, explicit written consent is uncommon. Less than 20 per cent of American adults under the age of 55 have completed living wills and posthumous sperm retrieval isn't generally covered in end of life directives. Implied consent – where consent can be conferred through an individual's words or actions, rather than via a signed document – is generally considered the second-best, or at least better-than-nothing option, though it can be an ethical minefield. If a man explicitly stated his desire to father a child, does that desire extend to a situation in which he'd play no role in the child's life? Can the partner or family be relied on to present the wishes of the deceased accurately when they have a vested interest in the procedure taking place? Could sperm extraction fall under the Uniform Anatomical Gift Act thereby allowing a spouse or next of kin to consent, and bestow the 'gift' to themselves?[1]

The problem with these questions is their breadth, their tendency to swell outwards. You can't pin down the meaning of a paternal urge without asking what makes a father; you can't determine the extent of bias without calling into question whom we reproduce for. The moment they're asked, the scope and the implications of these questions unfurl into something unwieldy, unanswerable even. The material process – extraction – quickly becomes abstracted.

In the UK, and in some hospitals in the US, extraction requests can only be made by a surviving spouse, but it's relatively common for the parents – particularly the mothers – of the deceased to ask for, and receive, their son's sperm. There's no national or international database of cases so it's difficult to get a comprehensive view of the exact numbers of requests

from parents, but of the 148 cases of posthumous sperm retrieval dealt with by the California Cryobank between 1980 and 2014, 59 were requested by the parents of the deceased. It's the cases involving parents which interest me. It's difficult not to read these cases as a grieving parent trying to create a living effigy of their departed child; that the desire for a grandchild is not so much the execution of the deceased's wishes, but instead an attempt to replace the lost object with a simulacrum. In 2018, the Ethics Committee of the American Society for Reproductive Medicine published an article laying out their stance on the ethics of posthumous sperm retrieval. They conclude that extraction requests from spouses of the deceased ought to be viewed 'with sympathy', but that cases where the parents make the request are 'more troubling'. They write, 'Ethically, these situations are not comparable. In the case of a surviving parent, no joint reproductive effort can ever be said to have existed. Nor do the desires of the parents give them any ethical claim to their child's gametes.'[2] They recommend that requests from parents should be refused. Across medical and legal academic writing, these children, fathered by the dead and carried by a surrogate at the request of grandparents, are described in uncharacteristically poetic language: they are 'memorial candles', 'living monuments' and 'child souvenirs', born into 'planned orphanhood'.

*

In 2009, Nikolas Evans got into an altercation outside a branch of Coyote Ugly Saloon in Austin, Texas. He was punched, which caused him to collapse and hit his head on the pavement. Although he was responsive at first, doctors were unable to stop the clusters of bleeds on his brain and his condition rapidly deteriorated. Nine days later, the doctors disconnected his ventilator; he was 21 years old. The day before his death, Nikolas's doctors had explained to his mother, Marissa Evans, that her son had failed a succession of neurological tests and was considered brain dead. Marissa Evans didn't understand why her son couldn't stay on life support forever. His heart was still beating; he looked unchanged. As the doctors described how Nikolas was, in fact, essentially already dead, a single thought crystallised, arriving fully formed: she needed his sperm so she could give him the children he'd told her he wanted.

Marissa Evans's case is unusually well-documented. She's given interviews to major news outlets, was the subject of an extensive profile in *GQ* magazine and, for a time, kept a personal blog. In the *GQ* profile she recalls the last time she saw Nikolas before the accident. How he'd told her – as he'd done many times before – of his desire to have children young, just like she did. Though she already knew the answer, she asked him how many children he wanted. Three boys, named Hunter, Tod and Van, he replied. Within 24 hours of her son's death, Marissa Evans assembled a legal team and entered probate court – still in the same clothes she'd been wearing for days – to plead her case in front of a judge, who ruled in her favour. Nikolas Evans's sperm was collected by a team of urologists 50 hours after he was removed from life support.

*

Both cryogenic freezing and posthumous sperm retrieval require immediate intervention following a death. The viability of sperm begins rapidly

to reduce postmortem, and most surgeons agree that the extraction procedure ought to be performed within 36 hours. Procuring sperm from the dead is rarely straightforward: it's not something you can simply ask for. It's likely that you'd have to produce evidence of explicit or implied consent and locate a urologist who is not only ethically comfortable with performing the procedure but also has the relevant expertise. You'd likely need to secure legal representation, then petition a judge or present the case to the hospital's ethics committee. And you'd have to do all of this in a day and a half, even if your loved one died on a weekend or in the middle of the night.

Exceptions notwithstanding (they once exhumed and cryopreserved the embalmed body of a man who had died more than a year previously), Alcor, too, prefer to act quickly, while cells are still ripe for optimal preservation. Members are primed for, and exist in a state of, constant preparedness: they wear medical ID bracelets to alert paramedics of their desire to be cryopreserved. (The tags read: 'If dead, cool with ice. Especially head.') Alcor is also staunchly anti-autopsy, describing it as 'one of the worst things that can happen to a cryonicist.' They advise their members to avoid illegal activities and travel to remote places; they ask that members consider carrying wallet cards expressing their religious objection to autopsy. They counsel them not to die by suicide.

Alcor boasts that the record between time of death and the beginning of the cryopreservation process at their facility is 33 minutes. When I hear this I make a note: *What of saying goodbye?* When my mother died, it took several hours for the hospital to confirm officially the death. I waited in the room with her body, comforted by her unambiguous deadness. The finality was soothing; she nearly became an object and I almost forgot she was there.

The speed of action necessitated by these processes is at odds with the temporal dislocation of bereavement, the cleaving effect it has. Days pass differently after loss; it takes time to learn to bridge the void between the before, when someone was there, and the now, when they aren't. Quick decision-making strikes me as a terrible companion for grief.

<div align="center">*</div>

The contracts, the permissions, the assembling of legal and medical teams; the logistics, the phone calls, the transportation of a corpse to the outskirts of a desert town in the American Southwest. All of this amounts to a prelude. What follows are precise somatic interventions, a series of surgical procedures to transform the deceased into a vitrified mass or to extract the 'essence' of their being, their genetic code.

There are several techniques to procure sperm from a dead or nearly-dead man. Minimally invasive procedures, such as vassal aspiration, microsurgical epididymal sperm aspiration and testicular sperm extraction, are preferred but other methods are also used, including orchidectomy (the complete surgical removal of the testes) and rectal probe electroejaculation. For antemortem extraction, employed when the patient is brain dead but hasn't yet been disconnected from life support, doctors can induce a seizure with the hope it will result in

ejaculation or even rely on manual stimulation (doctors aren't fond of this one, but there was a case in which a father masturbated his comatose son to see if his sperm was viable).

For cryonauts, the process is significantly more involved. As soon as the patient is pronounced dead, a standby team, who've been waiting on the sidelines like expectant fathers, place them in an ice bath. A device called a 'squid' circulates icy water around the corpse while breathing and circulation are artificially restored by a heart-lung resuscitator, affectionately known as a 'thumper'. An intravenous line is inserted, through which the patient is infused with 16 different medications, including propofol (an anaesthetic to stave off resurrection, to ensure the patient doesn't wake up), antacids and anticoagulants. The patient is then transferred to Alcor's operating theatre where they are treated by a team of contract surgeons. They are placed in the optimal position to mitigate the risk of fracturing, which is exactly what it sounds like: when cooled to extreme sub-zero temperatures, the human body – transformed into a solid, frigid mass – can fragment, like the laminated safety glass of a car windshield. The surgeons drill burr holes through the skull to observe the brain. They open the chest cavity and connect the aorta to perfusion machinery, which washes out the patient's blood before replacing it with a cryoprotectant solution. The toxic solution is essentially antifreeze; without it, crystals would form and the sharp edges would cause cell damage, millions of microscopic punctures and cuts. For neuropreservation 'patients', the perfusion machinery is hooked up to the carotid arteries instead. These patients then undergo a decapitation. Their disembodied heads, or 'cephalons', are placed upside down in a Perspex box for cryoprotectant perfusion and cooling.

Cryogenic cooldown, in which the patient is vitrified, takes several hours. A 'crackphone' is placed on the surface of the brain to sonically detect fracturing, while software-controlled liquid nitrogen is pumped around the body. In the course of this process, eyeballs freeze solid and brains retreat from the edges of their skulls as they dehydrate and freeze. During the tour, I was shown a CT scan of the frozen founder: a shrivelled mass – his brain – barely half-filled his skull. ('This is a good thing,' they assured me.) When the bodies reach $-90°C$ they are placed in sleeping bags and transferred to a dewar, a thermos-like tank filled with liquid nitrogen. In the dewar, where they remain indefinitely suspended, they gradually reach a final temperature of $-196°C$.

All of the methods, even the 'minimally invasive' procedures, involve incisions and catheters and result in the extraction of chromosomes. They call into question issues of bodily autonomy: what is an acceptable or ethical postmortem intervention? There isn't a neat or correct answer to this, and there's precedent. Dead bodies, after all, are subjected to medical (organ and tissue donation), legal (autopsy) and aesthetic (embalming) interference as a matter of routine. Supporters of posthumous sperm extraction liken the process to organ donation, both because the next of kin can provide consent on behalf of the deceased, and because a part of the donor has a second life of sorts. But restoring the function of a body to extend life is not the same as creating a life from scratch.

Consent is less of an issue in cryonics given that Alcor members are presumably fully aware of the process when they join. Still, Alcor's first patient, Linda Chamberlain's father-in-law, signed cryopreservation contracts after suffering two strokes. During the tour, she told me he had a 'deer in headlights' look at the time and 'didn't really know what was going on'. 'He might need some therapy when he's revived,' she added.

*

Alcor charges 200,000 US dollars for full-body cryopreservation, and 80,000 dollars for neuropreservation. Annual membership dues are 500 dollars. To ensure you have adequate funds upon your resurrection, they also recommend setting up an Alcor-controlled 'asset preservation trust' of at least 500,000 dollars (you can set up a smaller trust of at least 25,000 dollars but Alcor will charge you 5,000 dollars to do so). Alcor currently controls over 17 million dollars in 'patient' funds and, owing to their (somewhat baffling, considering they have a failing finance and accountability score on Charity Navigator) nonprofit status, are tax exempt.

Alcor recommend neuropreservation, presenting it as the more affordable and sensible option.[3] By the time technology exists to re-animate the body, they argue, it will be 'relatively straightforward' to rebuild an entire working – and youthful – body from the head down. As one member writes, 'We all grew a body once. [...] Considering this everyday miracle, growing a new, improved copy of your body for your brain (i.e., you) to occupy seems almost easy.' Construction is simpler than repair; Max More says they'll just 'tinker with those genes. Change the signals.' This tinkering, I am told, will probably be carried out by 'bio robots' made of, but different to, human flesh, that will convert your molecules into atoms and then rebuild the atoms into cells. (As they say this, I do my very best, and not for the first time, to remain straight-faced. I'm painfully aware I'm on camera and I bite the inside of my lower lip.) If the process of rebuilding were ever to be possible, it would likely involve some form of therapeutic, as opposed to reproductive, cloning. Cryonicists take pains to differentiate their work from cloning, both to distance themselves from the associated ethical quagmire and to tout the superiority of their practice: they are not producing a mere lookalike, but rather restoring the life of an individual with their memories, personality and experiences intact.

During the tour I am told not to worry, that cryopreservation isn't only for the super-rich. The vast majority of members pay through life insurance. Linda Chamberlain, who seemed to think I was younger than I am (she asked me if I was working on a school project), tells me that one's twenties, when premiums are cheap, are the perfect time to set up a policy with Alcor as the sole recipient. They aren't exactly lying about accessibility. I'm 28 and a 200,000 dollar life insurance policy would cost me about the same each month as a subscription to a streaming service; if I were 50 it would be around 30 dollars a month. The membership dues are in fact the highest cost, and work out to around 40 dollars a month.

I suppose I shouldn't have been surprised by their recruitment efforts. Organisations on the peripheries rely on conversion and need members who believe in what they're hawking. Linda Chamberlain has devoted her

entire adult life to cryonics; her father-in-law and husband are already suspended in liquid nitrogen, and she seems genuinely excited to join them. Talking with her was a little like speaking with an elderly religious relative, only if, after tenderly telling you how much they look forward to going to heaven, they then, like a pardoner, try to sell you indulgences. Alcor takes pains to point out that you can ask to be revived at the same time as your partner, children or parents. Yet this conjuring of a future family reunion conceals the fact that Alcor relies on the dislocation of an individual from their typical networks of support. Alcor works under the assumption that the families of many (if not most) members will be opposed to their decision to be cryopreserved. In a lecture entitled 'How to be an Exemplary Cryonaut', Max More suggests ways of preventing family objection, from simply informing your loved ones of your wishes, to putting in place extensive materials to block any legal disputes your family may have. He recommends asking family members to sign affidavits stating they will not interfere with the process or the finances, and suggests that members add to their wills a 'no contest' clause, which stipulates that a beneficiary will lose their inheritance if they dispute the conditions of the will. Alcor even go as far as to advise that members record a video where they state their wish to be cryopreserved and declare that they are not doing so under duress. It's perhaps unsurprising that Alcor suggests these procedures. Cryonics disrupts, or dismisses, traditional inheritance; instead of being passed on to the living, financial resources are withheld for the dead. Savings accounts are invested for a potential second life.

Most disturbingly, Alcor asks that terminally ill members relocate to Scottsdale for hospice care. They reason that dying close to the facility ensures speedy preservation, reducing the risk of damage or decay. But these benefits can't outweigh the sacrifice they impose. For international members, the price of end-of-life care in the world's most extortionate health system could be financially devastating, but it's the social implications I find most distressing.

When Kim Suozzi, the 23-year-old who funded her preservation on Reddit, was close to death, she and her boyfriend flew to Arizona to be close to Alcor. In a *New York Times* piece, her father describes how he had threatened to bring her back home to Florida, but reluctantly agreed for her to stay in Arizona. (He wasn't a supporter of cryonics and had previously told Suozzi, 'I can't help you with this. We don't live forever.') After 12 days in the Alcor-recommended hospice, Suozzi was discharged and told she would have to be treated as an outpatient. She moved into a rented apartment nearby (which delayed her cryopreservation) and died shortly after; her boyfriend was there but her father was not. CT scans taken after Suozzi's neuropreservation showed, according to Alcor's report, that 'while surgery and perfusion were accomplished without incident, the actual success of perfusion in this case appears negligible.' Suozzi's brain did not dehydrate and the cryoprotectant failed to reach the subcortex, leaving it susceptible to damage by ice crystals.

As I read through the public patient files (many patients choose to remain anonymous) on Alcor's website, two narrative threads emerge. There are the diehard cryonauts, those who've spent their lives advocating for the practice, contributing stories to *Cryonics Magazine*, attending get-togethers with fellow members. And there are those like Suozzi, or the

child who died of paediatric brain cancer, or the AIDS patients that Alcor cryopreserved in the 1980s and 1990s, who sign up because they are in situations seemingly without hope. There are two ways of reading Alcor's role in these cases. Either they're offering opportunity – a second chance at life – when no one else can or will, or they're proffering false promises: aiding the denial of the desperate while simultaneously cashing in.

*

In 2015, an unnamed wealthy British couple, from a 'notable' family, spent upwards of 150,000 dollars to become grandparents. The child was born with the assistance of a surrogate and an egg donor. The biological father of the child was the couple's deceased son, who had died in a motorcycle accident at age 26. He had not formally consented to posthumous sperm retrieval, so it's most likely that the extraction, which took place in the UK, was performed illegally. The baby was born in the US, where gender selection is legal. David Smotrich, the obstetrician who oversaw the conception at the La Jolla IVF clinic in San Diego, said, 'This couple were desperate to find someone who would be able to create an heir. They wanted a boy.' He added that the couple had been very specific about the 'type' and 'calibre' of both donor and surrogate. They wanted women who held the qualities – in terms of looks, intellect and education – that they believed their son would have sought out in his future wife. This bingo card approach is used by sperm and egg donor banks, where you can sort donors by race, weight, height and educational background, but there's something slightly odd about employing the same selective framework to a surrogate who shares no genetic material with the child she's carrying.

Using posthumous sperm retrieval with the express purpose of creating an 'heir' isn't unusual. In 2019, the parents of Peter Zhu, a 21-year-old military cadet who died in a skiing accident, petitioned a court to allow them use of his sperm. In their statement, they wrote 'In Chinese culture, only a son can carry on his family's name. Peter is the only male child in the Zhu family [...] Without obtaining genetic material from Peter's body, it will be impossible to carry on our family's lineage, and our family name will die.' The patrimonial impulses in cases like these are unsettling. It signals a return to archaic and damaging reproductive codes, where the motivation for creating a life seems to be the desire to acquire (or perhaps replace) a family asset.

In academic writing on the subject of posthumous sperm retrieval the 'welfare' or 'interests' of the theoretical child are a key focus. This is particularly true of writing from the 1990s and early 2000s, where there was a sort of moral panic surrounding the practice of posthumous sperm extraction. The alarm was spurred, I believe, by wider governmental, societal and media demonisation of single mothers, their dependence on the state and the supposed antisocial behaviour of their offspring. I've read numerous journal articles which cite the 'disadvantages' of growing up in a single-parent household or of being raised by grandparents. In a 1999 essay, Ruth Landau, a professor of social work, writes that children have a 'basic right to two living parents, at least at the time of [their] conception'. She goes on to argue that posthumous sperm extraction will lead to: 'economic inequality', 'idealization of the missing parent',

'internalization of the features of the illness from which the parent died', 'behavioural and emotional problems', 'discrimination' and lawsuits.[4] Here, novel, specialised medical technology is being wielded as a means of enforcing reactionary ideological tendencies. This line of thinking is dangerous. A quick search leads me to polemics arguing that single mothers – rather than the racist late-capitalist societies which fail marginalised communities – are to blame for unemployment, underemployment, the prison population, obesity, the 2011 London riots and police violence to name a few.

We know very little about the lives of the children born from posthumous sperm retrieval, with the exception of the Blood family. After her husband, Stephen Blood, died in 1995, Diane Blood was the first woman in the UK to become pregnant from posthumously procured sperm. During an event to mark the twentieth anniversary of her winning the legal right to conceive using her late husband's sperm, Diane's son, Liam, who was born three years after his father's death, described his experience of growing up:

> It's not really a thing of 'the father I never knew' because, although he's not physically here, he's still there. [...] Although I never met him, I kind of know who he was; you kind of get to pick up these things. There's plenty of families who haven't got a full family for one reason or another. In some ways it wasn't any different to that, and maybe, in some ways, it was almost easier because although he's always been there, it wasn't that I knew him and then lost him later.[5]

It's not uncommon to be born into grief. It's certainly not unusual to grow up without a father. How significant is the difference – is there even a notable or experiential difference – between this occurring through tragic but uncontrollable circumstances and this happening by choice? Watching a teenage Liam Blood on stage, sandwiched between a lawyer and a urologist while he justified his existence to a packed auditorium, made me uneasy. The experts on the panel interrupted him when he spoke, as though inconvenienced by the fact that he couldn't be confined by the facts of his conception and birth. It reminded me of the media attention that Louise Brown, the first child to be born from IVF in 1978, continues to receive, despite the fact that her parents – the ones who experienced the treatment – are no longer alive.

*

Posthumous sperm retrieval doesn't guarantee a child. In the majority of cases, the sperm procured is never used. Perhaps the sperm isn't viable, or the cost of surrogacy is too high. Maybe, after the imposed 'bereavement period', conception no longer feels urgent, or it might simply be that knowing that the possibility exists is enough. Cryogenic preservation doesn't ensure a second life. I was surprised and somewhat baffled to discover that Alcor do not conduct research into the technology needed to revive their clients; they just assume someone else will take care of it. They conceive of their work as preservation rather than the facilitation of circumstances that could make revival possible. 'If you have a heart attack, you get an ambulance to the hospital,' Linda Chamberlain tells me. 'We like to think of Alcor as an ambulance. It's not taking you down the street, but through time to a facility in the future.' Alcor may be a (very

expensive) car ride, but the destination is pure fantasy. It does not, and probably never will, exist.

Both practices rely on the creation of a kind of suspended state, in which the deceased isn't fully dead. The foundation of posthumous sperm retrieval, the idea that fatherhood is 'what they would have wanted', is hardly novel or uncommon; with that notion in mind, grieving families plan funerals, select flowers and dress a corpse. They may place a memorial bench at a favourite spot, run a marathon or start a charity. This line of thinking, though routine, creates a space in which the desires and therefore, to an extent, the consciousness of the departed can continue to exist. Though the consequences are far greater, posthumous sperm retrieval also produces a similar site of possibility, where death is no longer quite the end. The potential of a new life, formed in the image of the deceased, lingers, as though the replication of genetic material is akin to resurrection, or perhaps reincarnation. It's possible to read posthumous sperm retrieval as a biological insurance policy, one which has the potential to deny, mitigate or alleviate grief, but also to compound it. (Marissa Evans has been open about the grief and guilt she experienced when the embryo fertilisation using her son's sperm failed, and has said that, though she doesn't regret her decision, having her son's sperm in the first place has hindered her ability to 'move forward'.) At each one of the many stages of extraction and assisted conception lies the possibility that something will not work. And there aren't unlimited chances to keep trying; the sperm of the deceased is a finite resource. What at first looks like hope, in fact reveals itself to be a nexus of potential re-traumatisation.

Cryonicists take things further, going out of their way to avoid using the word 'dead' without the modifier 'clinically'. Citing the shifting definition of medical death over time as evidence, cryonicists are adamant that their 'patients' are not biologically, and therefore not actually, dead. To them, the only true or permanent death is 'information-theoretic death', a state when 'the structures encoding memory and personality (necessary for consciousness) have become so disrupted that it becomes theoretically impossible to recover the person'.[6] All other definitions of death are 'arbitrary, and subject to revision'. The problem with 'information-theoretic death' is that it's not a real thing: the term was invented by, and is exclusively used by, cryonicists as a way of justifying their beliefs. When their arguments fail to cohere, they simply reinvent the terms.

The nebulous conditions that these practices produce aren't just theoretical or a matter of language, there are legal consequences. In many countries, deceased men can only be named as fathers on birth certificates if the child is born within a few months of their death. In Russia, in 2006, a woman had a grandchild via a surrogate, an anonymous donor egg, and the sperm of her son who had died two years previously. When the baby was born, Russian authorities tried to place him in an orphanage because he legally had no mother or father and therefore, in the eyes of the state, didn't exist. In other cases the response isn't as extreme, but Diana Blood went through a lengthy battle to have her husband's name on her children's birth certificates. Cryonicists, too, worry about the legal ramifications of becoming undead. If revival were to happen, they are unsure if you would reawaken as yourself, legally

speaking. Would your social security number still be valid? Would you
have to pay back any death benefits your family received? How old
would you be? Would you technically exist?

At the core of cryonics, in my view, is not an interest in the future,
or a sense of adventure, but a pathological fear of death. To freeze one's
corpse in the hope of an afterlife is perhaps the most extreme measure a
person can take to refuse their own mortality in a world overflowing with
ways to refuse your own mortality. Cryonics doesn't promise eternal life,
just a nanoscopic chance of having to do this all over again. 'What's the
point of living,' a monk asks in DeLillo's *Zero K*, 'if we don't die at the end
of it?' I wonder if revived cryonauts would opt for cryogenic preservation
upon their second, third, fourth deaths. I wonder if the cycle would ever
end. I can't help but find it all supremely selfish. How do you grieve for
someone who wouldn't believe they are dead? Who has hoarded capital
for their impossible return? Who squanders natural resources to keep
their body or head suspended in a vat of liquid nitrogen behind bullet-
proof glass in the Arizonian desert? It seems to me that cryonics, even
if it provides some comfort for the cryonaut, is a renunciation of the
workings of grief and a rejection of change.

In an Alcor tour on YouTube, Max More asks a Russian man if he'd
like to visit the 'patient care bay'. 'I'm dying to see it,' replies the man
enthusiastically, without apparent awareness of his utterance's double
meaning. 'You only have to clinically die to see it,' says More, obviously
frustrated, as he opens the door, 'not be truly biologically dead.' I adore
the clip: More's humourless, pedantic response; his refusal to acknowledge
idiomatic language; the fact that the conversation is taking place in a
room full of dead bodies. The exchange is perfect, emblematic of the
fragility of the cryonicist's logic. How easily the framework is destabi-
lised: a throwaway remark is all it takes for More's carefully constructed
reasoning to crumble.

1 The Uniform Anatomical Gift Act (UAGA) was established in 1968 and subsequently revised in 1987 and 2006; the act permits individuals or their next of kin to consent to organ donation and allows for individuals to 'gift' their cadaver to be used in scientific research. In 2007 a judge in Iowa ruled that, under the UAGA, the parents of a deceased man could extract his sperm and 'gift' it to his fiancée.

2 Daar, Judith & Benward, Jean, 'Posthumous retrieval and use of gametes or embryos: an Ethics Committee opinion', in *Fertility and Sterility*, 110 (2018).

3 Some quick calculations make Alcor's claims of the neuropreservation option existing to benefit their members fall rather flat. A single dewar fits four full-body 'patients' and five neuro 'patients', or can be altered to fit 45 neuro 'patients'. A dewar filled with bodies and heads represents 1.2 million dollars of income for Alcor, whereas a head-only dewar represents 3.6 million dollars.

4 Ruth Landau, 'Planned Orphanhood', in *Social Science & Medicine*, Volume 49, Issue 2 (1999), pp. 185–196.

5 Liam Blood, speaking at 'Life after Death: A Woman's Victory in Having Her Deceased Husband's Children', at the University of Sheffield (13 November 2017). Site: https://www.youtube.com/watch?v=N7hXUgT3jUI (Accessed October 2021).

6 'What is Cryonics', published online by Alcor. Site: https://www.alcor.org/what-is-cryonics/ (Accessed October 2021).

INTERVIEW ZACH BLAS

In Zach Blas's 2018 film *Contra-Internet: Jubilee 2033*, a prophetic figure by the name of Nootropix muses on a world after the Internet. Nootropix asks, 'if we were to dissolve the image that looms in the network foreground... what shadowy network forms might come forward?' Throughout Blas's career as an artist, he has been interested in shadowy networks – technical, political and social practices and communities that exist in contradiction to the dominant ideologies of late capitalism. In his work, collective utopian gestures hijack power from those who hoard it.

Growing up in rural West Virginia in the 1990s, it was via the Internet that Blas first connected with communities talking about and making avant-garde, counter-cultural and queer art. His five-year project, *Queer Technologies* (2008–12), paid a kind of homage to those early online encounters, producing tools and programs for technological intervention. The *Queer Technologies* project featured *Gay Bombs: User's Manual* (a technical manifesto for queer activism), *transCoder* (a software development kit encouraging experimentation and open-endedness in coding) and technical support available at the 'Disingenuous Bar' (an alternative to Apple's 'Genius Bar', installed in galleries when *Queer Technologies* is exhibited). The works of *Queer Technologies* together imagine a technological landscape designed for queer use.

Blas's art reveals the ways in which new technologies are designed to do political work, however banal they may seem. In *Facial Weaponization Suite* (2012–14), he developed ways of evading and resisting facial recognition surveillance, producing masks which subvert the data logics that purport to be able to recognise someone as gay. Both *Queer Technologies* and *Facial Weaponization Suite* put into practice what Blas has called 'informatic opacity': the right to exist as a digital subject without identification. For Blas, informatic opacity is a utopian gesture, rooted in the thought of Caribbean philosopher and poet Édouard Glissant, who argued for opacity as a refusal of the twinned logics of transparency and privacy, which determine who gets to be the subject, and who is made the object, of Western knowledge.

Utopian gestures, in all their messiness, are also the subject of Blas's more recent work, *The Doors* (2019), the first in a trilogy of immersive installations, collectively titled *Silicon Traces* (2019–). Bringing together historical stories of Silicon Valley with speculative fiction, the trilogy looks at the technologies made by, and the cult of the visionaries who own, California's silicon empire. Real historical figures appear in strange guises, from Jim Morrison, front man of The Doors, whose psychedelic poetry features in the installation, to Ayn Rand, the protagonist of *Jubilee 2033* – a feature film, considered by Blas as a prologue to the trilogy – whose novel-cum-manifestos on individualism are widely read in Silicon Valley today.

Blas and I spoke over the course of various lockdowns, when the platforms that mediate Internet access grew ever larger and their visionaries ever wealthier. ZARA DINNEN

THE WHITE REVIEW Throughout your practice, you have made work about computing technologies and the Internet. I wanted to begin by asking you about your early experiences with the World Wide Web. What did the web mean to you when you first used it? Do you remember first 'going online'?

ZACH BLAS I do remember! It was 1997, in my hometown in rural West Virginia. It's challenging to convey how isolated I was growing up. There were only three traffic lights. I was surrounded by farmland, rivers and the Appalachian Mountains. The closest bookstore was an hour's drive; I'll always remember that. All the men in my family were coal miners, except for my father, who was a Puerto Rican transplant to the area and worked in an aluminium power plant. It was a poor, difficult, working-class environment. I stress all this because suddenly being able to communicate with people beyond my geographical location was a revelation. One of my uncles, who was a bit higher up in management at the local mine, got AOL when I was 15. My entire extended family, at least 30 people, would crowd around a single computer and watch my cousin Cory chat with strangers. Everyone would watch this silently in awe.

I got my first computer shortly after – a Gateway – and immediately headed to the chat rooms. I was a teenager of the 1990s, a period when alternative culture went mainstream, which greatly benefitted me because queer music, film and literature reached my tiny little town. I had Nirvana CDs, Dennis Cooper novels and Gregg Araki VHS tapes. Having access to popular culture was everything to me then.

I quickly found the Tori Amos fans. I first heard Tori Amos on MTV Unplugged in 1996. After that, she was my goddess and saviour for the rest of the 1990s. Like her, I play piano, and encountering her music touched something deep inside me. I think my attraction to her was, in part, due to the way she confronted her Christianity, and also her powerful sexuality. I grew up in a place that was fanatically religious. People were baptised in the river. There was snake charming and speaking in tongues. Only one kid was openly gay in my town, and he was beaten up daily. It was extreme and terrifying. And then Tori opened up so much positive possibility for me: her music was empowering, healing and nurturing; it genuinely helped me survive those incredibly hard years in West Virginia, the violence that I endured, and also gave me reasons to want to live.

Online, I met a guy that also liked Tori. He was a few years older than me and lived in Utah somewhere. His name was Toby. This experience blew my mind; it was my first time connecting with another queer kid. Interestingly, we quickly switched from chat room buddies to pen pals. We would write each other long, detailed letters with drawings and photo collages.

I think my 2018 film *Contra-Internet: Jubilee 2033* has some of the libidinal energy of 1990s Tori Amos music. I'm thinking of her album *Boys for Pele* (1996) and how it conceptualised sacrificing men and patriarchy.

TWR *Jubilee 2033* is a film about the end of the Internet, maybe the end of the world. You've described the film as inspired by the feminist political economists Julie Graham and Katherine Gibson, who go by the pen name J.K. Gibson-Graham, and their writing of the late 1990s and early 2000s. Rather than study the dominant operations of capitalism, Gibson-Graham were interested in all the ways people already live and organise beyond and outside capitalism, situations they referred to as 'the end of capitalism (as we knew it)'. Do you see *Jubilee 2033* as taking up this proposition?

ZB *Jubilee 2033* is an immersive film installation and the centre piece of *Contra-Internet*, a series of works I made between 2015 and 2019. The *Contra-Internet* artworks imagine various alternatives to and exits from corporate Internet culture and infrastructure. 'Contra-internet', a neologism, is a play on Paul B. Preciado's theories of 'contrasexuality' and the 'post-Internet'. Under this conceptual banner, these artworks were trying to reconfigure the Internet's horizon of possibility by specifically experimenting with queer and feminist writing. I utilised Gibson-Graham's theories, in particular, because of the way they critiqued the left for totalising capitalism. Gibson-Graham were arguing for a post-capitalist outside, and I wanted to explore what that outside could be for the Internet. I started *Contra-Internet* by asking some colleagues if they could imagine an alternative to the Internet. All the reactions I got were incredulous. I found that so provocative – that even just imagining an alternative, let alone practically building one, was out of the question. I've spent much of my life in queer bars and spaces. When you're queer, you

think about where you're going to hang out; there are intentions around building sociality. I was longing for this queer way of being together online – I still am. Facebook will never be enough.

For some time, I had been planning to make a documentary focused on activists and technologists around the world who are building alternative network infrastructures. But in the end, I followed my aesthetic proclivities and made a rather baroque, queer sci-fi. I was trained in film directing before I studied visual art, and I wanted to channel some of my queer cinematic influences here, like Derek Jarman and Pedro Almodóvar. Particularly, my film is a reimagining of scenes from Jarman's 1978 queer-punk movie *Jubilee*.

TWR At the opening of Jarman's *Jubilee*, which is set in the sixteenth century, Elizabeth I asks to see the future of her nation. What she gets is Jarman's rendering of 1970s punk Britain. The film plays with the historical pageantry that punk internalised, but it also feels very of its moment: it stars Adam and the Ants, and the punk icon Jordan. Do the historical figures haunting *Jubilee 2033* tell us something about our present moment?
ZB As a whole, the *Silicon Traces* trilogy, of which *Jubilee 2033* is the prologue, contend with the beliefs, fantasies and histories influential to Silicon Valley's visions of the future. I lived in California for most of my 20s and have since felt drawn to make work about its cultural contexts. A key development in making *Jubilee 2033* was turning to the writing of Ayn Rand and learning more about her influence in Silicon Valley and California. Rand is a main character in *Jubilee 2033*, because I think of her as the philosophical queen of Silicon Valley. The film begins in 1955: Ayn Rand and Alan Greenspan [Chair of the US Federal Reserve,1987–2006] drop acid and are visited by an artificial intelligence who guides them to a future Silicon Valley in the midst of being overtaken by queer militants. The German actress Susanne Sachsse played Rand brilliantly, with a touch of soft camp, and the artist Cassils plays Nootropix, a contrasexual, contra-internet prophet who destroys a networked universe with their CGI dildo-fountain.

Soon after I made *Jubilee 2033*, I was pleasantly surprised to discover that queer scholar Lisa Duggan published a book on Rand, with the delightful title *Mean Girl: Ayn Rand and the Culture of Greed* (2019). Duggan argues that Rand's fiction

is a key influence on contemporary manifestations of American capitalism. Spending time with this claim led me to research more broadly around various beliefs and fantasies that animate Silicon Valley today. In my most recent work, *The Doors* (2019), I focus on the re-engineering of psychedelic drugs to enhance worker productivity.

TWR *The Doors* seems to partly riff on Aldous Huxley's writing about LSD, in particular *The Doors of Perception* (1954). What is the connection between LSD and psychedelia in the 1960s, and drug taking in corporate Silicon Valley today?
ZB In recent years, micro-dosing LSD has become immensely popular in Silicon Valley, alongside the booming nootropics industry, which produces commercially available supplements to increase cognitive capacities. I'm quite taken by this return to the 1960s psychedelic project of mind expansion and the altering of consciousness – but for the purpose of advancing neoliberal work culture. *The Doors* is a six-channel video installation with a surround-sound design; it's meant to evoke a psychedelic liquid-light show as well as a corporate garden. I think of the work as being like experiencing a psychedelic trip on nootropics. The doors of perception are recast as black glass portals, like our phones and screens. Strange lizards roam about, which I like to think of as creatures that teleport between 1960s psychedelic culture and today's Internet meme wars. In the centre stands a drug menagerie filled with nootropics, with pill bottles named Utopia, Eternus and Obedient x3. I also worked with artificial neural networks, complex computer modelling programmes that are designed with reference to biological neural networks. By inputting particular data sets you can train artificial networks to model possible futures. The sounds and images in the installation are generated from training neural networks using a multitude of image and sound datasets, from binaural beats to music by The Doors, poetry by Jim Morrison to brain scans, psychedelic rock posters to sacred geometry, lizard skin to crystal bowl sound-baths. The lizards recite poetry based on the literature that drug companies use to sell nootropics, with a voice generated by training a neural network on hours of audio files of Jim Morrison's voice.

TWR In both *Jubilee 2033* and *The Doors*, California is an important site of Internet history.

The confluence of place and history has been discussed by the historian Fred Turner in his book *From Counterculture to Cyberculture* (2006), which connects countercultural ideologies of the 1970s – the back-to-the-land and hippie movements – to capitalist ideologies of the 1980s as they coalesce through the emergence of the World Wide Web. For Turner, much of what the web becomes is shaped by Californian culture. What does California mean to you, both as a subject of your work and as a place you have lived?

ZB Fred Turner's book is an exhilarating read. The detail with which he historicises the entangling of California hippies and entrepreneurs from the 1960s onward is impressive and crucial context for works like *The Doors* and *Jubilee 2033*. Making artwork about California is my own way of taking a situated approach, as I know the place quite intimately. Los Angeles is my spiritual homeland. I also lived in Berkeley, but I didn't care for it. I remember people there would mock me for having lived in the 'cultural wasteland' and 'simulation' of LA. It did take me awhile to get there. I ended up in Boston first – what a mistake! One of my first weeks in Boston, when I was 18, I went to my first ever gay and lesbian group meeting. I'm quite sure it was only gay and lesbian back then. I was so excited. I wore a t-shirt that I made, which had 'Kafkaesque' written on the front of it. I also probably had on my Tori 'Raspberry Swirl Girl' necklace. The event was a shock. Everyone there with so preppy, with popped collars and khakis. I didn't have the words for it at the time, but the class divide was stark. I hadn't met many queer people, so this was a wake-up call. It wasn't until years later, when I finally moved to LA in 2006, that I got to experience some semblance of queer elation on this earth. Personally, that's what is dear to me about California: the kind of queer liberation I experienced there.

TWR The *Silicon Traces* trilogy was a departure from your earlier work, which took the form of activist art, or to use the 1990s term, 'tactical media'. Primarily exhibited in galleries, *Queer Technologies* and *Facial Weaponization Suite* also make interventions in the world; they repurpose, or hack, systems and technologies that police everyday life. Do you think of these works as activist?

ZB When I look back to those earlier works, the mark of 1990s 'tactical media' is evident. These works were about extending beyond an arts context and also maintaining a public dialogue through the making and presentation process. For example, *Queer Technologies* was a critical branding project, and the objects produced look like legitimate products with bar codes and all. I would go to an Apple Store or a RadioShack and surreptitiously 'shop drop' these *QT* products on the shelves. They included a queer programming language and hacked adaptors that change the 'sex' of plugs. The idea was that you would encounter these items as actual products in tech stores and therefore approach them with questions like, 'What does this do?' or 'How might I use this?' *transCoder*, the queer programming language, was created to be a software development kit composed solely of code poetry and speculative code functions like 'qTime()', an executable file which would transport the computer into a queer temporal dimension beyond binary logic. There was also a speculative function called 'iDo()', a play on the marriage speech act. If you made the computer execute the command 'I do', then it would self-destruct.

With *Facial Weaponization Suite*, I made masks in public workshops. I started by aggregating participants' facial data with a 3D scanner. I then used these 3D scans to make a composite 'face' which could become a collective mask. As a result of this process, the masks were amorphous and abstract. Comprised of the many faces of the workshop participants, they could not be authenticated as a human face by biometric machines. But *Facial Weaponization Suite* wasn't only about this practical takeaway of evading algorithmic surveillance. The work was conceptualised around a demand for opacity, *not* privacy. What I mean is that the masks were not a simple gesture of individual hiding but a collective political demand to be viewed beyond the norms of recognition, visibility and representation.

Like much tactical media work of the past, *Facial Weaponization Suite* has been described as activism, but I think that is unfair. The work attempted to connect with the aspirations of social movements, particularly their use of masking – think Anonymous, the Zapatistas, black blocs – but the work is ultimately art, not activism. The work doesn't need to occupy and lay claim to the difficult work activists do. I see *Facial Weaponization Suite* as differently political, and part of this is how the artwork offers something practical (evading facial recognition) and philosophical (the demand for opacity).

TWR 'Tactical media' was a term coined in 1996, at a conference of artists and activists in Amsterdam called 'Next 5 Minutes'. Those present came up with a basic definition of tactical media: the critical use of old and new media toward non-commercial, subversive political ends. The term has also become a more general description of the ways users exploit flaws in technology to make it suit their own desires. Was this your intention with *Queer Technologies* and *Facial Weaponization Suite*?

ZB I was attracted to the idea of a work that could operate simultaneously as a political tool as well as being something more conceptual, utopic, metaphysical. But after *Facial Weaponization Suite*, I felt like I hit a dead end with tactical media. The self-inflicted pressure to come up with a political pseudo-tool felt too narrow and unproductive. I felt a strong desire to pursue work that could accommodate ambiguity, meaning the work might communicate a longing for a political alternative but not exactly offer how to achieve that alternative. Turning to this mode of making felt intuitive at the time. I wanted to incorporate more complexity, multiple lines of inquiry. I also wanted music to come into the work and give space to the part of me that is a musician. Unsurprisingly, I turned back to filmmaking.

I've always been a cinephile, but I never pursued film after I studied it. I probably could have, but it always seemed too expensive. My training was completely analogue. I used a Bolex camera, shot on 16mm and edited on a Steenbeck. Perhaps because of this, film always felt like a mode of creating at odds with my more computational interests. Shortly after I finished the last *Facial Weaponization Suite* mask workshop, I was awarded a Creative Capital grant in the US, and with these funds, I decided it was time to give filmmaking a go. I began writing the script for *Jubilee 2033*, which I finished in a couple weeks. Once I went into production, I quickly realised just how computational filmmaking can be. I shot with actors in LA for a few days, but then post-production for computer graphics took about seven months in London.

TWR A recurring aspect of your work is weaponisation – looking at how supposedly neutral technologies like social media are weaponised against users for activities like data mining and surveillance. But you also show how users can be tactical, and how they can weaponise use beyond capitalist ends.

ZB My interest in weapons began while making *Queer Technologies*. I had recently found out that the US Air Force, in 1994, proposed a bio-chemical weapon that would turn enemy combatants homosexual. These military documents were exposed by an NGO in the early 2000s, and the development of the weapon was no longer pursued. When discussed in journal articles, the weapon was always referred to as a 'gay bomb', even though this is not the military's terminology. Quickly, the gay bomb exploded across popular culture, appearing on an episode of the US television series *30 Rock* (2006–2013), a comedy stand-up performance by Margaret Cho and even a gay porn film. I was particularly taken with the idea of the military weaponising homosexuality to secure and protect the nation. The weapon seemed to operate via a logic of gay shame: enemy combatants and are exposed to the bio-chemical weapon; they become gay… and then just surrender because they are so embarrassed and ashamed? Another gay bomb also caught my attention. In October 2001, right after 9/11, when the US invaded Afghanistan, a photograph of a bomb attached to a US military fighter jet circulated. The bomb was graffitied with the statement: 'High Jack This Fags'. Here, 'fag' is projected onto the US enemy target: Al-Qaeda. The *Gay Bombs: User's Manual* (2008) explored these various entanglements of homosexuality, the military, racialised others, terrorism and weapons. The manual imagines a 'queer bomb' that resists the US military, nationalism and war. This felt classically queer to me, taking a gesture of injury and reconceptualising it as something affirmative and empowering.

TWR Weapons also feature in *SANCTUM*, an installation you created in 2018 at Matadero Madrid. In the dark, cavernous spaces of the former slaughterhouse, pounding techno, sculptural screens and cages evoked a sex dungeon. Nearby airport security scanners alluded to other sites of bodily interrogation – frisking, militarised surveillance. Why did you want to bring together these very different environments and experiences?

ZB *SANCTUM* is about the complexities of desire, surveillance and security. I wanted to explore the dynamic of taking pleasure in submitting and exposing oneself to surveillance systems. One might know that they are being surveilled or one's data is being gathered, but one still exposes one's self – and takes pleasure in doing so. This

could be irreverently performing for a public CCTV camera. It could be uploading selfies on Instagram and Facebook. Or even enjoying when an airport security guard pats down one's body. Bernard Harcourt sees these behaviours as belonging to what he calls our contemporary 'expository society', a society in which subjects willingly, pleasurably expose themselves to systems of power, domination and control. *SANCTUM* explores this, but the other side as well: those people violently forced to submit, harassed and profiled, secretly detained and tortured. This is why *SANCTUM* is a sex dungeon, torture chamber, religious temple, dance hall and weapons factory all at once; it holds together the various perversities of security and surveillance today.

The protagonist of *SANCTUM* is the 'generic mannequin', which is the cartoon-like figure on the interface screen of ProVision airport body scanners – found in airports across the globe. When a person is scanned, 'areas of concern' are mapped onto the image of 'generic mannequin' for airport security staff to 'read'. 'Generic mannequin' is the official corporate term for this figure. I became extremely obsessed with the generic mannequin. I dreamt about it nightly. The figure struck me as a troubling symbol for being a human being during times of global security. In the installation, this figure is subjected to a variety of metal structures: a stretching rack, cage, chains and a whipping post. Sexual pleasure and torture are indistinguishable. The generic mannequin's body is also harvested for liquid, which collects in a glass cube. This liquid-like metal is then used to fabricate the various steel devices in the installation, which appear as both torture devices and sex toys – they are like futuristic weapons of security, created out of the very bodies that they are being used on.

I think of *SANCTUM* as a digital update to the genre of body-horror cinema. Instead of all that gore spilling out of embodied things, there is a different kind of violence that happens to digital bodies like the generic mannequin.

TWR *SANCTUM* brings playful acts in proximity to violent capture, as the piece stages scenes of consent and exploitation at the same time. In your work, parody and pleasure often function as critique, as with the 'gay bomb' manual, or Susanne Sachsse's earnest, camp performance of Ayn Rand in *Jubilee 2033*. How do you think of comedy and play in your work?

ZB I'm quite fond of horror and humour. Together, they capture much of contemporary life – at least for me. I'm glad you picked up on the funny of it all! It's fascinatingly something that is often disavowed in the art world; there is a performance of seriousness in that arena which does not appeal to me. I mean, I'm a serious person but I need to laugh a lot. And I use humour, typically dry and dark, to tease out the absurdities of political realities.

With *SANCTUM*, I used the cheesy trope of speaking Latin in horror films. If you are summoning a demon or sending a demon away, you usually need to be chanting some Latin phrases. I worked with the musician xin, who composed a 30-minute house track for the installation. In the music, a male demon voice chants common security phrases translated into Latin. 'If you see something, say something' becomes 'Vide si vos aliquid, dicere aliquid'. Instead of saying 'Ave, Satanus!' or 'Hail Satan!' the demon proclaims, 'Ave, ProVision!'

TWR I wanted to end with a question about vision and futurity. In a recent piece of writing, 'Psychedelic Vision' (2020), you muse on whether psychedelic visions might activate unmapped futures beyond the 'grim reality' of the present. In a place like California, psychedelic drugs tie together histories of counterculture with military-industrial and Big Tech complexes. In these histories, 'vision' is a condition for, and technique of, power. Who gets to be a visionary? Who has the right to imagine and make futures?
ZB In the past, being a visionary was something mystical, like the twelfth-century saint Hildegard von Bingen and her divine visions. In the twentieth century, artists like Salvador Dalí and Nam June Paik were hailed as visionary for their innovations in the aesthetic field. Today, in 2021, visionaries are primarily found in the tech industry. These 'tech visionaries' not only dominate discourses about the future (being a Silicon Valley futurist is a full-time job); they also steer much of the world towards their particular neoliberal techno-utopian vision of tomorrow. Why should a handful of American tech companies get to have a stranglehold on the future? Tech visionaries do not just receive visions of the future – they predict the future, in order to delimit what is to arrive and prevent what they dislike from ever coming to be. I explored this in a few works that took on Palantir Technologies, a data analytics company currently based in Colorado,

previously headquartered in California. Palantir has been responsible for rolling out predictive policing software in California, and more recently the company was revealed to be providing services to ICE, the US's immigration enforcement agency. Palantir is striking for its name, which refers to the crystal ball used by wizards in *The Lord of the Rings* (1954). Linked to racial profiling, police violence and caging migrants, why does Palantir imagine its work with big data as similar to wizards consulting their crystal balls? I call this 'metric mysticism', when the absolute is no longer God but data. Companies like Palantir want to be perceived as wizardly, as if they have an erudite means to see the future that many of us don't. In reality, the abilities of their software are materially limited.

I like to think that having a psychedelic vision can interfere with Silicon Valley futurism, because consciousness gets altered when you trip. Having a psychedelic vision isn't limited to drugs; it's about what can expand your mind. Of course, as *The Doors* lays out, Silicon Valley elites know all about mind expansion: they take nootropics to increase the mind's abilities; they go on meditation retreats to have visions; and they use AI as a means to free their minds from a variety of cognitive labour as well as distribute and automate their visions of the future. In this context, psychedelic vision is a key site where the struggle over who gets to visualise – and control – the future is playing out. To answer your question directly, everyone holds the power of psychedelic vision; we all have the innate ability to alter consciousness and see another future contra to the tech visionaries.

Z. D.,
January 2021

WORKS

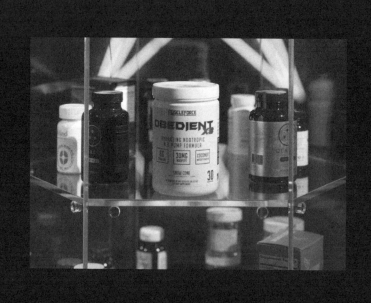

VIDE SI VOS ALIQUID DICERE ALIQUID
SUBMIT AD SCAN

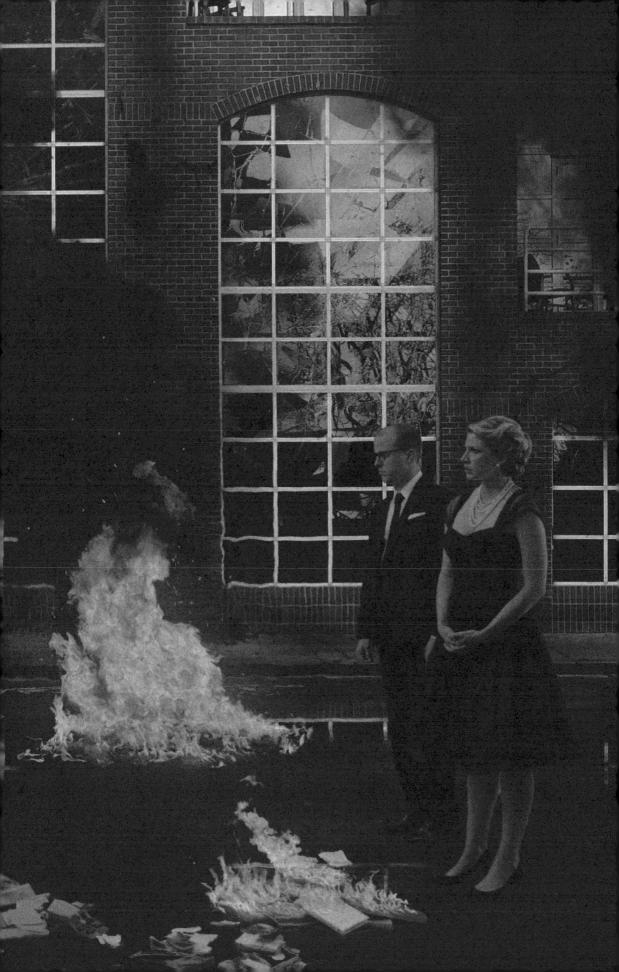

THE GARDEN HAS A STRANGE ATMOSPHERE
THERE ARE MANY MONSTERS WITHIN

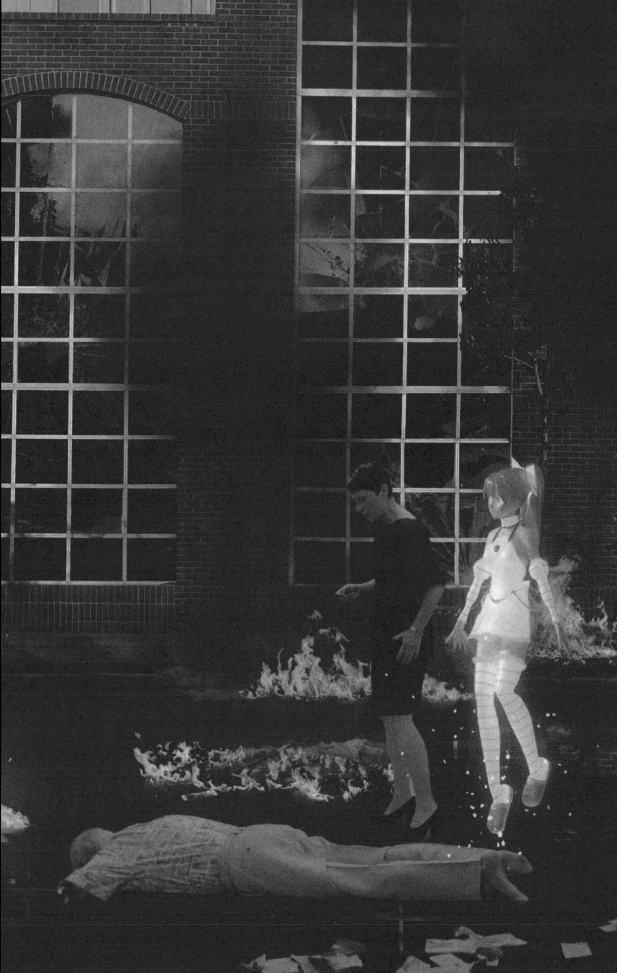

KANDACE SIOBHAN WALKER

POETRY

LOVE IN THE WEST

At the Langham, at the Mandrake, at the Shangri-La.
Retired psychiatrists, retired agency men, retired fathers.
Always a joke in lurking somewhere, like a thin gold band
shaken free from his suit trouser pocket. Cried so hard
my teeth came loose, the client caught handfuls of bone.
He pocketed a couple. My insides felt like porcelain after.

Hairtie wrapped tight around the stack kept in the cobalt lining
of my overcoat. My heartbeat slowing on a comedown.
Noise of traffic rising from street level. A dance routine of doors.
Ease of a script. A back against a mattress is a familiar arc.
My opener was always, Are you a pig? Beat. Wink.
Beat. The client winks back, but the funny ones oink.

SIERRA

A swimming pond is a national project.
Horse girls are my Mr Hyde.

Police ride horseback through Hyde Park,
like armies training in the trees.

Real life arms and trains me against symmetry.
Politically, I am the object of war.

I am more and more an objection to policy.
Nature exists in opposition to you, not me.

My existence isn't naturally oppositional
but I will always have dark sky status,

and you'll be lurking my statuses in dark mode.
A nation without a heart is a country without lakes.

I will be the heart, the nation, the without, the lakes:
a swimming pond is a national project.

FORREST GUMP

Being twenty-one is like being god, like the cocky blue
dress I wear at every party, like the burning tree
in the wilds beyond my ends, like supermarkets
at night, the coolness of the light at dawn in an unfamiliar bed.
I play sad gay albums to a nub, summer grinds like a school dance.
I'm wise enough to know there are just two kinds of people:
girls with smudged mascara and girls with baby wipes.
July is as short-sighted as she is alive.
I can't get at love by swimming laps. I gather relics:
starry lip gloss, 7 a.m. glinting off running tap water,
mismatched earrings, a lonely box braid on the subway.
Kindness is sharing jeans and deleting numbers.
The faces of strangers mean less and less.

PRISM

Board trustees tapped heirloom spoons against the graduates'
wet green skulls to get at the yolk. Academics, in chorus,
drilled and blew until we were bright and
airy, ready for democracy. Cheeks inflated like bubonic plague,
foreheads stretched like drumskin, rainbowed
like wounds, skin whining, funny helium voices.
I watched the best essayists of my generation float
over the Amazon rainforest and burning California
to drink the sun from the sky, bite and chew and beat its yellow,
so they came back to us rigged, rainless sierras.
Each time we fell to the ground like flies under an educative glass,
never realising: some skies have a limit, and this is ours.

GREEN PARAKEETS

Are there as many green parakeets in your daydream universe as there are
in my daydream universe? Like the actress arriving at the train station in the rain,
I've been waiting for myself. What love means to the people who love me,
I don't know. Am I sad or ill-equipped? I close my eyes and it's just static. I want
 to be a sculptor's
model, neurotypical clay. I want to be sexy and profitable like
a perfume advert or rivers of streetlights, a Romantic language, a music video.
I want to exist in a straight line. Will you love me when I do not know how
to love me, because I'm searching the platform? I want to ask everyone,
wrong answers only: do you need me the way I need me? When I close my eyes
it's glittering noise, non-native birds and tropical storms mapping my limits,
 never striking the earth.
One one thousand, two one thousand, three one thousand, four.

BAS-RELIEF

Patient is most herself under threat of violence.
She moves easier than ribbon eels, like water
refractions under a stone bridge in the favela.
High spirits, in good humour, remarks:
a husband is just a man in your house.
Raise a fist and she becomes graceful
like a holiday, a housewife in a summer dress
with her back pressed to the light-
house, its guiding eye never falling
across her shade. Never revealing the deal
she's made. Being a ghost is delicious.
Nightmares: barrels of light, knives
in safe harbour. Certainty is a flat palm,
ringing ears. Storms are the presence of peace.
Look at what you love, then look at where you are.
Sadness and lust in bas-relief, dreams of turning men,
the lyre that wakes the sun, the honey, I'm home.

CLEANING LADIES

And we scream on the way to work, fuck working! we're flirting with the future on the nightbus. Between this job and the next. Washing-up liquid and vinegar'll do the trick. The astronomical metropole lit up like winter. The villages, the realm of humans. Automatic, the hotel. Every body dismissible. Against the white neutral, kill-able. Employment is just a way to justify employers. We suspect you suspect of us a lack of interiority. Cardboard cut-out Western town of a girl. Wife without pearls. But everyone has a third life. You can tell who's comfortable to sit with a magazine while we work. Dirty thumbprints on the doorframe. Shit in the shower. Cigarettes in the freezer. Laundry line, designer dresses like bills on the breeze fluttering out of the blown-up cash machine. We see what you can't see. Train lights. Reflections sliding across unpolished silver. Caught holding the rag, fingers made of air. If you pay for the bunny suit, we'll clean in costume. If you pay for the language, we'll sing. Tidy away the debris of being alive so you can appear very alive. Lifts destined for even floors. Death by protagonism. Jeans from our twenties, failed sciences of being. Angel-eyed bioeconomic, we're the de-godded women. We're made of music, like birds. Like magic. Like the world perdu. Sad to have a view from somewhere, the unskilled under-privilege. Byproducts of education and empire. Ugh, the downstairs of it all. We charge our phone under the kitchen counter, but we don't have to drink your water. These are not your children. This is not your house. Is anything even playing in your earphones? The walk-in bathtub is a managerial class. The townhouse steps are an ecological threat. Let us go like a thousand pink party balloons. Paper lanterns labouring like the sun, when all the time your mother's earrings are under the bed. We know what you can't know. The P4 waits for no Man. Whatever happens, happens to you because of us. We own nothing in the world, just the world.

YOUNG FOREST
SHANE JONES

FICTION

He told me that at 2 p.m. the sun hit the flowers at the peak of the ladders and if it was hot enough the flowers burned. I didn't believe him because sons no matter what age don't believe their fathers. He once told my brother that if he jumped from a specific tree branch he would break his ankle in two places, so my brother jumped and broke his ankle in two places. At first I didn't move, just stood there trying to understand my surroundings, and then I climbed the ladder painted red. Don't be scared of heights because it's only air, I thought, which was a saying I had repeated when I was a child climbing the tallest trees with my brother. It didn't help then, and at first it didn't help climbing the structure designed by my father, but I repeated the words until they became a mantra moving me toward the flowers possibly catching fire. Horse turned her head and sneezed mist below me. As a child we had weekly bonfires at the lake, which my father would start early so my mother could cook potatoes, which she'd peel in the kitchen with my body pressed next to hers, my eyes level with the table, her face mom-serious all morning with the sun shedding red rust as it rose like a circular machine from somewhere behind the forest. Silent until done, the cast iron pot filled with water, we'd wait until dark to walk to the fire. Everyone arrived from Rainbow Farm speaking the adult language. Two men had children my age who said my mother always looked sad, her eyes were always wet, which was maybe why she loved bonfires so much, a way to dry them out, but I don't think my mother was always sad, she just had wet eyes. The adults played a game called What Are You where they asked questions like What are you going to do before you die? and What are you guilty of? and What are you scared of? Children weren't allowed to play, but I said mudpuppies and my brother shoved me into the lake. My father was scared of a nightmare he had a few days prior – waking in bed but the house was only a white outline of the structure itself, and me, brother, mother, Horse, were gone. We watched our mother inching closer to the fire because we knew she was capable of the most interesting answer. I was expecting her to say she was scared of losing Horse, because back then my father always joked that she loved Horse more than him, but she didn't mention Horse, because what she said was the word heaven. She sat with her bare feet too close to the fire for our skin and no one said anything – all insects chirping and the fire snapping – to her answer because it was too difficult to respond to, just the next adult saying it was a waste of time to dwell on fears because what mattered was work, physical motion and tactile accomplishment. I liked this answer back then, but now I know people who say they are scared of nothing are scared of everything. That's why they are constantly moving – if they stop the fear comes out. I poked a finger into the warm flowers that weren't hot enough to catch fire. Far below, my father carried chopped wood with Horse walking in front of him, saying the fire was coming, look at the size of the sun. As I moved back down the ladder a gunshot went off. My father entered the forest with Horse. My foot missed the next rung and, stumbling, I stepped into the air and looked up to see the flowers coloured orange in a flickering holographic light;

my father was right, but I didn't want him to be right, maybe the light was the sun striking the petals intensely, not igniting them, so I climbed back up and at the peak the flames were burning through the flowers, twisting and folding each petal into a brittle black. A second gunshot went off. I climbed down the ladder carefully and walked toward the forest. The third gunshot scrambled the trees into a muddy yellow as I ran at the shapes of my father and Horse in the distance and wished to be in the tree houses and to be a child again. My energy days are behind me. I think the forest once held more colour.

*

My family has always been obsessed with our bodies not touching the ground – father on the ladders, father swimming in the lake, brother on the roof naming clouds, brother living in the forest for the summer in the tree houses we connected with bridges and balconies and ran over them all, from tree house to tree house over boards that sank into the air, sometimes cracking – we weren't scared – we just smeared the forest in a smooth blur, kissed each other when so little. To be in contact with the ground was to acknowledge your future inside it. My brother ate peanut-butter-and-apple sandwiches in the trees. Some time ago he had walked into the forest and never returned. Rumours from Rainbow Farm and the recluses who inhabited the further forest had reported sightings to my father who was hesitant to travel so far alone. He was bound to the home he had built and my mother had departed in. Over the phone my father had told me it was a matter of brother rescuing brother, and I didn't say I would help find him, I merely agreed to return home because he was worried, but after the burning flowers on the ladders I considered it, because everywhere was empty space my brother should have been in; without him, my childhood environment was somehow exactly the same and also drastically, depressingly, different. Following my father to the lake he said he had to tell me something. I thought he would mention the hunter in our forest again, firing at deer. He stepped over a tree branch and said, I've had a recurring dream for three nights. For three nights? That's right, he said, three nights, the same dream. I stepped over the same tree branch. It's important, he said, but I don't know how to tell it. He walked a little further before speaking again, saying we had to find my brother before 10/10 because of *the happening*. He didn't say more, only continued walking. When I said he was being dramatic, what's going to happen in four days, he said 10/10 and *the happening* had flashed in numbers and letters on a window in the dream for three nights. I stopped walking and so did my father. What are you talking about? By the dream's end, he said, the numbers and letters had fallen apart into a liquid that dripped down a tall window to a city sidewalk where a person stood, and then he turned and kept walking again with me following, continuing to say that 10/10 and *the happening* would take place, he was sure of it. You think he is in – There she is, interrupted my father. Once a year an animal walks

onto the partially frozen lake, the ice cracks, and the animal drowns. When my brother and I were home we could save the animal, but with my father living alone he had to wait for help in removing it. Now at the lake we studied the dead cow, which, from bloat, the water inside had expanded to three times the size of a normal dead cow, and instead of dying at the bottom of the lake or being pushed by waves and ending at the shore where my father could break down the body, this dead cow had death-bloomed upward from where it had drowned downward sometime months ago, and this dead cow, huge and bloated and illuminated by the sun that had ignited the flowers, was now floating in the centre of the lake. My father threw a rock and struck the cow, which didn't budge. I undressed to my underwear and my father continued staring at the lake until he too undressed. Frogs had laid eggs in scrambled puddles of white foam, and my toes sunk in the mud. The cow became larger as I sank lower, the water rising to my waist, my father at my side, ripples of water moving from him and colliding with the ripples I had made, coating the lake in diameter before I swam around the cow with its legs aimed at heaven. My father was talking on the other side when he threw the rope over, saying the reason an animal walks onto a frozen lake is dehydration, which was him blaming Rainbow Farm, the children I had played with who had grown up into gap-toothed mouth-breathers with no work ethic or sense of responsibility, according to my father. Another rope flew over the body as he continued explaining that for a cow to become distressed enough that it leaves a grazing field, crosses a road, and walks onto a frozen lake is a crime. Okay, he said, you know what to do now. I instinctively swam under the cow, entering through a pale yellow world with blurry strands of green. I ran my hand over the cow's spine – an unbreakable structure thick as my wrist – and I touched the skin outside her spine – short silken hairs – then swam with a rope in each hand making sure they ran taught along her back, taking the task seriously, this rescue of a dead cow, because accomplishing this task would prove to my father that I was capable of the larger task ahead. I was aware of my father's general location, but in closing my eyes and swimming upward because I couldn't hold my breath any longer I had moved directly under his legs and swam up between his legs, my right shoulder splitting him hard, forcing him to flop backward, not because of any real physical pain but because my body was touching his body, between his legs. Embarrassed, we swam toward the shore each with a rope in our hands, yanking the dead cow, which finally budged and floated across the water. My father was incredibly strong – as he swam he breathed with his mouth closed. Living alone had polished him tough in spite of ageing, but for me each kick with the rope in my hands hurt until my calf muscles folded inward in pulsating cramps when I tried one big kick to balance myself, prove myself to my father, to the cow beginning to tilt and angle away from my father swimming ahead. Splashing in the water, I couldn't use my legs to hold me up anymore. I let go of the rope and went under before I screamed for my father. I wondered if he thought too, at the

sight of me going under, how much easier removing the dead cow would have been with my brother. Then he swam to me, a dark shape becoming larger as he approached through the watery blur. I continued kicking my feet, but when I looked they were just hanging there, separated. Above me the dead cow sailed smoothly over the water as my father's arms hooked under me, positioning himself firmly behind me so he could push off from the muddy bottom where the muscles in my calves were still convulsing. Air bubbles swirled around us. He squatted and pushed off. The ropes were going under so he kicked harder and harder. When we broke the surface, Horse, at the edge of the lake, was meowing at the cow approaching the shore. Tall grasses were waving all around the lake and they doubled in thickness and tripled in height. Treading water, my father looked at me in a way that made me think he was remembering when I was a child and now he couldn't believe I had become this older version. But his eyes were loving – we were connected in the lake with the cow touching the shore. I told him I would help find my brother.

*

I packed a bag with fresh clothes. I had used the lake system – shirts and pants scrubbed clean by rubbing my fists underwater and then laying the wet clothes on panels of wood to dry in the sun. I hadn't slept. My father would wait at the house until I returned with my brother, an image I couldn't see, the two of us, what, walking hand-in-hand back to the house? I thought *the happening* and saw myself in a tree house crouched behind my brother's shoulder, another version of myself far below saying hello while walking through the clearing into a hail of bullets from the outstretched arm of my brother. Before leaving, I hugged my father and I saw the flowers burning on the ladders. He said, See you tomorrow kid-o, which surprised me as it assumed I would spend the night in the forest – midnight would be 10/10 – but also reminded me of my mother's wake, standing beside the black coffin with the Horse carving. He was the last to say goodbye, my brother and I stepping back to give him room, my father kneeling and just talking to her about what he was fixing around the house, her bedroom door hadn't been closing properly, saying to her as he began to stand, See you tomorrow kid-o while patting her hand. The first blue ribbon was about 50 feet behind the yurt. Sparse trees made it easy to see a far distance but I couldn't find a second one. The second blue ribbon I eventually spotted, at least 100 feet from the first, hanging from the branch of a birch tree. After the third blue ribbon my vision locked-in and I ran, plucking them from trees traced yellow by the sun. It was as if I could see only the blue ribbons. I located a dozen throughout the forest, 100, 200 feet apart, each suspended at a distance from the last. I covered a mile in a timeframe during which the sun had barely moved, the shadows stayed the same. Following the ribbons had a meditative effect – I could find them without thinking about them. When we were children, my brother cut his foot

in the lake. We had been taking turns jumping from the shore and he landed on a rock, splitting his foot open between two toes. Later, he said it wasn't a rock he had landed on but a mudpuppy, they had teeth. On the shore it didn't look so bad until I separated his big toe from his next toe and an arc of blood – transparent in the sun – shot into the water. When he asked if there was blood I thought he was joking, but he had his head back on the grass, he couldn't see the blood hitting the lake because he was naming the clouds, whispering – deer, robin, cow, buffalo, creation animal – and trying not to cry, so I used my towel to wrap his foot and said it wasn't too bad, three mom stitches, and helped him limp into the house. After the fortieth ribbon I saw a clearing in the distance with wooden bridges framed by ropes built high in the trees. Another memory: my brother leaping from one tree house to another over an empty space too large and terrifying for me to jump. I moved from the final line of trees and into the clearing. Another memory: the danger of being in his bedroom when he wasn't there, his head-form in his pillow and lying on his bed and pushing my face into his pillow, if only for a few seconds. I moved deeper into the clearing. Above me was a fortress of wooden ladders, ramps and balconies, tree houses constructed with ropes, nails and metal hinges. Below, three of my father's wet shirts were hanging over a horizontal branch supported by chopped vertical branches hammered at an angle into the dirt. Some of the trees had triangles carved into them. I called his name while admiring how he had cut planks of wood to fit in half-circles around the rising tree trunks and nailed and roped the bridges connecting them, hoping to spot a body through the cracks between the boards. I walked back and stood where I had entered and said his name again but still no answer, just more birds leaving the trees, chipmunks darting into holes, a silence only the deep woods could produce. I admired my brother's kingdom of forts. My father said that when my brother was born he came out laughing, but when I was born I came out peeing, until I cried, until my brother puffed his cheeks and stuck his tongue out and I laughed. I don't remember my first year of life but my father said that anytime I would cry the only person who could calm me down was my brother. I touched a tree with the bark carved out in the shape of a triangle. At the base of the tree the shaved bark had formed a little pile and ants were crawling all over it. Under the bark they had made several dirt hills above the moss where they carried crumbs of food. The forest doesn't belong to you, I thought, the forest belongs to itself. Then the bottom of two feet moved across one of the bridges connecting the tree houses. They moved onto another wooden bridge that connected to a tree with a ladder built down it. The wooden bridge creaked as the figure walked across it, and eventually the figure came down the ladder. It was him. He wore a striped blue and orange t-shirt with a monster truck illustration and jeans with the knees ripped open and held one of our father's guns at his side. His hair was long at the back but scissor-cut short on the sides in crude uneven layers. He looked like someone who had been living in the forest to escape but was now discovered – dazed, wide-eyed, drooling,

full of rage. I wasn't sure he recognised who I was so I said my name and stated – not wanting to get shot by my own brother – that I was there to help, with my hands held high in the air. He said firmly, I'm not leaving. His voice tore through me. He said, I can't believe you came here, you were warned. I thought *the happening* as he aimed the gun at my eye level, stepping toward me. Wait, I said. He stopped and lowered the gun slightly. I told him about the cow in the lake incident, the stink traps, the window we had installed. He listened without responding. My brother said, I'm not going back home, but you already know that. I had to come up with a plan. I never thought the city version of myself could be useful, but in this situation I needed to create a lie that he would be forced to respond to emotionally, taking him away from his thoughts and pulling him toward me and then home. Go away, he said, and don't ever come back.

<p style="text-align:center">*</p>

The idea came to me in a blurry cloud-shaped image that I quickly edited and rearranged. I said our father had attempted suicide. His arms were infected from a rusty knife he had used in the kitchen and he needed my brother, he had wished for us to be together if this was the end. I said these words so convincingly, on the verge of tears and looking off into the trees with my fists clenched, that even I was moved imagining our slashed father, bedridden with blood-soaked bandages, pleading to find my brother, and then I saw what was most likely the reality, our father in the basement unclogging a toilet while whistling. I had no idea how, if my brother decided to return home, I would explain to him what was going on when we arrived, but I pictured myself sprinting the last quarter mile, joking it was a race to see who could touch the house first, hopefully able to rush through the front door and tell my father what I had told my brother to get him to follow the plan. My brother climbed the ladder and disappeared back into the structure. No, no, no, this couldn't be, I couldn't return home without him because what would I do if I wasn't defined as the son who saved the other? With my brother home I could continue living, and in that glow I could live a meaningful existence, but not bringing him home would be a total loss, a future life unliveable because of failure. Maybe suicide wasn't the right lie, but I had nothing else, my imagination wasn't working. I paced around the clearing. A row of tiny brown birds sidestepped along a wood railing. Hanging from a rope, a badly broken green lantern was tied over the doorway to a tree house. I sat in the dirt and flipped rocks over my knees, thinking I should climb one of the ladders, yes, that was it, I should go into my brother's creation and bring him out. I stood and tried to talk myself into it but he appeared on the wooden bridge again, coming from around the back of a tree house, now wearing a dress-shirt wrinkled with filth. You think he's going to die? It's possible with all the bandages. Bandages? He covered the wounds himself with what looked like twine and bandages. How bad? I couldn't see through all the dried blood.

My brother paused, breathing. You shouldn't have come here, he said, and disappeared back into the tree house. I continued looking upward. He's refusing the hospital because it would mean going into the city, I yelled. It's possible he will recover, but he asked for you. He needs you. A few minutes later my brother reappeared, angrily stating that he would go home, but he would return to the forest. It's what he wants, I said, just come home and then, like you said, return to the forest. He looked wild even dressed in one of our father's shirts, and soon we were walking, ducking under branches, shielding our faces with our arms, retracing where the blue ribbons had hung on the trees until he broke off, saying he knew a shortcut. I was worried my plan to run the last quarter mile to explain the situation to my father would be brutally unsuccessful. When I saw the field and the lake past the last visible trees I said we should race like we did as children, to which he responded We never once raced as children, only ran as fun, and I said Perfect, as long as I can touch the house first and he said, Why would you want to do that, but sure, go for it, his voice sounding the way a voice sounds when not routinely used, an effect I knew well while living in the city. Once I didn't talk for a week, smashed silent by my inability to function in the office life, and when I did speak to answer an aggressive question about the routine tardiness of my time-sheets my voice exiting my body was garbled and half-formed, something partially alive and struggling through birth, the receptionist asking if I needed a glass of water and I answered that I was fine, sorry about the time-sheet it won't happen again, both of us knowing it would happen again the following week and the week after that, the scenario playing out in mutual exhaustion until one of us was permanently gone from the office. Another time I tried to beat my not talking record but was stopped three days in because Paul, who had been working for months in the office adjacent to mine, was being transferred to another department. I tracked his approaching voice stopping at each cubicle, saying he was leaving for another job, a promotion of sorts, which I later learned was a lateral move due to poor job performance. When he walked into my cubicle, a move only my boss performed on a weekly basis to interrupt me, I recognised him from the bathroom where he stood at the urinal with his pants pulled down to his thighs. I had never had a conversation with him before but I shook his hand and said, Good luck with your new position, to which he said that he liked working with me on the Peaman project, and how much fun, he added, was Liv's party with you and Melanie, and it was the first time I had ever noticed Paul's wet moustache, shook his hand or wished him well, and after he exited my space I never saw him again. I was faster than my brother owing to what I assumed was his non-activity while living in the trees. He had only used his legs in a vertical sense whereas I had helped my father rescue a cow from a lake.

*

I entered first, not sure where my brother was, and thought maybe my trick was really his trick, that he had waited at the edge of the forest for me to take off running until I was a good distance away and then he could turn and walk to a new location which I would never find. My father was standing in the living room holding a framed picture with the four of us at the lake. When I moved towards him he dropped it. The shattering glass sent a memory wave of my mother through me, and my father didn't move to pick it up, and instead asked about Nick, where was my brother, that's his name, Nick, you were supposed to bring him back. I could barely speak because I was out of breath. I told him he had attempted suicide and was suffering a terrible infection. My father asked again where he was, how bad was the infection, and I said No, not him, you dad, you tried to kill yourself, you have the infection, and he stepped backward, totally confused, and became more so when Nick came running into the house, my father taking another step back, then the two of them looking over each other's arms and finding no harm. I stared at my father, hoping he would understand how I had tricked Nick into coming back home, but before anyone said anything, before I was exposed for my lie, Nick reverse-rushed for the door. My father moved in a flash, his boots crunching through the glass on the floor. We grabbed Nick by the arm and neck and simultaneously said No, and now my father understood what I had previously said, a lie he disapproved of for moral reasons but a necessary one to have Nick there with him, a body he was now wrestling to the floor with my help, my father saying Calm down, just calm down, Nick, enough, calm the fuck down, which, in my experience, is the least effective thing to say in order to calm someone down, and it didn't work on my brother. My father gave me a look, and, acting like someone I didn't understand at all, I found myself grabbing Nick's flailing legs around the knees, even punching his thigh, five times, very weakly, as my father lifted his torso which was twisting as if involuntarily wrung, moving him deeper into the heart of the house, carrying him upstairs and pausing on each step like we were moving an unwieldy piece of furniture that needed repositioning, with Nick screaming and spitting and trying to bite us, and getting one arm lose and yanking my hair before my father unclenched his fingers, he could manage Nick's rage while I struggled to keep his legs pinned together, his jeans shifting down and around his knees which I unsuccessfully tried to pull back up after we reached the top stairs. Get him in there, said my father, holding Nick in a kind of chokehold with one arm wrapped around his forehead, the other around his neck, Come on now, just shove him in there. I went at his legs while my father went high, pushing Nick who was now clinging to the bedroom doorframe; I couldn't raise my head the guilt was so deep as I trudged forward peeling back the feet of my brother, forced to step backward as my father worked on his arms and chest, eventually the force too great, making him fall into the room, making me fall backward and away from him, wondering, in my fall, my father collapsing as well, if any of us had ever been that close.

OVID VOID

MARIA STEPANOVA

PARAPHRASES OF OVID

RUSSIAN

EUGENE OSTASHEVSKY

PARAPHRASES OF MARIA STEPANOVA

ENGLISH

Как вспомню, как собирался на пожизненное
– Тогда первый раз во мне закоченела душа,
Словно знала, чему ей теперь пора учиться –
И жена плачет, и друзей двое, кто посмелее,
А дочка в отъезде, вернётся, а меня нет,
И уже светает, а я полночи жёг документы и рукописи,
Ни одежды не взял, ни рабов не выбрал в дорогу.
Как вспомню – и сразу уже на корабле,
Море вокруг, и на палубе тоже море,
Кормчий молится, рёв вод, мат матросов,
Хлещет в ноздри волна, а я знай пишу,
Поглядим, кто раньше устанет, буря ли, жалоба.

Whenever I remember that time I was packing for life,
The soul stuck under my neck, its hard sphere
Like the head of a cabbage blackened by frost (it was foreshadowing),
My wife weeping and the braver two of my friends,
And my daughter at school, she comes home for break and I'm gone,
It's practically dawn, I spent half the night burning papers,
Couldn't pick what clothes to pack or who would carry them,
Our bodies so heavy with weeping,
Whenever I remember what I remember next,
Me on the heaving deck, waves coming like stormtroopers over the taffrail,
Helmsman despairing, breakers roaring, the sailors at sea,
But I'm having words like 'heaving' rise in me, and a line
Springs into formation, then waves 'come on!' to another,
That was the first heave. We'll see now ('we' meaning
The poem and the storm) who'll be the first to die down.

Если у вас в мегаполисе ещё помнят обо мне, ссыльном,
Знай, кто спросит: я умер, едва приговор огласили.
Мёртвый живу, хожу, тело донашиваю,
Оно послушное – ссыхается на костях.
Я здесь чужак, варвар, языка не носитель,
Неба коптитель, волосы стали белые,
Мёртвыми губами учу гетскую грамоту,
Мёртвыми ногами топчу твёрдую воду.
Что тебе рассказать, чтоб не скучала? Скачут
Кони по гладкой реке, и стрелы летают,
Рыбы торчат изо льда с открытыми ртами,
Некому их вынимать. Некому меня понимать.
Вино замёрзло, стоит само без кувшина,
Кусок вина отломлю и сосу, как сиську.
Яблок не достать. Ты бы меня не узнала.
Местные замотаны в шкуры, на тогу косятся,
Только лица и видно, да и те в бороде.
Даже звёзды здесь не как у людей.

If anyone in your global city still holds me, exile, in memory,
Know that I died as soon as they read out the sentence.
I live dead, walk around dead, wear out the remains of my body,
My agreeable body, flesh cracking on dry bones.
Here I am an alien, barbarian, non-native speaker,
Idler with time on his hands but white in his hair,
I don't get their speech, I forget the words that I study,
Just consonant clusters, no vowels for poetry.
What can I talk about so as not to bore you? Horses
Slip on hard rivers, arrows hit targets, philosophy is stupid.
Fish stick out of the ice with mouths agape,
Too much air for them, too little ear for me.
Wine frozen overnight, it stands by itself, the vessel in shards,
I chop a piece off and suck on it like an infant.
The apples at the market are tawny and wrinkly like shrunken heads.
The locals, fir-tall, fur-clad, point at my toga, make shivering
Gestures. No human faces – just beards and hair over fur.
Even the stars look down on me.

Книжечка ты моя, написанная за пазухой
Времени, в краях, где таких, как мы, днём с огнём,
В Город приди, где каждого видно-слышно,
Где что ни слово – с добротной красной каймой,
Небритая приди, с застиранною полою,
С ногами сбитыми, с наплаканной щекой,
Туда, где и мест несчастливых нет,
Где что ни площадь – та в уме зацелована,
Много не говори: мол, жив, и этого довольно.
Сами пускай расспрашивают, если хотят.
Таких будет мало, и все с оглядкой.
Прочие, так и знай, тебя захотят обидеть,
Это ничего: чтобы попасть в руки читателю,
Я и сам бы свернулся в трубочку, сам бы на почту себя отнёс.

Baby book, toothless libel, my fool, literally begot
In time's bosom, where there's nobody but us,
To quote the police, toddle to
That global city whose multitudes buzz,
Darting iridescent like dragonflies over Assyrian channels,
Unshaven go, in washed-out clothing,
Feet with blisters and corns, face swollen with tears,
Modestly enter that felicitous city of old-time love,
Go to piazza Mattei, via Giulia, via Funari,
Stay composed, say 'still living', that should be sufficient,
Let them pose questions if they care, of questioners
There won't be too many, each looking over her shoulder
To see what she could see, as for the rest
They'll be dismissive because they gain by being dismissive.
Don't mind them. To curl up in the hands of the reader,
Is your lot, lucky complainer, would I were you but I'm not.

Ещё на корабле, ещё в декабре, поначалу,
Когда болело так же, но было в новинку,
Я заметил, что зима выясняет со мной отношения,
Пробует меня, тёплого пока, на зуб.
Ветры были ледяные, я с ними разговаривал,
Больше и не с кем. Холод мне: всё пишешь, дурачок?
Ну, пиши, пиши. А я давай торговаться:
Если я уйду из литературы, ты от меня уйдёшь?
Я брошу стихи, от них и так ничего хорошего
И здесь в чёрной воде я болтаюсь из-за них,
А ты перестанешь мне в губы дуть и держать за кости?
Думал зиму обмануть, а она сама меня надула:
Только пристали – и она уже тут
И пересчитывает рёбра и страницы в книжечке,
Как при обыске, когда пора протокол.
Теперь-то ясно: я сослан не в чужие края,
А во время года, меня в него засунули
Как в рукав одной из здешних вонючих шуб,
И кого ни вижу, все такие же ссыльные,
Каждый в зиме как в сыром мешке.

Back in transit, shipboard, back in December, at the outset,
When the hurt was already there but it had a rawness about it,
I felt that winter was having a go at me,
Testing my mettle while I was still warm.
Icy gales blew, I got into conversations with them,
Not like there was anybody else. 'You still writing, baby?'
That was the cold. 'Write till you're blue in the face.'
But I acted like I was an ace at the art of the deal:
'If I let letters alone, you gonna let me alone?
Say I quit poetry, it makes nothing happen anyway
Except getting the po of the poet into a Tiber of trouble,
Will you stop playing my bones? It's not a tune I enjoy.'
I wanted to put one over on winter, but winter won.
Right as we docked – there it was
Numbering each rib, turning over each leaf in my notebook,
Like an agent at inventory during a search and seizure.
Now I know: they confined me not to a place in space
But to a time of year, no one may behold me here,
Shoved into the sleeve of one of those greasy barbarian furs.
And everybody before me is yet another exile
Submerged in the almond milk of winter.

Всё, как есть, помню, ничего не забыл,
И что сегодня в Городе день поэзии.
Сам-то я разучился: стихи игрушка счастливых,
Которым нравится ладить себя несчастными.
А всё равно, подумаешь, как все вы там
Туда-сюда на поэтические чтения,
Алкоголи в горле, венки ещё свежи –
И ни одного, кто прервал бы исповедальную лирику,
Поставил рюмку на стол и: 'А как там Назон?'
Или хоть 'Давайте выпьем за тех, кто в море!' –

И хочется плеваться мёрзлыми ямбами,
Тупыми, как наконечники здешних стрел,
Единственной на весь край сувенирной продукции.

I remember everything as it is, I forgot nothing,
Even that today is National Poetry Day.
It's not like I know how to anymore: poems are playthings
Of the happy who like to pretend they are unhappy.
But still to think of the way all of you
Shuffle this way and that for poetry readings,
Pile together at the reception bar, still in your laurels,
And not one of you to interrupt the gossip,
The heartfelt welcomes from the august sponsors,
The stage whispers that at the release of Senator
So-and-so's sophomore lyric collection, Falernian will be served,
Set down the Mamertine and be like, 'Anybody heard from Naso?'
Or simply, 'Let's drink to those who cannot be with us today.'

It makes me want to spit iambs your way, a hail of iambs
Blunt like the arrowheads of local production,
The only thing they got here that passes for souvenirs.

Что ж я, в тебя, сухая земля, и лягу?
В тебя, из которой только полынь и лезет
Задрипанными аптекарскими пучками?
Ни участка на Аппиевой, ни алтаря,
Ни огонь погребальный не взрёвет, ни рыдальцы,
Даже птиц и тех тут не дозовёшься,
Похороны на казённый счёт,
Споро, экономично, убористо.
Каменная земля плугу не по зубам,
Каменная вода под мрамор покрашена.
Греческий тут ломаный, как сушка в кармане,
Латыни вовсе нет, и хорошо, что нет,
На своём скажут: 'отмучился дед', и поминай как звали.

Is it you in whom I will end up lain, deadland?
You who let sprout only wormwood
In ratty bunches from the chemist's.
No plot on the Appian, no altar,
No funeral pyre roaring, mourners scratching their cheeks,
Only earth and sky here and the birds between them,
In transit for elsewhere, anywhere but this flyover state.
I shall have a funeral at public cost,
Which is not to be confused with a state funeral.
This rocky soil, breaker of ploughshares,
What water there is – streaky like marbled beef.
The Greek, crumbly like a pocketed ship biscuit,
Only piece of Latin in circulation: 'Stay, traveller, or I'll shoot.'
They'll say in or on their tongue, 'Well, his ordeal is over,'
And carry out the rest in silence.

84

То ли три года, то ли тридцать три,
То ли десять, как греки у троянских стен,
А всё одно – время на месте стоит,
Как взаперти: новый день тот же день,
Ночи все на один покрой, и сны всё дрянь:
Стрелы дождём, снег верёвками, рабья доля.
Вскинусь, ресницы смёрзлись, на пальцах солоно,
По одному этому и пойму, что плакал.
Не снятся мне ни Амур озябший с крылышками,
Ни начало навигации и с первым кораблём передача.

Is it three years, is it thirty-three,
Or a decade, like for the Achaeans under the Skaian gate,
It's all the same – time runs in place
Like Achilles in a paradox, a new day
Is the same old day, every night tarred
With the same brush, repeating dreams:
Rain of arrows, block and tackle of snow, slavery.
I jerk awake, eyelids sealed shut,
It is the wax of weeping.
Nights show me no baby-winged Cupid
In the cold, shivering,
No first ship of the year a-sailing on the sea
With pretty things for me.

Мне бы ум – думал бы, например,
Как там мокнет лавр, а в доме зажгли свет.
Или римские вывески вспоминал,
Чтобы в носу защипало от слёз и гарума.
Или со страхом: как тебя обниму,
А рука не узнает твою спину,
Обшарила лопатки и замерла,
Или хотя бы – вот за стенкой вьюга трясёт
Запертые от ворога ворота
А не это стыдное: как там мои книжки,
И что они мне всю жизнь поломали,
И читает ли вас, бедных, кто.
Вон пошли из моей головы, погорельцы,
Ковыляйте прочь неровными стопками
В литературные памятники, если возьмут.
А я ваш язык давно держу за зубами.

If I only had a brain, I could think
Of the laurel swaying in the rain
Outside, while lights go on in the house,
Remember the shop-signs letter by letter
And wail like Isis over the recollection.
If I only had a heart, I could embrace you
In my unimaginative nightly scenarios:
When I have arms, I throw them around you
And the hands do not recognise your back,
They grab onto the shoulder blades and then panic.
Or at least I could think about awakening
Then, how different it was from awakening now.
I wouldn't then be thinking this shameful bullshit
Of how my books are doing, books,
You ruined my life, is anyone reading you,
My poor lovely hysterical books. Who is reading you.
Get out of my head, refugees,
Hobble away on your so-called feet, one dactylic,
The other trochaic, beg for asylum
At the Modern Library, see if they take you.
I had your tongue in my cheek, but I bit it off
And spat it out.

Из-под зимней Медведицы, из-под косматого брюха
Горюю о космической перемене.
Что, правда одним земным богом стало меньше
И властные инстанции перекосило?
Кому теперь возносить молитвы
С прошением о скорой амнистии?
Зачем пишу, ни тебе, ни мне не понять,
Люди знают, поэты сплошь не в своём уме.
Между моим письмом и твоим зрением –
Время года, оно всё то же: холод
И долгий снег, а там ещё целая Фракия
И много вёрст непросыхающей воды.
Рыбы, когда зима, живут под крышкой,
Так и я. Закрываю рот в темноте.
Язык за зубами, и есть два про запас,
Гетский, сарматский, оба новенькие
И ни в один не хочется сунуть ногу.

Under the shaggy belly of the Great Bear,
I mourn the geomagnetic reversal.
Is it true we are one earthly god poorer,
And all authorities have been deauthorised?
To whom are we to offer hecatombs
Of metred pleas for speedy amnesty?
Why am I even writing, can you tell? I can't.
People say poetry makes nothing happen except exile.
From my writing you to your reading me
A season passes, it is about the same: cold,
Snow, cold, snow, Thrace without a trace,
And the grim grimaces of winter water.
Fish say even less under a roof of ice.
The same for me. I shut my trap.
Is there a tongue in my cheek. You feel for it.
These are two little ones saved for a rainy day
Of March marching, Getic and Sarmatian.
I make it new, I'm a modernist.

В этой зиме как в том лесу с золотой веткой,
Где золотому дубу служит золотой жрец
(где пишу 'золотое', читай 'белое')
Или как в лабиринте с Пасифаиным сынком:
Некуда деваться, пока не придёт сменщик
И не собьёт рогатую голову с человечьих плеч.
Я и возражать не буду, ни для проформы
Оказывать сопротивление и махать мечом,
Хотя тут оружие – просто орудие,
Без него и отлить не выйдешь, есть и у меня.
Уже чую, голова тяжела, ноздри раздуваются,
Где было речь – теперь вык и мык и як.
Скоро за мной явится такой же бывший
И уже сам будет учиться местным звукам
И как очищать от снега крылечко
И что ходить в меховых штанах срам, но теплей.

Wintering here is like being interned
In that wood with the golden bough,
On a golden oak with the golden pussycat
On a golden chain, telling olden tales
How gold is a metal bled free of guilt,
Wherefore it is white as snow
And as cold. Or like being enclosed
Among the closeouts at the Labyrinth bookstore
With the Minotaur behind the cash register,
And you are he! Or are you him? Wait till the next shift
(A PhD in her third year of job applications)
Threads her way in to knock the horny head
Off the human, all too human shoulders.
It's not like I'll object or offer resistance
Just for the sake of resistance, waving my 'sword',
Which the pen is said to be mightier than,
But only by those holding the pen, holding it in
A penal colony, especially. O my word sword,
All the fun you used to have. Baby,
Do you feel it baby, baby, do you feel my head
Growing heavier, nostrils swelling, mouth frothing,
Its musical language made one long moo?
Soon, soon my replacement will come, another other,
A quicker picker-upper of local phonetics,
Better at cleaning the porch from the snow drift,
Better at pulling on trousers and going clubbing.

Какого бога какого героя какого хуя?
Можно хоть Героиды перепереть на сарматский
И унавозить местное чёрствоземье
Ряженкой культурной экспансии:
Дескать, где я – там и Рим, а снег – чисто мрамор,
И вообще моя родина – греческие трагики.
Можно накрутить гетскую космогонию,
Две-три сивых байки про мирового ужа
Упаковать в компактные двустишия
И там у вас продавать в 'Колониальных товарах'
Вместе с гиметским мёдом и германской кабанятиной.
Можно ещё открыть сельскую школу,
Излагать истории исторических женщин,
Грубо брошенных богами или героями:
Про Дидону на берегу, про Ариадну на берегу,
Про тебя, как, когда меня повели,
Ты свалилась на пороге и лежала.

What god, what hero, you want to hold my id?
How about you translating the *Heroides* into Sarmatian?
 You meaning me.
It's my feminist book because the speakers are women.
They sure could use poems by – or at least about – women.
About time they get some culture –
Other than bacterial – in this country.
Like, ubi ego, ibi Roma, and snow is, like, poor man's marble,
And my homeland is my language, and my language
Is my homeland. My homeland is a motherfucking Greek tragedy.
How about you composing a Getic cosmogony? You meaning me.
Something about the world having worms (culture!)
And the whole thing in couplets
To hawk it back home, at the Colonial Wares Emporium,
With honey from Attica, German bloodwurst,
And other representative products of traditional cultures.
Or how about you, meaning me, opening a village school
To instruct about the women in history, meaning herstory,
Brutally abandoned by gods and heroes,
Dido on the beach, Ariadne on the beach,
You, meaning you, when they led me away,
Falling in the doorway and lying there face down.

И даже как будет пора переплывать,
И не эту пресную воду, смешанную с морской
Так, что она даже зелёной зимой не синяя,
А ту, по которой отчалим и мы, и наше всё –
Даже там мы будем стоять в очередь на посадку
Сообразно материнскому языку:
То есть тому, на котором во сне материшься.
То есть: моя тень отдельно от остальных –
Прямиком на паспортный контроль,
Под табличку "для граждан РИ",
А эти длинною вереницей в другую дверь,
Не оглядываясь на меня, не смешиваясь.

Хорошо, они не говорят по-нашему,
А когда говорю я, прыскают в кулаки,
И вся моя лингва проливается, как подлива,
Какую никто и не пробует пробовать.
И да, их волосы висят, топорщатся шубы,
Стрелы, щетина, глаза не сразу найдёшь
И у магазина не о чем обменяться репликами,
Потому что погода всегда одна и та же
И видно, что я не гожусь для строевой.
Но даже когда мы будем голые безволосые тени,
Сколько-то гетских и одна латинская,
Не найдётся такой, чтобы, пока ждём парома,
Встала рядом и левый бок чуть отогрелся.

Even when the signal is come for the ferry
Not over brackish estuary water,
Muddled and tugging now this way now that,
But over the universal water of mankind,
Even then we'll be lined up for boarding
By mother tongue. It is the tongue
You call for your mother with. In dreams
Or not, that word is your password,
Ask those the police killed recently.
That is, my shade alone shall pass
Towards the passport control station
Under the sign of 'Roman citizens only',
While these others converge on another entry,
Mobbing it listlessly, never turning their heads.
Marius this way, Jugurtha that.

Fine, they don't speak as we speak
And, if I try to speak to them, their faces
Take on a pained expression, or else
That of somebody studiously escaping giggling.
If I ask them at the bakery to slice my loaf
They hand me the loaf whole,
Not out of malice but because they can't make out
The meaning of the movements of my mouth.
And if I could make myself understood,
Why? One look at me and they know
I'm not one of them. I'm

Educated. What would we talk about,
The weather? 'It's cold.' 'It sure
Is cold.' 'It's grey, too.' 'It sure is
Grey.' 'Will it snow?' 'It may
Or may not.' 'Have a nice day.'
But still, even then, when we are naked
Shades, so many Getic and one a Roman citizen,
Not one shade will be standing near enough
To feel warm during the wait for the ferry.

А что делать ещё, когда ничего не поделаешь?
Мы поём как потеем, такое устройство.
Каторжники поют, дальнобойщики поют, грузчики,
Швея за машинкой что-то бубнит себе под нос,
Ну и я тоже; сам себе пою, сам себя читаю,
Иногда думаю: ай да сукин сын! Или: сегодня я гений.
Я уже старый, седой как колос, а всё за своё,
Будто не стихи меня загнали на крайний север;
Будто тем, кто не отвечает на мои письма,
Есть дело до тех, кто поёт, чтобы не сдохнуть,
Будто литерадура важнейшее из искусств
И сам кесарь, перед тем как отойти ко сну,
Спрашивает референта, есть ли новости от Назона
И что он там пишет в своём воронеже.

So what's there to do when there's nothing to do?
We sing like we shvits, that's the covenant.
Convicts sing, truckers sing, so do the homeless,
The seamstress at the sewing machine hums under her breath,
Same for me, I sing myself, read myself,
Praise myself for a turn of phrase because who else will.
I'm old, grey like cream of wheat, but I'm still at it,
As if it weren't poems that got me to the Far North
In the first place, as if those who don't write me back
Care if somebody sings so as not to croak,
As if literature were more than more litter,
As if Caesar himselvis, before hitting the pillow,
Asks his manager what news there be of that poet,
Whether he's being productive up in his artists' colony.

На меня разгневалось божество, я совершил
Оплошность, какую не скажу, не скажу, какую
Совершил ошибку, и где я вот я тут я

Лучше не навлекать на себя гнев того,
Что мощью равен богам, так что
Если вы навлечёте на себя его гнев,
Можно только надеяться, что и милостью и милостью
Он тоже богам равен, каким именно?
Кто из богов отличался особой милостью?
Я совершил оплошность, ошибку, по ошибке
Я оплошность совершил, какую не знаю,
Только догадываться могу, что ту же,
Что и этот вот, и этот, и этот
Я не буду их называть по имени,
Это было бы непростительной оплошностью
В моей непрошеной непрощённой
Новой земле. Я любил:
Город, и чтоб весной толпа вдруг вся на лёгком,
Дачный диван и когда занавески дышат,
Себя, когда я с тобой. Это была ошибка,
Я был было была ошибка, какая не знаю,
И вокруг меня люди с холодным оружием
И ни за какие деньги не найдёшь корректора.

I have given God an occasion
For wrath, I have taken
A false step, I can't say more, just how
I went astray, what my error was, where am I here I am here

Blessed he seems to me, whoever manages
Not to provoke him who is equal to god
In terms of power, so should some misstep of yours
Attract his wrath, all you may do
Is pray he is also equal to god
In the quality of mercy, but what god
In particular, which of our gods finds entertainment in mercy?
I made a misstep, I made an error, I committed
A false translation, I stepped into
An error, what step I took
I know not, I can only guess it was the same
One as this one, and that one, and that other
One had taken, I won't name names,
Who do you take me for, naming might prove
An occasion for correction, the first
Slip-up in this unasked-for, sudden landing
Into a brave new world. No naming. I loved.
I once had the right to love. I loved
Our city, and its crowds, especially in March, everyone
With spring in his or her step, I loved the couch
Of our country cottage in the calm
Environs of Pompeii, the curtains
Breathing in the morning, I loved myself even
When I was with you. I made an error,

I was mistaken, I was taken amiss,
I don't know what for, what it was
I committed inadvertently to be
Committed here, where I am, here,
Around all these correction officers
Armed with penknives, specialists in translation,
I know not what error, but I know the terror,
I know I committed an error
Incorrigibly, unknowingly, may God
Let none other commit the same, to be committed
Here, sentenced here, to be on the lookout here
For galleys charged with forgetfulness.

94

Я благодарен, нам указали наше место,
Тебе и мне: тебе сказали, веди
Себя поскромней, ты жена сама знаешь кого,
С такой анкетой особо не высовывайся,
Сын за отца не отвечает, но ты-то ему не сын.
А на меня наконец рецензия, ура, рецепция,
Меня прочли и даже позаботились укорить:
Я пишу одно и то же, про ту же зиму тужу,
Монотонно и без огня
Твержу единообразные призывы к друзьям –
Поручиться за меня, заверить, что ничего не было
И что больше никогда, и что был на хорошем счету,
И что ноги мёрзнут, и неужели тут и умру,
И что стыдно просить, но кроме вас некого,
Одно и то же, монотонно, без огня,
Бессовестно, без остановки,
Как нищенка трясёт трещоткой у Тройных ворот
И будет, когда не будет ни ты ни я.

I'm so thankful, they showed us to our seats,
You and me: To you they said,
Don't make such a racket, you know whose wife you are,
Keep your head down with that profile,
The sins of the fathers will not be visited on the sons,
But you're no son, are you. Whereas me,
I finally got reviewed, I mean that literarily,
I am the recipient of feedback.
I write the same thing over and over again,
They say, going on and on about the weather,
The cold especially, it's tedious, there's no fire in it,
And I keep asking my friends to do things
Like for them to ask *their* friends to do things, it's somewhat
Tactless, to guarantee nothing happened
But never again, to highly recommend to the attention,
And then there's the 'it's really cold here, am I really to die here,
I am sorry to bother you again but I don't have anyone else'
Over and over again, it's tedious, there's no fire in it,
And so inconsiderate of others to carry on like that,
Like some beggarwoman outside Porta San Paolo
Begging with that tinny voice of hers, who'll go on
Begging with that tinny voice of hers until all Rome is in ruins
And the Tiber reflects only clouds as it bears to Ostia.

На любом камне без надписи
Впредь читай так: может быть, именно подо мной
Лежит Назон, который писал про лёгкие вещи жизни,
Про блядки, про шалости, про любовь и вдруг погиб из-за этого.
Идёшь мимо? Потрудись, вспомни о нас,
Скажи: пусть земля будет лёгкой ношей.

Any stone you see with no writing on it
Read so: It may be that under me and no other
Rests P. Ovidius Naso, who sang the light things in life,
Love, fooling around, one-night stands. Then he perished because of it.
Are you going by, traveller? Do us a favour, remember us,
Say: May the earth lie lightly over you, poet.

И тебе скажу одно, хотя ты не спросишь,
Живи тихо, тихо живи, как вода под колодой,
Звука не подавай – курлык и загонят в землю.
Ходи по безопасной стороне улицы,
Ни на чьей сетчатке не будь отпечатком,
Не дружи: с красивыми, с заметными, с теми, кого любишь –
Тут же с неба молния хлоп и загонит в грунт.
Малой лодочкой будь, древесной корочкой,
Вода её туда и сюда, а ей хоть бы хны.
Летай низенько, а то скажут 'ишь разлетелся'
И в землю забьют. Поспешай медленно, а не то
Успеешь куда не надо, скажут – тебя и ждали,
И будешь удобрять почву под виноград.
То, что я сейчас говорю, говорю не я,
А кто угодно: на зоне все назоны, имя
Лишняя роскошь, когда земля с землёй говорит.

I'll tell you one thing, though you're not asking me to,
Live quiet, live quiet, like a pool under a stump,
Make no sound – one cluck and under the ground you go.
Take the safe side of the street,
Register on nobody's retina,
Don't socialise with celebrities,
Steer clear of those you love, especially, or else
Lightning will crack the blue and drive you into the ground.
Be like a bark, you know, boat or a strip of bark,
Water carries it this way and that but it don't care.
Fly low or they'll say 'get a load of that'
And lower you into the ground. Hurry slowly,
Have you heard that one before, or you'll make it in time
To hear, 'There he is! The one we were waiting for!
Lower him into the ground, let him rot under the vineyard.'
The thing I'm telling you, it's not my opinion,
Everybody says the same thing, everybody's a poet
In the pen, get it, don't ask for names,
It's like we're already in the underground.

Ещё никогда не болел один, без никого,
Ни разу не умирал один и без провожатых,
Носом в стенку, тебя нет, никого нет
И некому почитать вслух про греческие игры
Или последнюю газету с военными сводками.
Лежал, воду не узнавая – другой вкус у воды.
Встал – землю не узнал, ноге не мила, лёг обратно.
Где-то там: страны, города, Город, ты не спишь, ходишь.
Всё это ко мне не относится. Я не отношусь ни к чему.
На отрезанном, дальнем ломте всемирного пирога
Я сам себя крошу, сам рассыпаюсь в прах.
Даже письмо не моей рукой написано
И понятия не имею, на каком языке.

Never been ill before, with nobody there,
Never lay dying before, without accompaniment,
Nose to the wall, you're not there, there's nobody,
Nobody to read the sport section aloud
Or the military communiqués on page one.
So I lay there. Couldn't recognise water.
Water had a different taste. I got up, my foot
Couldn't recognise the ground, lay back down again.
Somewhere far away: lands, cities, The City, you
Can't sleep, staring at the TV blaring in the thalamus.
It has nothing to do with me. I have nothing to do with anything.
On this here point on the bye of the Roman pie crust
I'm falling apart into crumbs, it's a crumbling experience.
Even this letter is written by another hand
And in other words, maybe, I have no idea.

98

Странный ты человек, всё-то тебе не даёт покоя
Моя участь, и что обо мне скажут, и что я сам виноват.
Я и не отрицаю, я и тогда не защищался,
Меня и не спрашивали, но и тебя никто не спросил.
Вот меня нету: ни в бане, ни в книжном, ни на рынке,
Имени и того не осталось, вместо него 'тот самый',
А ты всё жужжишь на рынках и у фонтанов,
Словно окна закрыты и некуда влететь
Со своей басовитой обвинительной речью.
А меня-то нету, я умер вчера-позавчера
И хожу куда хочу, как воздух под тогами,
Пока ты выясняешь отношения с привидением
И приводишь в свидетели старых друзей
И трясёшь линялыми вырезками.
Забудь ты меня, уже нету никакого меня,
Мы с тобой незнакомы, общих дел никаких,
Можно вволю топтать ногами бедную тень,
Когда её никто не отбрасывает.

You just can't lay it to rest, weirdo:
Not my lot, not what people may say, or that it's my own fault.
But it's not like I'm denying it, nor did I deny it back then
When nobody asked me, but nobody asked you, either.
You see, I'm not anywhere: not at the baths, not the bookstores, not at
 the market,
Not even my name is anywhere, people say of me, 'you know, him,'
But you keep up your buzz over tables in piazzas with fountains
As if somebody closed the windows and you couldn't find your way in
And kept bumping against the glass in moral indignation.
Hello. Is it me you're looking for. Because I'm dead, I'm not anywhere
 anymore,
I go wherever I like now, like steam from an espresso,
While you're still settling scores with somebody who's gone,
Calling on mutual friends to be your witness,
Shaking clippings from *la Repubblica*, their letters sun-blinded like that
 cougar Phaedra.
Draw a circle, erase it, there's no me anymore, no my me that is, only your
 me is left,
This is why there's no distance between us, or anything else between us,
What you are trampling under your feet is only a shadow,
But there's no body to cast it anymore, weirdo.

Я, письмо того, кто боится собственной подписи,
В город, в котором ему запрещено проживание,
К тому, кто боится названным быть по имени,
Запечатанное печаткой с мифологическим сюжетом,
Каким – на всякий случай не скажу,
Содержащее то, что ты уже знаешь,
И просьбы о том, чего ты не сделаешь,
И напоминания о стёртых воспоминаньях.
Сломаешь печать – а там пусто, понимающему хватит.
Разреши тому, что устало идти и плыть и снова идти,
Побыть за вашим столом молча.

I am the letter of a sender afraid of the sight of his own name.
Off to a population centre where he is not admitted among the numbered.
To a recipient afraid to be named under these circumstances.
I am sealed with a seal whereon you see a mythological scene.
What the scene is I forbear disclosing because you never know.
You do know my contents already.
My contents contain pleas for you to do what we all know you will not do.
They also contain reminders of memories that are eroded, erased,
 or expunged.
When you break open the wax, you will discover nothing, which is
 enough for the wise.
Please permit the one who is tired of being conveyed past many peoples
 and over many seas
To sit at your table without saying a word.

In 8 CE, the Roman poet Publius Ovidius Naso was exiled on the direct orders of Augustus to Tomis, a distant imperial outpost on the Black Sea in what is now Romania. He died there a decade later, never receiving permission to come home despite his constant entreaties. The exact cause of Ovid's punishment is unknown; the poems he composed in Tomis appeared in two collections under the titles of *Tristia*, or 'Laments', and *Epistulae ex Ponto*, or 'Letters from the Black Sea', in Rome, the city in which the poet himself was not allowed to appear.

Ovid's poetry of exile is a much more important presence in the Russian poetic tradition than in the English-language one. This is because Russian-language poets get exiled much more often. They also have far more experience with the Black-Sea coast, where Russia has swallowed lands that once belonged to the ancient Greco-Roman world. Ovid's exile became a crucial point of reference for Alexander Pushkin, Osip Mandelstam and Joseph Brodsky as they endured political dislocation and persecution by the state.

The translations/adaptations/paraphrases of Ovid's *Tristia* published here were begun in Russian by Maria Stepanova in early March 2021. She had retreated to her snowed-in country house near Moscow for the winter because of the pandemic; among the books she had with her was a volume of Russian translations of Ovid's late work. The exiled poet's description of 'northern' winter, the theme and loneliness of exile and, last but not least, the political aspects of his predicament, all resonated with what, despite the seclusion, was going on around her. The protests against Alexander Lukashenka in Belarus had been taking place since August, but the dictator relied on a brutal repression apparatus to hold on to power. In mid-January, Russian opposition leader Alexei Navalny returned to Moscow from Berlin, where he had been treated following his poisoning by the Russian secret services, but he was arrested at the airport and jailed. Mass protests erupted all over the country. Police video-recorded protestors and arrested them at home in the following days. A viral video showed Dr Anastasia Vasilyeva, a Navalny ally, playing Beethoven on a piano as her apartment was being searched, her performance symptomatic of the antithesis, normative for Russian intelligentsia, between high culture and the police state. Hence, when Stepanova posted her first paraphrase of lines from *Tristia* on her private Facebook page, friends immediately recognised not only Ovid, but also the parallels with the current political situation. 'It suggests Navalny's cold [prison] colony and the masking of faces in these Covidian times', commented the poet Anna Glazova, writing from Hamburg.

Indeed, the pandemic brought another new way of relating to Ovid's poetry of exile. Sent into the no-place of Tomis, taken out of his social network and the world of habitual actions, the poet lost almost all of the things that structured his life and gave it meaning. But his exile also had a temporal dimension: every one of his days was like every other, and the lack of future prospects took away the motivation to do anything. Only composing poetry, which was read in Rome, gave him hope for a different future, a future of return, but that hope failed. In his poetry, the estrangement, the deformation of time, the sense of precariousness and fear find symbolic expression in the cold, in the slowing down of nature

under snow and ice, in the ever-present danger of barbarian raids over
the frozen Danube. The whole world's experience of pandemic isolation
wasn't accompanied by climatic effects that resembled those of *Tristia*,
but Stepanova's was. Winter weather helped her to read the psychological
effects of Ovid's exile through the prism of the pandemic. Above all, she
thought, Ovid described the temporality of being in lockdown.

Eugene Ostashevsky, who had recently come out of travel quarantine in
Shanghai, posted his English-language paraphrase of Stepanova's Russian-
language paraphrase the following day. Having translated Stepanova
before, he knew that what she, like many Russian poets, valued in
translation was not literalism but a response that was poetically creative
and intonationally adequate. So he treated her in largely the same way as
she treated Ovid – sometimes coming very close to the text, sometimes
veering away in language, but always trying to stay 'on message' with
respect to both the poems and, crucially, the history of their reception in
Russian culture. His paraphrases sometimes included lines from popular
music (Stepanova's earlier work, which he has translated, made references
to Stalin-era popular songs), and also gestured at the English-language
tradition of paraphrasing Latin poetry.

Stepanova posted new paraphrases of Ovid throughout March and April,
with Ostashevsky paraphrasing all of her versions. Their community
of mutual Facebook friends, many of them Russian-English bilinguals,
followed, encouraged and discussed the game. Her impersonating the
epistolary poetry of a male Roman author inverted the gender play of
Ovid's first collection, the *Heroides*, which consisted of letters putatively
composed by mythological heroines. While her paraphraser was arguably
inverting the more traditional poet-translator gender distribution, he
occasionally became anxious over his flights of fancy and would rush back
to the Russian text to reproduce its phrasing with greater literalness. The
current agreement between Stepanova and Ostashevsky is to switch roles
in the autumn of 2021, with him paraphrasing Ovid directly, and her
paraphrasing his paraphrase.

Maria Stepanova
and Eugene Ostashevsky

INTERVIEW OCEAN VUONG

'Dear Ma, I am writing to reach you,' begins Ocean Vuong's *On Earth We're Briefly Gorgeous* (2019). It is an epistolary novel, written from a son, affectionately called 'Little Dog', to a mother who cannot read. Their relationship is underscored by migration, loss, inherited trauma and the difficulty of navigating working-class life in America. Vuong's writing gives clarity to tender feelings. In his first collection of poetry, *Night Sky With Exit Wounds* (2016), is a poem entitled 'Someday I'll Love Ocean Vuong'. 'Ocean, don't be afraid,' the author writes, 'The most beautiful part of your body / is where it's headed.'

In the following conversation, which took place in the wake of a spate of high-profile anti-Asian hate crimes, Vuong discusses Asian American literature with the performance artist and writer Alok Vaid-Menon.

On 16 March 2021, a 21-year-old white male entered three massage and spa parlours in Atlanta, Georgia, and opened fire. He killed eight people, six of whom were Asian. 'Stop Asian Hate' flooded the global newsfeed, the shooting a brutal reflection of the anti-Asian sentiment already heightened by the Covid-19 pandemic. This conversation begins there, examining the ways in which Asian American literature has been recruited in the service of cultivating white empathy and humanising Asian Americans. What does it mean to write subjects who have been so overdetermined by the racist imagination? Vuong and Vaid-Menon grapple with finding ways to push beyond inclusion and appreciate the creative work of Asian Americans on their own terms.

Vuong's new collection of poems, *Time is a Mother*, will be released in 2022. They are poems of mourning and grief, which negotiate the aftermath of the death of Vuong's mother. They are also poems of survival. As he writes, 'How else do we return ourselves but to fold / The page so it points to the good part.'

THE WHITE REVIEW I've been thinking about this phrase 'Stop Asian Hate' and what it requires of us. You've written about how Asian artists are expected to serve as vehicles for white literary traditions, not as catalysts of our own. I'm curious about the role of Asian American literature as a place not just to represent different lives and identities, but different ways of thinking, feeling and caring too.

OCEAN VUONG I think it's a great risk for any Asian American writer to say 'no'. But at this stage in Asian American literature, the most important word we can say, metaphorically, and literally, is no. What are we saying no to? What are we refusing? When we consider how the bodies of our Southeast Asian elders are seen – we're brought over to serve and to tend to other bodies, often failing white bodies, in nursing homes as nurses. We are seen as purveyors of care. But the care is seen as a commodity, rather than an intentionality.

What are we saying no to in order to say yes to? I think it's a no, in order to say yes. It took me a long time to get there. When I first started, I would say yes to every invitation. I would break my back, and I was doing the same thing my elders were doing. When someone said to my mother, 'Your pedicure is too expensive here. It's 15 dollars down the street.' My mother would say: 'Okay fine, we'll do it for 15 dollars.' Just constantly debasing ourselves in order to participate. And a lot has happened since those days when I first started. I'm privileged to have a university job, to write myself into the middle class. While I'm here, I think it's important for me to use whatever means I have to reject what doesn't work.

TWR Where do we go after refusing? Negation and failure are two concepts you're constantly choreographing, especially in your novel *On Earth We're Briefly Gorgeous*, where inability represents an invitation to another way of being. Little Dog writes to his mother that 'the very impossibility of [her] reading [his letter] is all that makes [his] telling it possible'. The feasibility of the novel is enabled by this 'failure'. You remind us that negation can yield innovation; that a refusal can be about proliferation. When you talk about how racial capitalism enlists Asian labour to resuscitate white bodies, I think about the ways in which Asian writing is thought to revive white literary traditions. In the reception of your novel, it was often said that you 'reinvented the great

novel'. This frustrated me because there was little consideration that you might be doing something else altogether. You're not trying to repudiate one canon and create another. It feels like you're much more ambivalent than that.

OV The question of where do we go is rooted in examining what origin means. Origin is often the obsession of white supremacy, right? Even the way scholarship happens. Scholarship has to dictate when a poem was written. There's an obsession, an archival obsession, of pinning down a life, putting it into a timeline. I think that obsession with origin is where canons proliferate. And so we're recruited, or sometimes demanded, into them.

I've been in situations where someone would attend my reading or panel and ask, 'Are you going to talk about another origin? Are you going to talk about what we want to hear from you?' I thought I had my own mind. But of course, it comes down to 'we're paying you, so we want you to talk about x, y, z'.

This is where Buddhism is so important to me. Because Buddhism doesn't care about an origin story. It's more like, we're here, we're fucked. Let's see what we can do, right now. I really love that. I think for me, deviating from a line or trajectory has to grapple with whether an origin is as crucial as it is often purported to be. When people write about us – when people write about you, when they write about me – it's often: 'Where were they born? How did they arrive at language?' or 'They are the exceptional exceptions from the mass that they come from.' When I hear that, I hear the sort of pleasant surprise of, 'Oh you weren't supposed to be here. Who let you in?' 'Who took you and taught you how to read?' It was actually women storytellers who taught me the craft before Mark Twain. Those writers were just supplements to a body of work that I already possessed from oral tradition.

TWR 'Where are you from?' sets the geo-political coordinates of who belongs and who doesn't. And it's often levied against us as Asian Americans. Where are you *really* from? When we don't offer the answer they presume, there's chaos. What I notice you doing is troubling whether that should be the question we should be asking in the first place. You seem so much more concerned with being and becoming, than with origins. In one of my favourite poems of yours 'Someday I'll Love Ocean Vuong' (2016), you write: 'The most beautiful part of your body / is where it's headed.'

When people ask me, 'Are you a boy or a girl?' the question is already presuming what is possible. I think a more interesting question is: 'Where are you going?' But they don't ask that. Beneath the question 'Where are you from?' is a surveillance desire. It's 'show me your papers', but by another name. I notice people describe your work as auto-fiction even when you explain that it isn't really based on your own life. There's a presumption that an Asian American queer writer cannot write in the abstract, that we must be autobiographical. What forces require us to be constantly transparent and legible? For whom? I want to think about Asian American abstraction with you. What does it mean to refuse, and be rendered obscure because of it?

OV I'm still surprised that *On Earth We're Briefly Gorgeous* took off. My heroes, like Theresa Hak Kyung Cha, Bhanu Kapil, were not bestsellers. Their desire was actually to complicate and disjoint. To create debris. What I hoped to write with this book was pieces of debris. I refuse to make it legible, cohesive. Refuse to perform a temporal linearity. I insist on detours that are philosophical and meditative. And because of that, a very common response to the book is that it's pretentious. This is something that's very familiar to me as an Asian American writer: we are so often coded as bodies of service, that when we finally sort of disrupt something, it's very jarring to the white gaze. Because it's saying, 'I'm not interested in translating myself to you.'

This happens at readings. I read in Vietnamese and the first question is 'What did you say?' It took me a long time to reply, 'I'm not going to translate that.' If I wanted to, I would have spoken in English. As bodies of colour, it is often demanded that we perform ethnography through our art, to drive the tour bus, and also put the microphone on and say, 'Look, to your left, this brown suffering of the Global South.' Then this is supposed to elicit empathy in a liberal white reader. And this is where I have a lot of trouble. For me, what it actually does is keep whiteness complicit in our erasure. So many of the horrors we're seeing are the result of Asian American invisibility. The Asian women in Atlanta were reduced to a category, and a symptom of one man's failure. Right? So much has to happen for human beings to be that way. Yet, it has been happening for 2000 years.

This was what European humanism in the nineteenth century was doing. It was: these 'barbarians' have art, they have music, and therefore should be spared. It should have been, 'How about you don't pillage them because they're people?' But we are still working in this tradition; I still see this project in the readings I go to in the academy. In the liberal enclaves. We are still supposed to be agents towards wider empathy. Empathy is often spoken about in literature as the final destination. That's the ultimate goal, the cherished goal. Reading is supposed to provoke empathy. Well, that's all fine and good, but it's a goal that is specific and narrowed to the white audience. When you flip that paradigm, all of a sudden the project of empathy falls apart, and you realise it was always for whiteness.

TWR The establishment still only understands creative work as the published work. But there's so much that goes into it, a biography to our writing, which comes from living. Poetry, for me, is a mode of living. It's actually about saying that there's no standard grammar to life, not just to literature.

You did a thoughtful series of stories on Instagram about metaphor, and one of the things that you said is that the work of writing isn't just happening on the page, it's happening in the mind. In that is an insistence that literature does not just belong in one place: it's pervasive and omnipresent. Living is the artist residency. So I want to ask you about the politics of metaphor.

OV Metaphor is political. I think there's been a very perennial aversion to metaphor in the twentieth-century Anglo tradition. After World War I, Europe and America had to turn their back on romanticism. Romanticism was no longer feasible. The sublime was no longer feasible when the pastoral was literally rotting with corpses. The cows had bullet holes in them. And then then we have Gertrude Stein, Ernest Hemingway, who truncated the sentence, took out the metaphor as an embellishment, as a decorous, decadent tool.

All the way through the mid-century, and even now, there's a very laconic line that's cherished in the more hegemonic literary criticism. Sure, that's white folks having their own conversation, but the problem with literary taste-making is that often it is white people having a conversation while everyone is left outside. They say, 'Okay, so here's what it is now, get on board.' If you're not on board, then you're failing.

I would like to see the metaphor from a different calibration. Metaphors are one of the

oldest forms of figurative writing, in thinking and speaking, that our species has ever had. All of our myths come out of looking at the stars and finding a metaphor for them. Which is why I titled my first book of poems *Night Sky with Exit Wounds*. The metaphor is also an autobiography, a vision. What does it say about someone who looks at the night sky – where so many see cohesion, and a sort of pinnacle, a utopia of storytelling – but for me to see loss, to see exit wounds?

The metaphor in other places on a global scale has very different meanings. In Vietnamese culture we say *chính xác*, and that means 'clear as corpse'. What does it say about a group of people who've been at war for so long, defending against multiple imperial forces, to now talk about clarity in terms of death? Then, when we think of Billie Holiday singing about strange fruit, that's a metaphor in order to not say the devastating exactness of what is happening. So, the metaphor there becomes balm, it becomes a way of teaching and passing down information without harm.

I think my biggest issue with Western criticism is that it holds everything else up to the dialectic that it came out of. It doesn't have the capacity to have a different dialectic. That's a great, great depravity. Maybe now we're adding to that, and that's a good thing. But I don't want to see us only as additions. I want us to really be on our own way. I want to be cautious of just telling Asian Americans to rectify whiteness. It's not our job, right? It's not, it shouldn't be; we shouldn't be the band-aid for the wound that preceded us.

TWR What feels so dangerous about metaphor, is that it exhorts us to see intimacies that must be renounced in order for the Western project to work. The Western project requires clear bifurcations and distinctions between us/them, man/woman, here/there. But metaphor insists that there's a crack in every one of those walls that are created. In *On Earth* you write, 'I studied him like a new word.' Suddenly, it's revealed that the body that speaks can also be spoken. The author is the text, and the text is the author.

That's why I understand poetry as a political praxis. Within the confines of a poem the only rule is there are no rules. That anarchy isn't chaos, it's creativity. It returns us to what we were speaking of earlier: the incessant imperative to disclose and prove is a pursuit we're not interested in. Why should we have to argue for what already is? We must naturalise what they politicise, and politicise what they naturalise. What the metaphor teaches is that everything is interconnected. I've listened to you speak about how the practice of writing can teach people how to construct a life or how to relate to each other. Writing is not just depicting reality, it's creating reality. I'd love to hear your thoughts around writing as a practice of freedom, writing as a practice of ethics, writing as a practice of being.

OV I love that you said that living is the artist residency, because our inability to name and own this comes from a pervasive sense of shame. It's strange to say so but I think beneath the white machismo embodiment of artists there's a lot of shame. I've had teachers tell me, 'You should never write a poem for anybody. Who are you to think that a poem could be for anyone? How dare you even think a poem can have political value and power, or a piece of writing?' And where they're coming from is a kind of Boy Scout vibe of subordination and self-flagellation. Humble yourself. Have elders humble you. Then you earn your seat at the bar over time. It's about bowing down. Harold Bloom talks about this anxiety of influence, writers just being so concerned about being mimetic of their elders. This whole narrative of how the son has to defeat the father in order to have value. David has to defeat Goliath, right? It's always supplanting the lineage to move forward, rather than collaborating. In that desire to destroy, in order to create or to replace, in order to take presence, is shame.

There's a lot of this argument of 'Well, you're just doing poetry, you're not doing rocket science' or 'Just put your head down and work.' And I think the informant of that, the greatest influence of that shame, is capitalism. The sadness is that we've allowed this patriarchal tradition to dominate us so much. Meanwhile, the folks who are building the weapons in the military-industrial complex, the folks who are designing the 'medicines' that often make us sick and make us dependent on the pharmaceutical companies, they're not saying, 'Be humble to each other!' They're not saying, 'Be grateful!' They're not saying, 'Why don't you pull back a little bit so that nuclear bomb, you know, has less circumference and radius.' 'That semi-automatic, let's have it shoot ten less bullets.' They never say that.

Yet, they've made it so that the artists always self-regulate. People get really uneasy when you say, 'My life is art.' This. The present tense is

worthy of art. I think there's a great discomfort in the Western gaze, because immediately they want to say, 'You're pretentious. There's museums where things are housed, there's the stage where you get to speak your art. You can't speak it here, not in front of me at the grocery store.'

When I really assess Western culture in how it grapples with other bodies and other ecologies of thinking, at the end of the day, my response is: please catch up. And I do mean – please – because we want you to catch up, we want you to be here, because where you're at is a quicksand that's killing you.

TWR Right. It's not just killing me, it's killing you. And that is so devastating, because how do you heal a wound that people don't even know that they're carrying? It is so much of what we're up against as writers. I'm tasked into this process of articulating my wound, saying, 'This is what it's like, for me as a gender non-conforming person... people laugh at me on the street, they insult me.' But I'm more interested in having a conversation about the wounds that had to happen to you in order for you to insult me. How have you become so conditioned to your perpetual unfreedom, that you mistake it as being alive?

They are so fixated on our dying, they forget to notice the incandescence of our living. Living is about refusing the confinement of art to the stage or the gallery or the novel. When I fashion my outfit I'm going to bring the art exhibition with me wherever I go. When I paint my face, you're getting an entire gallery at the store checkout, darling! I think the West is so terrified of heaven being made real here. I think so many people are waiting for the rapture.

What I felt when I was reading your work, Ocean, is that it's here now. Reading you write about love felt more real than love. Reading you write loss felt more real than loss. Even the way you write about writing, lands so deep. In *On Earth* you say, 'Writing is... getting down so low the world offers a merciful new angle, a larger vision made of small things, the lint suddenly a huge sheet of fog exactly the size of your eyeball.'

This brings me to myth-making. I think 'myth' has a negative connotation these days. People think that if something is constructed that means it's not real. But, actually, myths make things real. When people with power tell myths they become seen as a certifiable corroborated truth, but when we tell

myths they get dismissed as illusory, ridiculous, superfluous. I think that what we need now more than ever are different myths instead of the pursuit of 'real', empirical truth.

OV And also, does truth exist? Let's see how truth has been performed through historians. A truth in nineteenth-century America was that white settlers were predestined, ordained by God through Manifest Destiny, to settle the land where people had been thriving for thousands of years. That was considered truth. I have a lot of trouble surrendering the ground. When we surrender the ground, we have to assume that an objective truth is there to be seen. If we actually give up that ground, someone else is taking it over.

We're talking about a claim to storytelling. We are taught that a valid or useful education is one in medicine, science, bioengineering. That storytelling, or the 'liberal arts', are defunct or fading. Yet, in the Fortune 500 companies, in the Googles, the Amazons and the Facebooks, they're obsessed with storytelling. So you can have technology, but it's moot if you do not have a story to provoke it. We also see this in political campaigns. They're all about manipulation of story. I agree with you a hundred per cent, the urgency of the moment now is to create new myths.

This is also informed by Buddhism, because Buddhist practice is so interested in lucid dreaming. Monks constantly practice lucid dreaming. If you can be aware that you are dreaming, then you can also be aware that you are being foggy or ignorant in the living stage. This sharpens your ability for discernment, and the capacity to look at the world more clearly. Buddhism is very clear to me because it is *this* feeling, above all else – above even the object – that matters. So reading is not about the book, it's about the transition of the thought, orchestrated through language, into the brain. That's why it's so real to us. I think that's very true to how we live: sometimes the feeling is much more than the world can support. That's why myth-making, like you said, is where we're going. That's the future.

TWR As I'm hearing you speak, I'm realising that so much of the dilemma of being an Asian American artist is the imperative for a kind of empiricism to prove where we came from. White supremacy and transmisogyny are screenwriters that have made us into characters. People have pre-formatted tropes about us that are made

more real than our own existence. So the goal becomes shifting the modes of perception alongside the modes of production. What kind of intimacies could we generate, if we suspended the imperative to prove? How do you find the motivation to write, especially under the conditions of celebrity when everyone feels like they have already authored the story for you? I know I'm finding it increasingly difficult to parse out what I want to write, rather than what other people expect me to.

OV It's ironic, right? We talked about Asian American invisibility and the mythologising of transness. Fame works the same way. Instead of a selfhood, we get a hologram. We're made into phantoms. Through replication of the work and distribution, the self becomes abstracted and more phantom-like than before. Ironically, so much of our writing is about grief and loss and the ghosts of elders and through that, through that work, we become living ghosts.

As a writer, intention is so important to me. I think that's part of my practice. My writing is my Buddhist practice, my Buddhist practice is my life, and my life is my art. And it's not even in that linear trajectory. It's a constellation that informs one image. When I wrote my two books, I wanted to articulate something in a very specific way. I think the beauty of a book is that it's the fingerprint of the mind.

The world can misread us, and they will, and they have, and they won't stop. But we do not have to misread ourselves. We can't lose sight of what we came here for, which is to write for ourselves or for the people we love. The Western myth tells us to discard our former selves, that we have to constantly improve, move towards perfection. There's a sort of verticality to Judeo-Christian values. But I think when I am writing I'm going back. I think it's important for us to go back and say thank you to who we were, to go back and rescue that person and actually invite them into the present. I think writing is a dispersing of selves. When you sit down to write and to do your work, you must gather the phantoms in one place so they can work together.

Narrative comes from the Latin *gnarus*, which means to recognise or to know. We move horizontally – because that's how we're reading in the Anglo tradition – towards knowledge to propel a narrative forward. When I ask myself who I am writing for, everything else falls away.

Because that's what I want to privilege. If I write for whiteness, even to prove it wrong, then I've lost myself already.

Before you write, go back and ask, who was that person that wanted to be a writer? What did they see? What did they feel? What did they want? And when you're in that, you share that mindspace. From there, it clears everything, because that person definitely wasn't thinking about the things that we're thinking about now. We write for them.

Maybe do a little trick and just write 'Dear Alok' before every page. It doesn't have to be a letter to the self. It could be whatever you're writing, but just put that at the top of the page. It could be the middle of a novel. It could be an essay, just say, 'Dear Alok'. And then just continue and then just have that dearness with you in the work. I do that myself all the time.

A. V. M.,
April 2021

THE UNDERSTORY
SANEH SANGSUK
tr. MUI POOPOKSAKUL

FICTION

Often, in the afternoon, after school let out and the children were home, they would quietly assemble. Their entire universe consisted only of the village of Praeknamdang with its measly 20 dwellings; of the vast, verdant paddy fields, at the moment waterlogged; and of the sky, with its complete apathy toward the conditions and happenings in the world down below. Because the village had a dearth of activities with which they could entertain themselves, some of the children liked to pretend to be Luang Paw Tien and tell his stories – the one about his encounter with the elephants and others – and they did so while imitating his voice, his words, his gestures. They copied Luang Paw Tien wholesale: his mannerism when he sipped his tea or his bael juice, the raspy sound he made when he cleared his throat, the way he paused intermittently to scan his audience, passing his eyes over their faces one by one, and they also employed his method of leaving a story at a nail-bitter, or at a head-scratcher, or at a major plot twist, and *absolutely* refusing to continue until his listeners implored him to. The child impersonating Luang Paw Tien would begin a story, and the rest would focus their attention on him or her and occasionally interrupt with such comments as: no, that's not how it went – when Luang Paw Tien got to that point in the story, he actually coughed a dry cough, then, while hunched over, coughed hard two or three more times; or, when he got to that point, he actually worded it in such and such a way; or, when he got to that point, he actually paused and laughed to himself about something; or, when he got to that point, he actually looked up at the sky as he talked, and his voice became quieter and hoarse, and his eyes welled up. The children all played their part to help fill in the gaps until they were satisfied that the story was whole, and to trim the extras until they were satisfied that the story was polished. Each of them was determined to safeguard the phrasing, forms and flow of Luang Paw Tien's original stories, all of them insisting to Prae Anchan, the girl expressly assigned the task, that she must record all of it so they would have it preserved in writing. All of this the children did without allowing Luang Paw Tien or any of the other adults to become privy to it, because they feared that Luang Paw Tien wouldn't understand, feared that if he were to catch wind of it, it might trouble him and he might become bashful and refuse to ever tell them another story again, no matter how much they might beg and plead, and he might say something like, since you lot can tell my stories so expertly on your own, why should I waste my time telling them to you again? Luang Paw Tien had an endless number of tales to tell. Some of his tales were funny, some sad, some spooky, and many a time they were full of magic spells and supernatural powers. Nearly all of them were meant as feathery-light entertainment and nothing more, and nearly none of them had a moral to them. The story about the time early in his days as a pilgrim monk when, on one shivery winter night, a king cobra the length of twelve forearms slithered in and slept next to him – the children had heard that one before, and wanted to hear it again. The story about the time during one of his pilgrimages when he ventured into a secluded mountain range far away in the

west and came upon a large cave full of stalactites and stalagmites in unusual shapes and colours, no two the same, and it was cold and damp and silent inside, which he found conducive to meditation and prayers, and that cave turned out to be full of gems and jewels and gold ornaments, which must have meant he had stumbled upon a treasure trove belonging to one provincial ruler or another or one monarch or another, whom enemies had defeated in battle, or whom some kind of disaster had befallen, forcing him to flee his own domain and take these precious items with him to be cached, and he might have killed somebody, perhaps a courtier or a slave, so that the soul of the dead would guard and protect the trove, all of which might have happened in an era long bygone, back when there were still local lords and wars, and in that cave Luang Paw Tien discovered the skeletons of four pilgrim monks, some of them long dead, some only recently so, their remains dressed in worn, torn and tattered monk's robes; how they died was an enigma to him, all four of their alms bowls were filled to the brim with gems and jewels, so perhaps they had been too weak-willed and had fallen prey to avarice, forgetting that their chosen life was the life of beggars, and they were killed by the soul guarding the treasure trove – that story, too, the children had heard before and wanted to hear again. The story about the time during his pilgrimage when he encountered an ascetic robed in white who was 150 years old but could pass for a young man of 25 because he drank an elixir of life, and who, because he took a liking to Luang Paw Tien, offered to share some of his magic potion with Luang Paw Tien and also generously offered to give Luang Paw Tien the recipe for the potion, but Luang Paw Tien declined to take the elixir and declined to accept the recipe, because in his view to live a too protracted life was, in truth, a kind of sin – that one, too, the children had heard before and wanted to hear again. The story about the occultist who had learned by heart a spell allowing the incantator to transform into a tiger, which was an old, ancient spell from a faraway past handed down through the most secret and sacred means – later, when the occultist's father was murdered by the local ruler because of a quarrel between them, the occultist recited the spell, turning himself into a tiger, and killed the ruler as revenge – that one, too, the children had heard before and wanted to hear again. The story about another occultist who had learned by heart a spell allowing the incantator to transform into a tiger, which was an old, ancient spell from a faraway past handed down through the most secret and sacred means – but this occultist, out of conceit and a lack of respect for the long line of teachers preceding him, performed the transfiguration ritual to satisfy his own curiosity and to quench his own desire to show off his new power; he instructed his son that, should he return in the form of a tiger, not to be frightened, and to pour holy water onto the tiger's body so that he would be restored to human form, and then he changed into a large tiger and committed a slew of atrocities, killing anyone who stood in the way of his gains, murdering the innocent and persecuting people in all kinds of ways and to his heart's content; eventually he returned

home and headed straight toward his son, who, startled, let the bowl of holy water slip from his hand, and the occultist was obliged to live out the remainder of his life as a tiger – that one, too, the children had heard before and wanted to hear again. The story about yet another occultist who had learned by heart a spell allowing the incantator to transform into a tiger, which was an old, ancient spell from a faraway past handed down through the most secret and sacred means – this occultist, with humbleness and sincere respect toward the long line of teachers preceding him, performed the transfiguration ritual and performed it successfully; before shifting shape, he instructed his son that, should he return in the form of a tiger, not to be frightened, and to pour holy water onto the tiger's body so that he would be restored to human form; this occultist, however, uttered the spell out of sheer necessity, because a large tiger had invaded his village and the surrounding forests and had been menacing the people of his community, biting several to death and daring to trespass even in broad day-light; the dead were sometimes able to be recovered, other times not, or it also happened that only half of a corpse was able to be reclaimed; the people, panic-stricken and scared, commiserated with one another about how they needed to uproot their families to be free from the tiger, none of them being brave enough to thwart it, so the occultist was left with no choice but to incant the spell and turn himself into a tiger to go fight that tiger, and fight it he did for three days and three nights, during which time the entire forest was tense with the noise of their tussling; eventually, the occultist, in tiger form, returned home, battered and torn up, with wounds both trifling and severe, but his son, upon seeing his father in the body of a tiger, was frightened and let the bowl of the holy water slip from his hand, and the occultist was obliged to remain a tiger for the rest of his life, though he was a tiger that refused to run off into the jungle and still hung around his old village, a sad, sombre tiger moaning plaintive moans, long-ing for his former life as a human; he was a hero admirers were afraid to crowd around, the bearer of a hollow victory and cheerless peace; his son built him a separate hut of his own and brought meals to him, and that tiger still ate human food, shunning all meat, and with his appetite growing poorer and poorer as he fell sadder and sadder, he became very gaunt, sometimes consumed with weep-ing quietly, his tears trickling out in black, and sometimes consumed with groaning, his cries heard throughout the village day and night without the peo-ple having the heart or the courage to shoo or chase him away, but at the same time they didn't dare to approach and comfort him either, and when that tiger died, the villagers constructed a shrine for his unfortunate soul to have a resting place, and from generation to generation they all worshipped and honoured him by visiting the shrine and joining their palms before them or even prostrating themselves on the ground; later on, when a railroad was to be cut across the site of the shrine, the people moved it away, and later on still, the land where the shrine sat was laid claim to, and the new landowner, wanting to make farmland of it, cleared the plot and the shrine was razed with it; in subsequent eras, the

memory faded of how once upon a time there had lived a hero who had transformed himself into a tiger to fight a tiger, and whenever people (of later generations) heard somebody tell the story, their expressions would go wry and they would say it was all nonsense – that story, too, the children had heard before and yet wanted to hear again. The children wanted to rehear those stories again because their minds at that age are peculiar – they don't separate reality, dream and imagination, because childhood, in fact, was itself a kind of fantasy. Luang Paw Tien told those old stories and handed-down tales merely to kill time, merely to ease the boredom. It was a mystery to him, too, how he could recount those stories over and over again so many times, and for whom? Was it actually for him or for his young listeners? When it came to his stories, he never proclaimed any of them to be true, though he never proclaimed them to be fiction either, nor did he ever proclaim them to be true stories containing bits of fiction, or fiction containing elements of truth. He found that, in the end, he was just like Old Man Junpa, his own father: full of stories and impressions to call up and pass down to younger generations. Presently, the other adults gathered around the fire all seemed to have run out of topics of conversation and anecdotes to trade among themselves, so he sat up in a take-charge sort of way, tucked his robe tighter under his armpit and threw the loose end of it over his opposite shoulder, took a sip of his medlar tea, and then sprinkled tobacco onto a dried sakae leaf and rolled it neatly into a cigarette, which he then lit and took a puff from, finally blowing out a cloud of smoke. The children, at that point snuggled together on a ratty cowhide rug and under a ratty Chinese blanket, suddenly sat up with their eyes homed in on him. Those in their cohort who were still asleep were jolted awake; those still groggy were tickled at the waist, which made them jump, their eyes instantly alert. The children's faces were grubby and grimy, their clothes were grubby and grimy, but their eyes gleamed in the light of the fire. They observed Luang Paw Tien's every move, leaned their ears in to catch his every word. This bhikkhu was far ripened with age, though everybody (other than he himself) was of the opinion that he was the most robust-looking and was in the best health of any old man they had ever met. His hair, his eyebrows, his stubble and even the little strings hanging out of his nose were all white, his face was creased and sagging, and he had spots and moles scattered all over his chest, his back, his shoulders, the underside of his chin. He had a tall and solid build, which evidenced that in his youth he must have been exceedingly strong, though all that remained on him now was wrinkled, drooping flesh. But he still had a full set of teeth and none wobbly at all, which was a testament to the benefit of drinking one tall glass of one's own urine a day, and his eyes still gleamed in the light of the fire, and his voice was still spry and possessed of a great hint of cheeriness. He was their monk and the most senior elder of Praeknamdang, which made all the people revere him, and the grandness of his heart made all of them love him. Everyone, even his fellow bhikkhus, forgave him his unmonkly peccadilloes, one being that when he walked into the

village, he didn't train his eyes restrainedly forward while looking no more than three steps ahead as he was supposed to do according to Buddhist commandments, but rather he let his eyes fall on this and that and fall much too far ahead. When a large tree on the temple's grounds sprang a wayward branch, he would tote an axe and climb up and prune it himself, instead of assigning the task to a novice or asking a villager to help him with it. It wasn't only by the stream in front of the temple that he planted a 'Sanctuary Zone' sign; he extended his 'Sanctuary Zone' far, far out along the bank. Whenever one of the teachers at the local Praeknamdang Temple School had to miss a lesson, he would be mighty pleased and would eagerly jump in and substitute. When dogs went at each other with their teeth, he had the maddening habit of getting in and breaking up the fight, which irked the throng of spectators because they would never get to find out which dog was the superior fighter. When bulls went at each other with their horns, he had the maddening habit of getting in and breaking up the fight, which irked the throng of spectators because they would never get to find out which bull was the superior fighter. When Praeknamdang held a celebration and a generator and a loudspeaker were brought in, he would go and force the disc jockey to play Toon Tongjai at the crack of dawn as a way of waking everybody up, and to play Phon Phirom's story songs about the Buddha's past lives at night as a way of sending people to bed. As for the period in between, any music could be selected and he wouldn't intervene. He simply didn't refrain from meddling in the villagers' worldly pursuits, even though he full well realised the impropriety. As a mediator of disputes, he had a stunningly high success rate, despite the fact he did not know a single article of the law (but he understood the meaning of justice). As a storyteller, he had a way of adapting his tone of voice to the plot lines of his various stories. Presently, he held his head tilted back, viewing the sky, which was bright with moonlight and twinkling starlight; he spun his face toward the row of bamboo groves just as a koel bird within happened to caw out in its sleep; then he lowered his eyes and peered between the toddy palms on the horizon to the east, looking as if he was waiting to catch the gold and silver lights of dawn. The winter breeze continued to brush gently, steadily through. The later the hour, the quieter the sky grew and the quieter the land beneath it grew; the later the hour, the chillier the air felt, and the fields of Praeknamdang appeared ever more desolate, mysterious and lonely, spilling sideways and rambling forth and as far as the eyes could reach. Here and there dirt mounds and scrub blocked the eye's view of the horizon, and here and there toddy palms of different heights going up and down blocked the eye's view of the horizon. The open fields seemed to sink lower and lower while the village, built on a slight plateau, seemed to rise higher and higher every time after the floods receded; it was starting to resemble an island in a sea of gold-streaked green. A gloom washed over the elderly bhikkhu and inundated his heart when he thought of the fates of the men and women and children of Praeknamdang. The shadow of decline and deterioration had long loomed over those fields, and

that shadow seemed to be ever growing in size and intensity now, ever since large swathes of the jungle had been destroyed, and it seemed he was the only one able to sense the omen of ruin. The mute growls of tragedy emanating from beneath the ground were as powerful as tsunamis, and it seemed he was the only one able to sense their menace. The village was about to become deserted, and that it would be deserted seemed inescapable. The natives and their children and grandchildren would one day be relegated to the position of slaves because, even in those years, rights to the land that had from time immemorial belonged to the people of Praeknamdang were winding up in the hands of people from elsewhere. He recognised, too, that before long, Praeknamdang could have a golf course, and those born in this village might end up as caddies; that Praeknamdang could see an outsider with capital come in and build polyhouses for mushroom farming, and those born in this village might end up as farmhands at that complex; or that in Praeknamdang vacation homes could be built around an artificial lake, with the development given an English name like 'Praeknamdang Lakeville', and those born in this village might end up as landscapers or security guards at that property (the latter job, in his opinion, was 'one any mean dog could do, and do better than a person'); or that Praeknamdang could have ponds for raising barramundi, and those born in this village might end up as workers at those fish farms, as had already happened to people in other villages. The folks who now remained were too spiritless, made tame by despair, of which there was too much. All of them were feeble or pitiful in one way or another: they were the cursed living on cursed land. That was why he did not wish to devote his energy to them and directed it toward the children instead, which was a course of action he found more promising and gave him greater comfort of mind. That night, he began with a sigh and then with the following words:

In those days, people in Praeknamdang lived off the jungle. Oh, the jungle – so much of it was an enigma to me, so much beyond my comprehension, no matter how I tried to make sense of it. Take elephant boneyards, for example – I've never seen one, Old Man Junpa had never seen one either, but he said his father and his father's father used to speak of them. Or these things called kods. According to Old Man Junpa, inside giant termite mounds that are centuries old, sometimes you'll find these strange objects – these hard, white, roundish or ovalish nuggets with a smooth surface. They're not hardened soil, they're not stone, and they're not metal. People call them termite kods. If you get your hands on one and have a spell caster put a charm on it, then you've got yourself a phenomenal talisman. These things are much coveted for their magical powers. According to Old Man Junpa, inside giant beehives that are centuries old, too, sometimes you'll find these strange objects – these hard, white, roundish or oval-ish nuggets with a smooth surface. They're not hardened beeswax, they're not stone, and they're not metal. People call them bee kods. If you get your hands on one and have a spell caster put a charm on it, then you've got yourself

a phenomenal talisman. People in the old days believed in superstitions because they served as their security blankets. They put their faith in talismans and magic charms because they were constantly surrounded by different dangers, in wartime and peacetime both. They valued mental strength as much as physical power not because they were fools but because they had to live with various limitations, being prisoners of their own time. These termite kods and bee kods, I've yet to come across either. Crae birds are another example. Old Man Junpa said he'd seen them – they have the same build as crows, are the same size as crows, and are identical to crows in their character, meaning they're quick-eyed, clever little thieves. The only difference is they're dusty red from head to tail, not solidly black like crows. These creatures, too, I've never laid eyes on. I thought I was going to spot some in Burma or India when I journeyed through those countries on my pilgrimage. I did look for them, but I didn't see any. Some people told me lots of them could still be found in Kandy – these folk who had trekked all the way to Kandy, Sri Lanka, to pay respect to the relic at the Temple of the Tooth said they got to see many, many craes in the city. Old Man Junpa told me there used to be craes in Praeknamdang. Strange and sad... I've never had the opportunity to see one. Big turtles, too, are hard to come by these days. People have eaten them nearly to extinction. Old Man Junpa alone managed to ravage their population like you wouldn't believe. Eating turtles is a terrible sin, you know. It's such torture to kill them – you have to flip them belly up and set them on fire. Mae Duangbulan used to chase Old Man Junpa off, to make him burn his turtles somewhere far away from her. He was forbidden from killing a turtle or preparing turtle meat inside the house. And Mae Duangbulan absolutely refused to cook with or eat turtle meat, and she prohibited me from eating it as well. A turtle on its back, being flamed, would weep, and the number of tears gushing out of its eyes was unbelievable. Mae Duangbulan would yell and curse at Old Man Junpa: 'You damned old fool! You sinner!' Old Man Junpa, chuckling, would say how turtle meat was absolutely delicious, how people who'd never tasted it would never in a million years be able to understand, and he'd add, too, that regular turtle meat was second only to softshell turtle meat. Mae Duangbulan, she had a soft heart, she always conducted herself within the bounds of morality, of dharma. Old Man Junpa, on the other hand, was somewhat of a rogue – sin and karma were nothing to him. So there you have it, those were my parents. I'm used to calling them 'Old Man Junpa' and 'Mae Duangbulan' because that was how people in Praeknamdang referred to them back then. I had a sister, too, named Glintoop. She died a child, only five years old, by drowning. Her remains were never found. Some said a tiger stumbled upon her dead body and dragged her away, making a meal of her. But that was just hearsay. I was still too young to remember anything – when Glintoop died, I was only four. The matter of her body never being found, that was something no one dared to bring up in front of Old Man Junpa, because it would infuriate him, and he already had a hot temper. People had to whisper and gossip behind his

back, how they reckoned Glintoop's body had been snatched by a tiger and eaten. As a matter of fact, the rumours went so far as to say Glintoop hadn't died by falling into the water at all, but it was a tiger that got her. At the time of her passing, Old Man Junpa was away. He'd had to go and serve as a guide for the hunting expedition of some royal who'd come on a leisure hunt around the deep, dark woods of Sarahed District. By the time he returned, Glintoop had been dead nearly a year. I don't know how much or little of it was true – all I was told was that my sister had gone to play in the stream during the high water season, and we had a big flood that year, too, and she'd drowned. As for me, at the time of my birth, Mae Duangbulan had named me Kwantien – 'candle smoke' to my sister's 'joss-stick scent'. I only shortened it to Tien during the era of Field Marshal Plaek Phibunsongkhram's Cultural Revolution – the district chief had paid me a visit and urged me to change it, so I did. But before that, everybody used to call me Kwantien, and I grew up as an only child. Mae Duangbulan, she wanted to farm, she wanted to take over the plot in the forest she'd already claimed and make rice fields of it. Before I could even crawl, she brought me along when she went out to the fields, and there she'd lay me on a cushion under a tree and tie my leg with a waistcloth, tethering me to the tree. She was fair-skinned, tall and strong. Like most women of that time, she couldn't read or write. Unlike most women of that time, she didn't chew betel nut. She made such delicious gang liang and sang such beautiful lullabies – those are things I can still remember. She was a guileless, reserved, melancholy woman dreaming of a stable life, and she had her heart set on converting forest land into agrarian fields. But Old Man Junpa didn't quite cooperate in the matter. When it came time to chop and dig and weed to ready the land for planting, without fail every day, he'd grab Ninlagaan, his trusty percussion rifle, and disappear into the forest, and then he'd return hauling a muntjac or a larger deer, or laden with gaur or banteng meat. One might have taken him for a sluggard, but the truth wasn't so. He was reluctant to become a farmer and was never quite ready to go against his own heart. 'I'm a grand, mighty river whose course is tough to change' – this was the sort of expression he'd always wield as an excuse. In Praeknamdang in those days, as soon as you reached the bottom of your front steps, you were in the forest. Land that was farm, that was field, there were only a few patches of it. Planting vegetables like greens and beans and such and cultivating rice unirrigated didn't work particularly well. Usually, elephants or bears or monkeys or boars or birds came and interfered with the effort. One year, Mae Duangbulan appeared set for an ample harvest. Seeing her rice plants sprout in large bouquets of golden yellow, she hunkered down to prepare for a tam kwan kao ceremony, cooking meticulous dishes savoury and sweet, stitching together a flag two metres high in red and white, stringing a malai garland in seven colours and seven forearms long, all to be dedicated to the goddess of rice, Mae Posop. Just as she was about to reap the fruits of her labour, disaster struck: weaverbirds from who knows where, ten thousand of them I'd say,

swooped down and devoured the crop in one go. They only left her with bare straws; she didn't even get a full sack of rice. Old Man Junpa, beyond pleased, rubbed it in her face: 'See? What does farming get you?' But Mae Duangbulan refused to admit defeat. The following year, she planted new seeds and started farming all over again, on dry land. She dug holes, depositing four seeds into each of them – one for the beetles and the bugs in the soil, one for the crows, one for the monkeys and lemurs such, and one for the person who did the planting. And her rice sprang up in lush, fluttering bunches, flourishing even more as it got more rain. Mae Duangbulan, pointing for me to look, said to me, 'Behold Mae Posop's miracle!' Rice is a curious plant when you think about it – it never fails to grow. It might stall if deprived of rain, but given rain, it'll grow in a hurry, and if weeds don't smother it too badly and the sky isn't too unkind to it, you can be sure you'll see ears of it cropping up. It's a plant that truly agrees with Siam's climate. That's why people worship Mae Posop and bow down before her, and why farmers regard themselves as Mae Posop's children. So, you see, I grew up with a split in my heart: on the one hand, I yearned to be a farmer, yearned to tame forest land and cultivate rice with Mae Duangbulan, but on the other hand, I yearned to become a formidable huntsman like my old man Junpa, because from the time I was just six or seven years old, he started dragging me into the jungle with him when he went hunting, and also from the time I was just six or seven, he started forcing me to eat the gallbladders of snakehead fish, raw, and also butterfly pea flowers, so I'd have superior eyesight and be able to see in the dark. We were poor jungle folk. All we had was a roof over our heads, just a shabby little house. We practically didn't own anything else of value. Old Man Junpa's only asset was his Ninlagaan, and that was it. Mae Duangbulan was a little better off: she had a gold ring, smooth all the way around, which her left ring finger was never without – it was a small thin piece of jewellery, nothing worth a pretty penny, and she had a pair of stud earrings with little rubies, which she wore all the time, and she also had a gold necklace, a baht in weight, which she kept stashed away and hardly ever put on. But back in those days, poverty didn't make one feel inferior, because the jungle was still bountiful. As long as you had enough rice, matters of the mouth and stomach were pretty much sorted, because just beyond our fence, there was a cornucopia of herbs and vegetables, in a great many varieties, each one of them divine – you could pick them with your eyes closed. And there was an abundance of fish and crustaceans to be caught. Wherever there was water, there were fish.

On the ninth evening after the new moon in the first month of 2427 BE, 1884 CE that is, I was ten years old, rowing my boat to pick up Mae Duangbulan, who was out harvesting alone in the fields along the stream, to the south of the village. I'd done the same for days and had developed a routine: I'd help her load the sheaves of rice onto the boat and then take her home. I rowed the boat at my own leisure, having my fun and letting the boat drift along the water. On both

sides of the stream were forests dense with large, imposing trees; their branches arched and met in the middle, forming a seamless canopy threaded together with an assortment of vines, which made the passage underneath appear like a tunnel. Down on the ground was an underbrush of weeds and grass growing on top of each other. Haste was the last thing on my mind, and being a crafty kid, I let the water carry the boat at its own lackadaisical pace as I lay prone, chin hooked on the gunwale, peering through the limpid depth of the stream. The world beneath the water was soundless, peaceful and cool on the eye; it was full of grass, seaweed, duck lettuce and lotus clusters, full of shrimp, molluscs, crabs and fish. I gazed at the river snails latched along the stems of reeds, at the striped snakeheads suspended among the duck lettuce, still but for the fins fluttering by their ears and the tails wavering just at the tips. I gazed at the crabs scuttling clumsily on the muddy bank. I gazed at the hydrilla swaying in the soft current like tree branches blowing in the wind. All of it was novel and sublime, strange and beautiful, tranquil and intriguing, and refreshing to look at, the allure drawing me into an extended reverie each and every time. One giant mudfish, a new mother, patiently took up the rear behind her itty-bitty children – they were tinier than matchsticks, and there must have been a hundred of them. And with my boat approaching, she gaped her mouth open for all of her offspring to take shelter within – this, too, I watched, wonder-struck. A school of red-tailed tinfoil barbs swam, wiggling back and forth around a patch of blue lotus flowers; with their bright silver scales dazzling, they looked as though they weren't living things but rather ornaments fit for a splendid heroine. Now hampala barbs shot through the water like pewter fireworks. I didn't notice the strange silence of the world above at all. Under a cluster fig tree at the edge of the fields – this tree was so enormous it would take two people to wrap their arms all the way around the trunk – I steered my boat so that it would skim the shore, grabbing hold of grass as I readied to moor. A drop of dark red liquid splatted onto my left forearm – nectar from the fig tree, I assumed. Another red drop landed with a splat, again on my left forearm. Still, I assumed it was nectar from the fig tree. I used my hand to wipe the two red spots, rinsing everything in the moving water... I smelled blood! With a sinking feeling, I looked around myself: stillness, unsettling stillness. And then I heard a noise, and it nearly frightened me to death: what sounded like soft retching was coming from somewhere above. And right before my eyes, an ear fell into the belly of the boat, a human ear with a ruby earring, lustrous and flushed, attached at the lobe. As I looked up, I saw her graceful arm dangling down, saw her long, comely fingers tensed into a claw, saw her smooth gold ring bouncing light in the declining sun, saw her long, black tresses, saw her face drained of life, and I saw the terror in Mae Duangbulan's eyes as her body lay on its back, her head hanging down, her mouth frozen agape. Above her body, hovering conspicuously between the fruit-studded branches of the fig tree's fork, was the imposing face of a tiger, its fangs and teeth covered in blood, its mouth covered in blood, its white whiskers

covered in blood and fanned out into a sneer, its eyes sleepy and serene from satiation. In fact, it had indulged its appetite to the point of vomiting. I leapt onto the shore. I screamed something primal. I lost my mind for seven whole days and nights. I had nightmares again and again. I mumbled things no one could make sense of. Luang Paw Kom, the abbot of Praeknamdang Temple before me, had to make holy water for me to drink and bathe with for over a month. I refused all food and was wasting away. Word among the people of Praeknamdang was that the tiger had claimed two corpses in that incident: one was Mae Duangbulan's and the other was her son Kwantien's. But then I lived; I re-emerged into reality. Still, what I couldn't break free from was that sheer, indescribable terror that had been put within me. It would take me a good ten years to conquer it, and the victory came at a steep price, perhaps too steep a price. Mae Duangbulan's end turned Old Man Junpa into a mighty tiger slayer. Two days after her death, under the very same fig tree, he captured the murderous tiger when it returned to her body again. He didn't bother to stay and look after me, his badly ailing son; instead, he left me in Luang Paw Kom's care. He showed no attachment toward Mae Duangbulan's body and used none other than her corpse to bait the tiger. That was how much he wanted revenge. And how daring, heartless and barbaric he could be. He didn't kill the tiger with a single shot. His Ninlagaan tame in his hands, he shattered its legs one by one, bullet by bullet, calmly, intending to kill it slowly, bent on getting revenge more than anything else. The tiger thrashed on the ground, sending grass whipping in every direction as it growled ferociously. Old Man Junpa shot it twice more, in the flank and in the spine, methodical enough not to kill it and mindful enough not to leave it able to attack him. He cut down a vine, looped it around the tiger's neck, and dragged the creature out of the forest all the way to the clearing in the middle of the village, cursing the whole way. In the clearing (or so went the story going around Praeknamdang at the time, which matched the account later shared with me directly), he hammered down two posts and tied the tiger's two forelegs and two hind legs tight to each of the posts. He ran a flame along its skin, he pricked it with thorns, kicked it with the front of his foot, with the back of his heel, spat on it, pissed on it. He'd gone mad and looked it, with his hair wild, his eyes raging and bloodshot; he was tense, vulgar and wicked, all of it manifesting in his demeanour. He never changed clothes or put food in his stomach. He drank himself to inebriation and kept drinking relentlessly. And he refused to wander away too far or for too long; he only paced back and forth near the tiger, now reduced to his wounded captive, and stood by to torture it again and again with various methods of his devising. The tiger convulsed, growled, groaned, staring at him with vindictive eyes. He then set up a mousetrap, and twelve mice were caught, some large, some small. He placed the whole dozen into a bamboo tube with the node hacked off only on one end, held the opening against the tiger's rear, and set fire to the side left sealed. As he fed the flame, the mice scampered in complete chaos within the bamboo culm. In

their suffering, they were utterly panicked. They had no way to escape. Their only way out was to gnaw and dig and make themselves disappear into the tiger's rear end, into its back hole. But only eight of the mice managed to re-emerge, all of them soaked in blood from head to tail. The other four were stuck somewhere inside the tiger's body, and that was how the tiger died. From then on, Old Man Junpa would slay every tiger he could get his hands on. Whenever somebody from a nearby village or district came to fetch him with the request that he go after a tiger, he'd abandon all his other work mid-task and, gleeful, hurry out with the caller. His Ninlagaan was always impeccably cared for, and there always had to be plenty of gunpowder and percussion caps on hand, and they were always impeccably cared for. In the jungles in these parts, he'd slain so many tigers that he no longer bothered to keep a tally. He slaughtered them all, babies and elderly ones, nursing tigresses and strapping young males. Whenever anyone mentioned tigers in his presence, he'd hawk a spit and say, 'Bah! Those mangy cats!' He was bold and cocky, going after tigers in ever more perilous ways. Because he looked down on them, he didn't exercise enough caution. He was sure of himself, for he'd never been pursued by a tiger. He set up a gun trap, strung to a tree, its sole aim being to kill tigers. He built booby traps tirelessly, and time and time again he left the unlucky tiger to rot right in the contraption without ever dismantling it. He once snatched tiger cubs from their lair, after waiting for their mother to go out and search for food, and noosed their necks with vines and hung them in a row over the mouth of their den. He went out and bought me a percussion rifle of my own, which he named Sai Fah Faad – Thunderbolt – and, by training me himself, made a sharp, agile shooter out of me (when I was new to it, Sai Fah Faad kicked me over and over, pretty near knocking my shoulder out of joint). He had me accompany him into the jungle and made me hunt like a grown man. He brought me with him to hunt tigers and taught me how to follow their trails. But when the moment came to really pull the trigger, I couldn't ever muster the courage to do it. Every time I had to shoot a tiger, my mind couldn't help but flash back to the shock and horror, and the pain and suffering Mae Duangbulan had had to endure. Deep down, I always thought I'd be dealt the same fate as the one already dealt to Mae Duangbulan.

JAMES GIDDINGS

POETRY

YOU ARE WITNESS TO A VIOLENT MURDER

When you succeed in your new life,
remember I have not forgotten your name.

Before you left you told me it had to be like this,
that you saw a dangerous man

kill another dangerous man and now
it is too dangerous to live the life you are living.

Can't you take me with you, I said,
and a suited upright man told me coldly,

it's for your own safety. His teeth shone
like a newly waxed car and a gun sat muzzled

on his hip. *Guns have safeties but
I wouldn't call them safe, and criminals*

break into safes all the time. I felt safest
when we existed in the same room together,

the cool dark night outside the house
breaking down our door. The car you left in

made little fuss as it drove down the road,
and I've been missing you ever since.

I'm sad for the things you couldn't witness,
how despite all, I found love like a bullet

in a kidney, how this life I've made
stands up without my needing to hold it.

It has been hard not knowing you –
harder still to think the reason you're gone

might not have anything to do with decency,
but the part of you that liked danger.

HE RETURNS WITH BIRDS

His eyes are marked
 by crows' feet, he must blink softly
 to release their creaking tension.

I hoped after all this time
 he would reward me with tears
 but his first gift was the smoke

of black birds that streamed
 straight down from the chimney
 and circled his head like a feathery crown.

His second was the gentle
 resting of their talons, their tenderness
 in taking hold, a tornado

of wings, all their black meaning
 making my father faceless as the back
 of the moon. His third gift was the lifting

of birds, their tooling beaks
 picking at an invisible seam,
 his heft of flesh unsuited, hoisted,

the old difficulties unmoored
 from his mortal body, slipped
 off his shoulders like a shirt.

A man, no older than me, stood
 in the anaesthetic light of dawn,
 his head a coin newly edged in gold.

You are here, but everything has already happened.

I DIDN'T KNOW I WAS A FLOWER

He took me to the garden
showed me the flat brown earth

said, *this here is our dirt,*
then planted my heels

in a row of hollyhocks.
He brushed the muck and soil

off his hands, wiped sweat
from his neck and told me

it's time to grow. So I tilted my head
to the sun and by the time

he was out the gate,
I had bloomed and no longer

had a mouth to stop him.

SO YOU HAVE AN ASIAN MOTHER
REBECCA LIU

'Does an Asian American narrative *always* have to return to the mother?', the poet Cathy Park Hong asks in *Minor Feelings* (2020), her wide-ranging, partly autobiographical account of the history of Asian American identity. She is tired of being asked about her mother, often by other Asian poets who guess that 'she must be interesting'. Hong wants to give space to the others: the friends, the artists and the fathers. Her mother's influence, Hong says, runs so deep that it 'would take over' the book, 'breaching the walls of these essays, until it was only her'. Her glinting admission of the hurt she has inherited is simultaneously wrapped up in an impulse to withhold and protect: 'I will only say that my mother was broken then, though I don't know how.'

Writing a year earlier in the poetry collection *Flèche* (2019), which details the narrator's journey to get her mother to accept her queerness, Hong Kong poet Mary Jean Chan also introduces the language of walls. In *A Hurry of English* (2018), the poet asks: 'What does it say about me, this obsession written in a language I never chose? / My desires dressed themselves in a hurry of English to avoid my mother's gaze.' The poet's mother did not understand English in the way that she understood English. For that reason, English became a begrudged but crucial zone of safety: there, 'she let me be.' And yet something must break this unspoken truce; something must be confronted. 'An odourless room is not necessarily without trauma,' she writes. 'We must interrogate the walls.'

In these narratives, to write about the inarticulable legacies of pain without mentioning the mother is to write towards freedom; to reach towards all the things that open up your world and remind you that you're here to live in it, instead of being closed in by high, unforgiving walls that bear down on you with scrutiny and shame. The mother figure is the spectre looming across every corner of this tightly wound world who so often remains unnamed, because to name her would open up all the things you've buried in your chest. So you make a deal. 'When illness is unnamed,' Hong continues on the subject of her mother, 'the blame for it is displaced onto the child.' It's a broken deal, but it works. Taking blame and walking on feels like a better option than tearing down those walls – *interrogating* them, as Chan puts it.

But what would happen if those walls were interrogated; if the mother-figure breached them and ran on and on and on, taking everything until it was just her, only her? And how would you enact such a public breaching without being ensnared by all the traps lying in wait: the ease in which discussions of culture curdle into caricature; how exquisite particularity becomes flattening, offensive generality (the need to always hedge, lest one be misunderstood: *not all Asian mothers*); how well-meaning liberal pieties take the 'I' of the racialised subject and transform it quickly into a 'we', a we that apparently constitutes a meaningful representative unit. And finally, how do you accept that you may fail to protect whom you ought to protect? Without care, the 'Asian mother' can become – has already become – a popular Western punchline, a cartoon villain afforded no interiority; yet another thing that came from you, but you no longer own.

Being an immigrant child often comes with an impulse to protect the parent, inverting the traditional dynamic of care. Hong remembers seeing her parents being talked down to by white adults in America, her face

burning from fear and shame. So you harden your shell, keep everything locked in your chest, and walk on. Some things are better left in your own house; the walls are there for a reason. And yet, Chan's lines stay with me: 'An odourless room is not necessarily without trauma. We must interrogate the walls.'

<p style="text-align:center">*</p>

You know the risks of interrogating those walls. You remember when you first saw them.

You are 15 years old; not yet a woman (probably not even a girl). It is the late noughties. You have grown up in the West and now live in Hong Kong. The only famous East Asian women in the Western public imagination seem to be Lucy Liu and Tila Tequila. You continue to track signs of other prominent East Asian women in pop culture with the alertness of a ravenous dog, foraging where it can for scraps (and they were always scraps). Things like:

- Disney's 1997 *Mulan*, the only character you could intelligibly dress up as during Halloween until
- Cho Chang in the *Harry Potter* books
- Actor Brenda Song as spoiled heiress London Tipton in Disney's 2005–8 *The Suite Life of Zack & Cody*

In all these instances, save for the first, the young Chinese woman emerges in her predominantly white world alone. The audience learn little of Cho Chang's family; though you delight in Brenda Song's anti-stereotypical depiction of a spoiled hotel heiress, we almost never see her parents. This meant these characters could only go so far for you, simulacra pressed onto the world without baggage. You, too, developed an outward-facing persona apparently unrooted from anything. In the West, your private life, your home and your 'customs and traditions', belonged in the shadows, enclosed in the walls. It had no place Out There, and the other children of Chinese immigrants who failed to understand this were the hopeless ones who couldn't fit in, couldn't make friends and were left at the bottom of the rung while you climbed up the ladder to join the pack of the strong. There, they told you *you're not like the other Asians*.

Then an article appears on the Internet in 2011 and goes viral. It is an extract from an upcoming memoir by Yale law professor Amy Chua, who was born to ethnic Chinese immigrants in the 1960s. The article, published in the *Wall Street Journal*, is titled 'Why Chinese Mothers are Superior'. 'A lot of people wonder how Chinese parents raise stereotypically successful kids,' Chua opens, before sharing her strict, and insane, rules for her two daughters. No sleepovers; no television; no grades below an A; they must come top in all their classes, 'except gym or drama'. She remembers forcing her seven-year-old daughter Lulu to play the piano, instructing her to 'stop being lazy, cowardly, self-indulgent, pathetic.'

Chua's article does its best to navigate the impossible dance between the general and the particular; she writes that 'I'm using "Chinese mother" loosely,' admitting that she knows 'Korean, Indian, Jamaican, Irish and Ghanaian parents' who put a similar pressure on their children and thus 'qualify too' (which appears to undermine the premise of the article, but

no matter). Chua then describes an ethos for Chinese parenting defined by a relentless drive to succeed – 'if a child comes home with an A-minus on a test, a Western parent will most likely praise the child. The Chinese mother will gasp in horror and ask what went wrong' – and in which love, if it is seen, is shaded by strictness, falling into the space of silence and the withheld. Chua's conception of parenting uses the language of warfare. She makes numerous references to 'weapons' and 'tactics' when negotiating with her children; the house, she writes, becomes a 'war zone'.

'Why Chinese Mothers Are Superior' sparks a firestorm across the Internet, eliciting many angry responses; Chua is labelled an abuser, a demon, a hack trying to sell a book. It also breaks a part of you open. Your soul feels breached; your proverbial house is briefly turned inside out, walls battered and cleared for public regard for the first time. Your mother is not Amy Chua, did not do what she did. But you sense a shared something in the water; that although she and Chua took different paths, their lives are threaded together by a shared history. It is a history that makes them walk around on tiptoe, persistently nervous about an existential danger around the corner – which then causes a need always to push onward, taking their children with them. Life is a struggle for survival, a never-ending battle to protect themselves and their loved ones against vulnerability and the mediocrity that comes with being like everyone else. 'Even losers are special in their own way,' Chua writes with disdain, mocking what she sees as Western parenting.

What sort of history shaped these individuals, you wondered then and you wonder now, that would harden their minds and bodies in this way? What did a person have to experience in their lives to see a young child and reach for the armour and the sword? There was so much silence that seemed thick with meaning; if only you could understand what it was hiding, what it wanted you to know but couldn't say. What sort of impossible shared history did that child then have to carry in their body – a 'public history' that exceeded them, and yet one they had to fold into themselves, and burdened them with a demand to succeed?

And it wasn't just your house, nor was it just Chua's house. It was everywhere, a current underneath the surface. It was in every lacuna of silence that you shared with your Asian friends; the jokes you would make about your mothers and their mothers and our mothers; when you would interview writers about their families and lives and they would say, *We've only been talking for 20 minutes but there's just a shared understanding we don't even have to discuss.*

In 'On Tiger Moms', an essay published in *The Point* in 2012, Julie Park notes that despite the suggestion that Chua was uncovering an essential 'Chinese' secret, the article, and her memoir, did something that ran against tradition. 'By publicly discussing what in traditional cultures is simply taken for granted,' Park writes, Chua 'does what a true traditionalist would never do: she justifies herself on the basis of arguments, and exposes herself to the indignities of debate.' (Chua said herself, Park notes, that writing the book was a 'very Western thing to do'.) Chua's account held familial suffering up to the light and opened a space for conversation within the community about the all-too-unarticulated pain that gets passed down through generations.

Little such catharsis was offered in the mainstream conversation
surrounding 'Why Chinese Mothers are Superior'. Responses were
dominated by the status-anxious readers of *The Wall Street Journal*, for
whom people like your friends and you are threats to their own children's
security – Yellow Peril, this time on the steps of private schools. Readers
inquired whether they were teaching their sons the wrong way; what
they should learn from Chinese parenting and impart to their toddlers;
objected that they're surely raising more creative kids. 'Is US parenting
too soft?' one article asked in response. Chua received many angry letters.
Others were begrudgingly impressed by the achievements of her daugh-
ters, straight-A students who played at the prestigious Carnegie Hall,
and wondered whether, in spite of their reservations, she had a point.

After the article was published, Chua tried to walk back. She responded
to letters in the *Wall Street Journal* clarifying that her memoir was tongue-
in-cheek; that the extract was merely part of a story of her realising her
own shortcomings; that she very much loves her children. But she made
the error of expecting that she would be accorded nuance in a world that
asked that she strip it down, because the book needed to sell.

No, it would take another 10 years for this part of your soul to stir again,
to see in the universe a sign that you weren't alone; that perhaps one day
these things could be talked about again, this time on your terms. But
you were used to waiting.

*

Dear Ma,

I am writing to reach you – even if each word I put down is one
word further from where you are. I am writing to go back to the
time, at the rest stop in Virginia, when you stared, horror-struck,
at the taxidermy buck hung over the soda machine by the
restrooms, its antlers shadowing your face.

Ocean Vuong's *On Earth We're Briefly Gorgeous* (2019) is framed as a letter
to the narrator's mother that she will never read. In it, the narrator, Little
Dog, remembers a childhood in America inflected with love and abuse,
and a mother and grandmother mentally caught between the present and
their past lives in Vietnam during the war. Little Dog's mother, Rose,
upon seeing the taxidermy buck, shakes her head and says, 'Can't they
see it's a corpse? A corpse should go away, not get stuck there forever like
that.' Reflecting on his mother's reaction, Little Dog remembers the buck's
'black glass eyes', and realises 'how it was not the grotesque mounting of
a decapitated animal that shook you but that the taxidermy embodied
a death that keeps dying as we walk past it to relieve ourselves.'

The inability to move on comes across as perverse to his mother, pre-
cisely because she cannot do so herself. Little Dog continues to address
her in raw, elegiac language: 'The war you lived through is long gone,
but its ricochets have become taxidermy, enclosed by your own familiar
flesh.'[1] Throughout the novel, he remembers times when ordinary objects
become threatening reminders of a war that has never psychically left his
family. His mother finds a white dress she likes at Goodwill; she hands
it to Little Dog, her eyes 'glazed and wide', and asks him whether it's

fireproof. On the night before American Independence Day, as fireworks shoot into the air, Little Dog is wedged between his mother and grandmother, sleeping on the living room floor. He wakes to see his grandmother on her knees, scratching wildly as fireworks burst in the distance. 'If you scream,' she tells him, 'the mortars will know where we are.' 'When does a war end?' Little Dog asks his mother in the letter she will never read: 'When can I say your name and have it mean only your name and not what you left behind?'

Here, like in Chua's account, love is entangled with violence, but Vuong refuses to label anything according to the categories of 'good' and 'bad'. (To do so would feel like a pre-emptive concession to the Western reader, neutering complication in favour of virtuous, and simple, intelligibility.) And while others may label Rose a 'tiger mother' and discard her, the way categorising people can be a way of no longer seeing them, Vuong's moving prose suggests that to do so is their myopic loss. Rose is afforded, in Little Dog's letter, a depth, a history and a story. The stakes of her life are much richer and more beautiful than the status anxiety of middle-class white parents over whether their children can compete. Gone is the concept of 'Asian' as a conditional and often impossible-to-define state of being, condemned to loom against the spectre of whiteness; gone is the constant hedging lest you be misread, the delicate dance with sensibilities that were never yours.

Instead, Vuong crystallises the life of Little Dog, his mother and his grandmother, bringing to light all they have inherited but cannot speak about. The novel is unflinchingly honest about Little Dog's suffering, but refuses to tie pain up in neat, tidy parable. Little Dog is abused by his mother – 'your hand in the air, my cheek bone stinging from the first blow' – and then asks himself why. 'I read that parents suffering from PTSD are more likely to hit their children'; 'Perhaps to lay hands on your child is to prepare him for war.' Like Chua describing the 'weapons' she uses to negotiate with her children, Rose sees the world as a battlefield, partly because America, the purported land of the free, is replete with racialised cruelty. When Little Dog comes home from school after being beaten up by white classmates who exhorted him to 'speak English' in the 'dialect of damaged American fathers', his mother slaps him. You have to find a way, she tells him; 'You have to because I don't have the English to help you.' She then regularly asks Little Dog to drink milk, to fortify and harden his body against a world that is waiting to cut it down.

'Abuse is Rose's inheritance, bequeathed to her son half in helplessness and half in broken devotion,' observes Jia Tolentino of Vuong's novel in the *New Yorker*. You cannot understand this abuse without understanding the history that gave birth to it – a history that encompasses both the intimate (Little Dog imagines his grandmother holding baby Rose in her arms, standing in front of American soldiers) and the sweeping (the legislation, mass mobilisation and Cold War paranoia that led America to raze and bomb Vietnam, destroying Rose's school in the process). You cannot understand this abuse without understanding that the new worlds to which these women escaped dangled the prospect of equality, only to remind them every day of their desperate vulnerability. Little Dog remembers his mother being laughed at by locals and exploited by her boss. Tolentino writes that he 'must see his mother through the American eyes that scan her for weakness and incompetence and, at best, disregard

her'. Perhaps this is a perverse inversion of the parent-child relationship; it is also a near-impossible demand that stretches the mind's capacity for empathy, to hold suffering in the body without spiralling out yourself. 'There is a staggering tenderness in the way that Little Dog holds all of this within himself, absorbing it and refusing to pass it on,' Tolentino continues. 'I'm apprehensive about going to therapy,' a friend recently told me, mentioning her fear that her parents would simply be labelled 'evil' by the counsellor, who would then feel as if her trauma had been revealed, understood and could be wiped away. It would be a toothless rubber stamp purporting to issue finality on something that could not be closed so easily.

Little Dog writes from the long-awaited future. He is now a successful writer, the kind whose work is acclaimed as *necessary* and *urgent*, and has become, like many immigrant children whose lives are propelled by their parents' hopes, unintelligible to the very people who raised him. The American Dream validated once more; the tiger mother's race into the future vindicated. Or is it? 'Some people say history moves in a spiral, not the line we have come to expect. We travel through time in a circular trajectory, our distance increasing from an epicentre only to return again, one circle removed,' Little Dog reflects.

Against the onward-and-upward linear drive of the tiger mother, who attempts to render present pain acceptable on the premise of a glorious, success-filled future, Vuong posits instead that life, and our mental states, can feel more like loops. We never quite run away from all we want to forget. 'You cannot redeem your past any more than you can transcend or forget it,' the feminist theorist Jacqueline Rose observes in her essay collection, *On Violence and On Violence Against Women* (2021). Rose cites the 'transgenerational haunting' theory of psychoanalysts Nicolas Abraham and Mária Török, which proposes that traumatic histories can be passed down. 'When memory is buried or silenced by one generation,' Rose continues, 'it erupts at its most virulent in the next.'

*

You are 13, visiting family in China; extended relatives who have always been warm to you but – perhaps because of your broken, child-like Mandarin – with whom there is little intimacy. You are studying twentieth-century Chinese history in school and think discussing the past will help bring you closer together. *I know what you lived through, etc.* You mention the past at the dinner table and instead get kicked out of the house, told not to return. (They forgive you the next day, taking you in without mentioning the episode. A cataclysmic uproar, quietly put behind you without a single mention. Typical, you think.)

What allowed – *allows* – the tiger mother to remain such a cartoon presence in the Western imagination? Why did Vuong succeed in giving Rose interiority, a history and a story, when Chua failed? In popular conversations among the Chinese diaspora in the West – often involving reminiscences over food, jokes about family life and the need for cultural representation – it can sometimes feel like there is a beat missing, something not quite said. There is another story of pain banging against the door wanting to be acknowledged.

In Ling Ma's *Severance* (2018), a now-uncannily prescient novel about
a deadly pandemic called 'Shen Fever', disaffected New Yorker Candace
Chen makes her way across the Midwest with a group of fellow survivors.
Candace's journey through the apocalypse is interspersed with recollec-
tions of her parents, who migrated to America from mainland China in
the late 1980s and have long since passed away. As Candace navigates the
apocalypse, she often thinks of her mother, Ruifang Yang. 'For most of
my childhood and adolescence, my mother was my antagonist,' Candace
observes. She remembers being forced to kneel in the bathtub when she
was seven, after Ruifang caught her playing 'Homeless' instead of 'House'
('playing Homeless was what it sounded like; I pretended that I was
homeless'). 'We didn't come to America so you could be homeless,' her
mother snaps. Ruifang passes down to Candace the same well-intentioned
imperative issued to children the world over: live a better life for yourself
and, by doing so, redeem our past suffering.

In *Severance*'s present-day, Candace is among the few survivors of Shen
Fever. The illness suddenly and randomly strikes people and turns them
into zombies who are stuck acting out loops of learned behaviour: a
glassy-eyed cab driver repeats his journeys around New York; a husk
of an employee at Juicy Couture folds velour sweatpants over and over.
Their condition is a surreal exaggeration of Ruifang's obsession with the
past – and despite Ruifang's hopes, the future is uncertain. Candace is
pregnant, and being held captive in a mall by a power-hungry survivor.
But Ruifang emerges in her hallucinations to guide Candace to freedom.
In the final scene of the novel, Candace runs out of the mall, takes a car
and arrives in Chicago, the city piled-up with abandoned traffic. She
remembers a conversation she had with her mother. They were standing
outside a corporate office building in Chicago, and Ruifang imagined
a different life:

> What do you think it would be like if we lived here? She wondered,
> reverting back to Chinese. I would work, and then what would you do?
> You would work, and I would play, I said.
> I would work and you would cook, she decided. You would cook and clean.
> Do you know how to cook rice in the rice cooker?

Ruifang wonders what life would be like had she been a career woman
– managing people's money, helping them afford homes for retirement.
Then, Candace's memory ends, and we are taken to her chaotic present
universe, where the orphan fights her path to an uncertain existence.
The tacit understanding that Candace must do better than her parents
has been decidedly broken. The most she can hope for is to survive.

Meng Jin's novel *Little Gods* (2019) follows Liya, who, like Candace, is a
Chinese-American millennial. Her mother, an aloof and emotionally dis-
tant physicist named Su Lan, suddenly dies with no apparent cause. Upon
learning of her mother's death, Liya is sure that Su Lan had 'done it to
herself, not killed herself, not anything so tragic, but somehow arranged
it so she would cease to exist'. Her mother 'did not like to talk about the
past', and Liya flies back to China to visit Su Lan's hometown and uncover
her history. 'I was reversing something my mother had done, reconnect-
ing a line she had cut. Only the thought of undoing her moved me,' Liya

thinks to herself as she's boarding the plane. 'There are things you know without being told, the knowledge somehow baked into the making of you.' (Jacqueline Rose on transgenerational haunting: 'It is when memory is buried or silenced by one generation that it erupts at its most virulent in the next.')

Whereas the traditional narrative places the new immigrant in a land of fresh opportunity – a blank slate teeming with ambition and without history – *Little Gods* reveals very little about Liya's life in America. Instead, we peel back the secrets of her mother Su Lan's life. We learn about Su Lan's upbringing in a small village; that she was a brilliant, though socially ostracised student; that she attended Beida (Peking University in Beijing), the country's top university; that as a physicist, she was obsessed with a theory that could turn back time.

By playing with time, *Severance* and *Little Gods* challenge the imperative, issued down by mothers, fathers and nations alike, to forget the ugliness of the past in the march towards glorious progress. *Severance* creates a harrowing future, while *Little Gods* inverts and twists time in memory of a mother figure who was obsessed with travelling back through it. And, by turning around their gaze – by exploring their mothers' lives and the histories they refuse to speak about – Candace and Liya discover things their parents tried to protect them from, but could never exorcise from their own minds. The very first chapter in *Little Gods* is titled 'The End', and, significantly, is dated 3 June 1989, Beijing. A nurse walks past Tiananmen Square on her way to work and sees protesting students gathered in the summer heat. She remembers her own time as a child during the Cultural Revolution before putting the memories out of her mind. The nurse walks into her ward and runs into a desperate pregnant woman and her husband who ask her for help. She brushes them aside. Hours later, as bodies pile up in the emergency room and the streets of Beijing have emptied, the woman has given birth and is screaming for her husband. A few hours ago, he had stepped out in the square and is now nowhere to be seen. It is revealed that this woman is Su Lan, the baby Liya and the father gone. As Su Lan holds onto new life, cradling it in her eyes, the narrator tells us that the new mother 'begins to die'.

Midway through *Severance*, as Candace makes her way from New York to the Midwest, seeking safety with an alliance of fellow 'non-fevered', the story jumps back in time to an earlier pilgrimage taken by Candace's parents. When Zhigang Chen and Ruifang Yang arrive in Salt Lake City in the winter of 1988, Zhigang is ecstatic. He is the first graduate student from China to be admitted to the University of Utah's department for physics. Ruifang is more sceptical of what America can offer and gets a job at a wig company. They both fall in love with the local grocery store: a large, bright hall stocking gallons of milk, which feels to them like the pinnacle of luxury. Half a year into living in America, on the same night *Little God's* Liya is born, Ruifang is watching television at home when she hears a wild knock at the door. Zhigang bursts in, makes the cardinal sin of forgetting to take off his shoes, and switches the channel. They see 'grainy footage of what appeared to be a night protest', held by a shaky handheld camera. Scenes of smoke; scenes of a hospital.

Zhigang stares at the screen, transfixed by it. He mutters something inaudible to his bewildered wife. She asks him to repeat himself.

> Finally he looked at her and repeated his words, loud enough that they echoed through the basement apartment, decorated by the owners with dusty bowls of cranberry-spice potpourri and Precious Moments figurines and paintings of autumnal New England landscapes and Utah Jazz sports memorabilia and Michael Crichton paperbacks and pastel seashell-shaped guest soaps and other tchotchkes that did not belong to them, that they did not know or understand within any cultural context and did not find beautiful.

> We are never going back, he said. And, in case she didn't hear, he repeated it once more, louder this time: We are never going back.

It can be dangerous to go back. As Candace and her fellow group of survivors make their way around the country, one of them, a fashion student called Ashley, realises they are near her family home in Ohio. They could stop by and pick up weed, she suggests. The group sneaks into Ashley's home, a 'small, boxy ranch with blue aluminium sliding'. Something, Candace tells them, 'feels wrong. It feels wrong that we're stalking our former, old... I mean, would you go back?' Candace's intuition is correct. Ashley, upon arriving in her old room, starts to look glassy and unfocused, and begins enacting behavioural patterns from her former life. 'Don't you think it's strange that Ashley became fevered in her childhood home?' Candace asks the others, 'what if nostalgia triggers it?' To go back, in *Severance*, is to walk into death.

It makes sense that Candace, child of a couple who ruled that the past was for forgetting, never became fevered.

<div align="center">*</div>

You are 18, 22, 24, 27. You are far from home. You keep waiting for the day when true adulthood will arrive. When you can think of your past with a breezy, careless confidence, a box to bury in the ground as you skip into the future. An adulthood in which Hong and Chan's metaphorical 'walls' have been broken down, and you can dance about feeling loose and giddy, unencumbered by history.

'Asian American fiction,' writes Julie Park in 'On Tiger Moms', 'is filled with fantasies of conflict resolution. After a series of misunderstandings and personal crises, the mother and daughter have a meeting of hearts which allows them to better understand and appreciate one another.' Like the notion of finally mastering your past, Park suggests, the idea of complete reconciliation with the mother may also remain a fantasy.

So what is there to do? Certain histories may remain unsayable – but literature and poetry offer a way to bring into being the unspoken, letting you taste freedom and joy, even if only in the imagination. In *Flèche*, Mary Jean Chan includes a two-part poem: 'what my mother (a poet) might say'. The first part of the poem examines the tyranny of the withheld. Strikethrough text plays on the notion of the unspoken, leaving safe, unimpeachable dictums that do not get you into trouble:

that she had scurvy as a child

that I don't understand hunger until I can describe what a drop of oil tastes like

that Mao wrote beautiful Chinese calligraphy

Then, pages later, part two begins, and the poem leaves behind all inhibitions. The imagined mother urges the daughter to 'be a river she might say / be the water that flows / over & under & along'; to 'be the rainbow that leaps / into that cleansed dome / of sky after storms erupt / from the breasts of millions'; to 'be the roots that seep / through stone be the echo / of your blood song of your bones'.

Here, the walls have been interrogated, breached and broken. The poem imagines someone who is flying, and who is also mired in swampy, twisted ground. They have roots and an echo in their bones that seeps through their blood; they experience the expansiveness of running waters and the joy of the vacant sky after a storm. In part two of 'what my mother (a poet) might say', the poet rejects the idea that to confront history is to relinquish your liberty; that it is only by marching onward, hustling forward, that you can save yourself.

You, too, realise that you don't have to be one or the other: to remain mired in the past and bogged down by it, or to shake off history and shoot, unburdened, into the future. You find the space in-between, discover what it has to say to you. You speak the unspoken, in the way you can.

Note

1 This quote did not appear Vuong's novel of 2019, but was part of an earlier version of the letter, published as 'A Letter To My Mother That She Will Never Read' in the *New Yorker*, 13 May 2017.

INTERVIEW LUBAINA HIMID

I first viewed one of Lubaina Himid's paintings at the Art Institute of Chicago in August 2019. Small in size, *Venetian Palace* (1997) is a portrait of a Black woman dressed like a magician. The figure – who is also an architect – holds a wand in the direction of an ornate building. A dotted line connects her eye with the building's roof, as if she has constructed a space for herself to live in. The background is a medley of sky blues, broken by an arched entryway leading to an undisclosed, sun-filled location. *Venetian Palace* captivated me; like much of her work, it challenges the historical narrative and visual representation of Black figures, particularly women, by conjuring up lives that don't exist in the historical record, or re-painting those whom the archive has failed to adequately account for.

Later that same year, I came across a larger body of Himid's work at Tate Britain. Included in the display was *The Carrot Piece* (1985), in which Himid blends humour and violence to comment on the way that institutions were tokenising Black female artists in 1980s Britain. In the work, a wooden cutout depicts a Black woman holding a bowl and twist of paint in her hands, while peering over her shoulder. Behind her she sees a pink and white clown riding a unicycle and dangling a carrot in her direction.

Born in Zanzibar in 1954, Himid moved to Britain with her mother as an infant. She graduated in theatre design from Wimbledon College of Art in 1976, before working in shops and community projects, and eventually completed an MA in cultural history at the Royal College of Art in 1984. In addition to producing her own artworks, curation forms a fundamental aspect of Himid's aesthetic and social practice. The same year she made *The Carrot Piece*, she curated the landmark exhibition 'The Thin Black Line' (1985) in a long narrow corridor at the Institute of Contemporary Arts (ICA), London. The show featured 11 Black and Asian artists, including Sonia Boyce, Ingrid Pollard, Claudette Johnson and Himid herself, artists who had previously been overlooked by mainstream art institutions. More recently, she curated 'Carte de Visite' at Hollybush Gardens in London, with work by Claudette Johnson and Ingrid Pollard – artists Himid has known for 30 years, and who were a part of her very first curatorial projects.

Over the years, Himid's varied practice has undergone many evolutions, from making wooden cutouts to producing immersive installations and 'overpainting', a process that entails painting over household items – as in *Swallow Hard: The Lancaster Dinner Service* (2007), in which she took her brush to 100 second-hand plates, jugs and tureens. After exhibiting in group and solo shows hosted by regional art institutions in Britain for most of her career, Himid became the oldest recipient of the Turner Prize in 2017 – recognition that was long overdue. DREW THOMPSON

THE WHITE REVIEW Your installation *Naming the Money* (2004) is made up of 100 Black figures, each a life-size character, with a name, a profession, a disposition. Among the painted wooden figures are shoemakers, herbalists, dog trainers and map makers. Each person wears a hat or colourful garments, and carries objects of their trade. All are slaves and servants. Visitors can walk between the many figures, and listen to a soundtrack of voices and songs. What is the work staging?

LUBAINA HIMID I wanted to make a work that was large, significant, seemingly impossible. I like to surround and envelop the audience with an operatic and magnificent understanding of lost history, found text, deep tragedy, a yearning for belonging and the enactment of everyday resilience. The soundtrack is a voice reciting 100 texts, which tell, in 5 lines, each person's life story. Weaving through this are extracts from the music of John Coltrane, Miriam Makeba and Max Bruch, among others. I trained as a theatre designer so devising artworks as multi-layered, performative productions is something I have done for several decades.

TWR You've painted works onto planks of wood, porcelain tea sets, newspapers, instruments and doors, as well as canvases. How do you select what to paint on?

LH In every piece I make, whether it is a painting on the lid of a piano, a piece of cloth or a rectangular canvas, I am trying to resolve a tension, one that cannot easily be resolved. Mostly, there is action. People are moving, or have just moved, or are in mid-gesture – tipping forward or tipping backwards. They are communicating with each other, or trying to communicate and missing each other.

TWR The five figures in your painting *Le Rodeur: The Exchange* (2016) look in many directions. The title of the painting refers to a ship, Le Rodeur, which carried a group of unidentified slaves who were taken from West Africa to Guadeloupe in 1819. There was an outbreak of ophthalmia, as a consequence of which captured Africans and crew members experienced temporary or permanent blindness. You take a non-literal approach in representing the scene – the figures are dressed in contemporary fashions and there is an element of stylistic disconnectedness between the figures, the room they find themselves in, and the sea, which is seen from a window. Can you talk about the role of backdrops in your work?

LH If I am ever watching a play, or something on television or in a film, I am constantly looking at the background. That's something which comes from my old training in theatre design – I don't really like it, but it does happen. In my paintings, I want time to be fluid and changeable, so the backgrounds are open – not stuck or carved in stone. In some paintings, like *Le Rodeur: The Exchange*, the figures are not always in the same timeframe as each other. If the background were incredibly detailed, it would hold it in time. Figures come and go. Sometimes, there is only one person in the painting, but there have been three other people there, fleetingly, while it was being painted. By the time I've finished, two of them might have gone back to 1750 where they belong.

TWR Your works are dynamic and immersive, often featuring moving parts and sound that elicit audience participation. Has this always been your aim?

LH I try to create spaces in a painting in which you can enter, either physical spaces where you walk around an installation, or painted spaces. If you could climb into a painting, like *Le Rodeur: The Exchange*, there would be a space for you to stand. It would be as if you were in a room with other people. You aren't looking through a window spying. You are in the room, and in a moment one of those people will turn to you and say, 'Oh hey, what do you think of this?' So, I painted a space for the audience to be in there.

When it comes to my installations, the scenes, or the situations, are always subject to change. Perhaps I have made something you can change by pulling on a rope, and a painting goes from one side of the gallery to the other, like the paintings on cloth in *How Do You Spell Change?* (2018), installed at BALTIC Centre for Contemporary Art in 2018. Or there is something you can move, like the figures in *Naming the Money*, because each is a cut-out, and if you were allowed to, you could lift them and put them in a different place. Or perhaps I've painted something like a cup or a plate, an object that gets moved every day. And, there is sound. Even when you are looking at paintings made from acrylic on canvas, there is sound. There are people talking. Very often there is the sound of the sea. There is the sound of boats creaking; sometimes

of sewing machines and pencils. The feeling of space that can be entered into, situations that can be changed, and overlapping and repeating sounds, are elements that are always in the work I make.

TWR Your upcoming show, 'Lubaina Himid' at Tate Modern, will feature 40 years' worth of work. You've described the exhibition a sequence of sets. By this, do you mean that some works will be the main act, while others function as the backdrop?
LH With this exhibition, I want to lead my audience through scenes and scenarios, rooms and questions. I'm showing the installation *Old Boat/ New Money* (2019), which is made from 32 planks of wood, 15 feet high and 4 inches wide, that lean and dip across and along the wall in an enormous wave. Each plank is painted in a different shade of grey: there are pinks, greens, blues and lilacs in muted harmony. I'm also showing *The Operating Table* (2019), a painting in which three women of African descent sit together at an oval table planning a city, deciding where the parks and lakes will be, where girls will be able to play outside and in public places. There is a low ceiling lamp in the room indicating an intense and long conversation, while light streams in from the window to suggest that the exchange between the three is real and of the moment.

TWR There is so much storytelling in your paintings. In some ways you paint like a novelist. How do you come up with the characters – the city planners in *The Operating Table*, or the two women who appear in *Between the Two my Heart is Balanced* (1991), sitting side by side in a small boat? How are these characters constructed?
LH I watch and listen to people all the time: in shops, in restaurants, on the streets, in parks, on bikes, in traffic jams. I used to teach dozens of students every year at the University of Central Lancashire, and I am passionately interested in how they interact, how they communicate, how they speak or don't speak to each other. I also look at historical European paintings and note how the protagonists are placed and moved, energised across the picture plane. And from my teenage years until now, I have been an avid reader, consuming French; German; Spanish; Russian; British; American; West, East and North African; and South American novels. Novels and poetry have taught me at a very deep level the ways in which people develop and compete, decline, lose

control and survive, and also how they love and despair and forget.

TWR What has it been like for you to make work during the pandemic?
LH At the beginning of 2020, my mother died. I spent the year grieving for her. Lockdown was very useful for me. I couldn't go out. I couldn't travel. I couldn't meet a lot of people and distract myself by looking at exhibitions. I slowed down and gave myself time to think, feel and make work while thinking about her. It was a strange year and a very personal year. I did not stop working. I was already in the process of making *Blue Grid Test* (2020) with the artist Magda Stawarska-Beavan. We made the piece for WIELS in Brussels, and it is 25 metres of found objects that I have painted on. Magda's part of the collaboration is a six-part sound piece about the colour blue and my memories of blue, and the different words in French, Flemish and English for blue. Magda has woven this almost into a song, and in the background, a friend of ours is playing the piano part of Joni Mitchell's song 'Blue' (1971). So I was very immersed in this work, in finding the found objects, in painting them, talking to Magda about how we would make this piece and what collaboration even was. Both of us are visual artists, so we would talk about ways of painting, printmaking, seeing, listening. I lived inside of that for many months.

TWR Over the past year, prominent Black American, South African and British artists, including Dawoud Bey, Zanele Muholi and Lynette Yiadom-Boakye, have had shows at major institutions. These have been called retrospectives. What do you think of the category?
LH I go in quite a dutiful way to see retrospectives. When the artist is already dead, they are predictable. You start with a work made after art school, and you progress in this linear way to the last paintings the artist made with her assistant holding the brush. That might be physically how it happens, but it isn't developmentally how it happens. It isn't spiritually and creatively how it happens.

TWR How have you found navigating the British art scene over the past 40 years? Do you feel that, in the past, certain institutions were not interested in you and your Black contemporaries?
LH Institutions in Britain have been recognising

my work on and off for all of those 40 years. But just in a particularly contained way. In 1985, I curated a show called 'The Thin Black Line' at the ICA in London, which featured 11 Black and Asian artists: Sonia Boyce, Veronica Ryan, Maud Sulter, Claudette Johnson, Sutapa Biswas, Chila Burman, Marlene Smith, Brenda Agard, Ingrid Pollard and Jennifer Comrie and myself. The curatorial agenda was to showcase some of the Black women artists making strong and dynamic work at the time, and I wanted to highlight how different each artist's practice was from one another. The show in a sense said, 'We have arrived and we are here to stay.' The minute that show hit the walls, the British art establishment was talking about it. It was an incredibly important show, and people knew it. Ever since that time, I've had shows in public galleries in the regions of Britain, or I have been in group shows in places like the Hayward Gallery or the Whitechapel Gallery. I was always aware that I was on the radar of important curators in Britain, but they did not give me a public show at Tate Modern 21 years ago when it opened. They knew the work, they just held back. One of the reasons it's happening now is because I stayed alive long enough. I kept making things. And then there's the fact that feminist art historians have been writing about my work for decades. There was a solid underpinning that has allowed it to be called art of quality.

TWR Were these writers important to you conceptually, or in terms of your painterly process?
LH Women like Griselda Pollock, Jane Beckett, Dorothy Price and Rosemary Betterton asked very deep questions that I would attempt to answer, and they would respond to. These historians really interrogated what I was making – that was the way they were trained. They would say, 'You use this kind of purple in this kind of painting, and this pattern keeps recurring.' Or, 'When you paint women they seem to be doing this.' I never really thought in such a close way about what I was doing until they started to ask these questions. I understood that I did have answers, that I could answer, and that I was capable of shifting, changing and developing, too.

TWR You have often described yourself as a 'cultural activist'. What do you mean by this?
LH When I curated 'The Thin Black Line', two people – a student and a curator – called

me a 'cultural terrorist'. I was very angry because I was never, and have never been, interested in destroying anything or frightening anybody. I am not about terror. I was making an exhibition with 10 Black and Asian women in a corridor in a very prestigious exhibition space, but I was not trying to kill anybody. I think the experience of being called a cultural terrorist made me want to turn the phrase around. My entire life has been about brokering dialogue, and I am interested in making work that helps to open conversations and negotiations. That's how the idea of being a cultural activist came about. I refused the term cultural terrorist.

TWR Your name is frequently associated with some of the most important Black art movements in Britain, including the Blk Art Group (formed in 1979) and the Black Audio Film Collective (formed in 1982), in which the filmmaker John Akomfrah was a prominent member. To what extent were you involved with these groups?
LH I never set up any kind of collective or group, nor did I ever belong to one. But I was a part of many conversations and dialogues around spaces like The Black-Art Gallery on Seven Sisters Road in London, and the activities in Brixton, or what the Blk Art Group was doing in the Midlands. Some of the members of the group are my oldest friends, so I've been going to their shows and admiring their work for a long time. I was very aware of the bigger structures of the British art world, and I felt my task was making space. I saw myself as part of a bigger strategy. These days, if you go to a show by Lynette Yiadom-Boakye or Claudette Johnson or Ingrid Pollard or me, you will see audiences of colour in the gallery. I would say over the last 40 years, we have changed the audience for art. Policy makers may think they changed it, but we Black British artists were very much part of that shift. You can't say to visitors, to children, 'This is an interesting place to hang out,' if you haven't got some confidence that those young people will see some reflection of their lives and their history.

TWR Did curating work in the 1980s – for 'The Thin Black Line', but also 'Five Black Women' at the Africa Centre (1983) and 'Black Women Time Now' (1983–84) at Battersea Arts Centre – change how you exhibit your own work?
LH My theatre background has been important, in that I consider and speak to an audience.

Exhibitions, especially ones I have made of my own and other people's work, don't really work until an audience is in there. I imagine this audience to be a Black audience and actually a Black audience with many women, questioning the work and riffing off it. Before I make an exhibition that has other people's work in it, I spend a lot of time talking to the artists. For a recent show I curated at Hollybush Gardens, with works by Ingrid Pollard, Claudette Johnson and Helen Cammock, we talked about how the work was made; the difference between work made from found objects and collage, or work made with more traditional materials. Because I have worked and trained as a theatre designer, those conversations between practices are more fluid than they might have been if I had a specific training in painting. I do not consider the making of things from clay and the making of things from paper as different from each other. I have always been interested in the everyday. Very often, I make work that deals with familiar objects: painting on plates, jugs, musical instruments, paper bags, maps. I want the audience to come very close to a work, either spiritually or physically, and to not be afraid of it.

TWR There are many subtle and rich references to East African history and culture in your work that get overlooked. You frequently dress your figures in patterns based on kangas, a fabric widely used in East Africa, or exhibit works from your *Kanga* series (2010–), which are emblazoned with slogans and bold patterns. You've also spoken about how, when you visited Zanzibar 43 years after your birth, you realised that you'd been painting sounds and sights you associated with the island nation. How do you situate your practice within the context of African art history?
LH Much of the work I have made, specifically the series of nine paintings, *Zanzibar* (1999), has been an ongoing conversation between myself in England, and myself in Zanzibar – or *not* in Zanzibar, having been born there but having very rarely visited. I feel I've lost my African family since the death of my father and grandmother. I tried all my life to paint the connection back into my life. So, all those patterns, all those kangas, all that sea, is a conversation with my British self, my Zanzibarian self, my Tanzanian self. There are conversations I have with other Black artists, too, who are working in Britain, whose families have variously come from Africa via the Caribbean and back, and we have had conversations about knowing where you come from and knowing what you have come from. In recent years, conversations about contemporary African art and photography with the curator Christine Eyene, who is French and whose family is originally from Cameroon, have helped to open up that context, so that it is now more of public conversation, rather than the private conversation that has always gone on in my head, or on the canvas with myself. I do carry the weight of being somebody from the African Diaspora, who has lost my African family. I don't speak confidently about my origins because my coming here was an accident of history. My father died in Africa, and my English mother returned to her family in Blackpool at the end of 1954, before moving soon after to London. I have tried to belong in two different places at the same time. It is quite difficult to do that.

D. T.,
June 2021

WORKS

PLATES

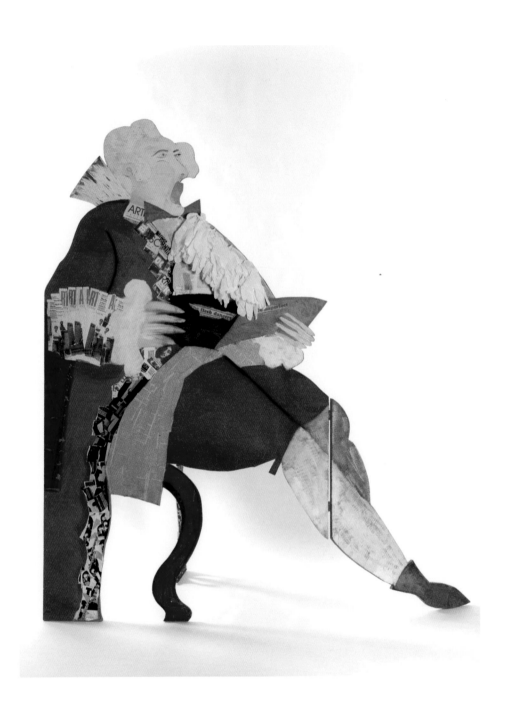

XIII

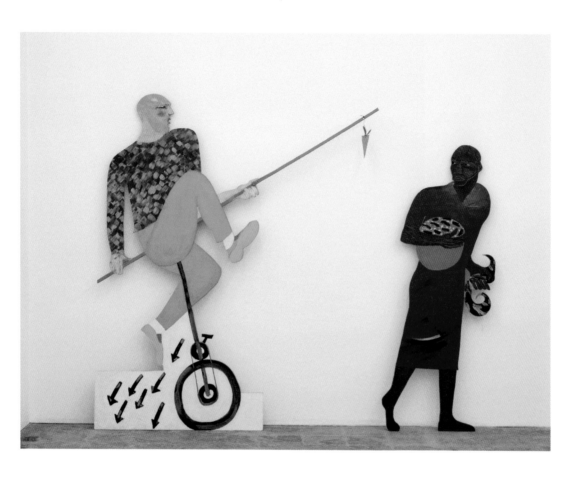

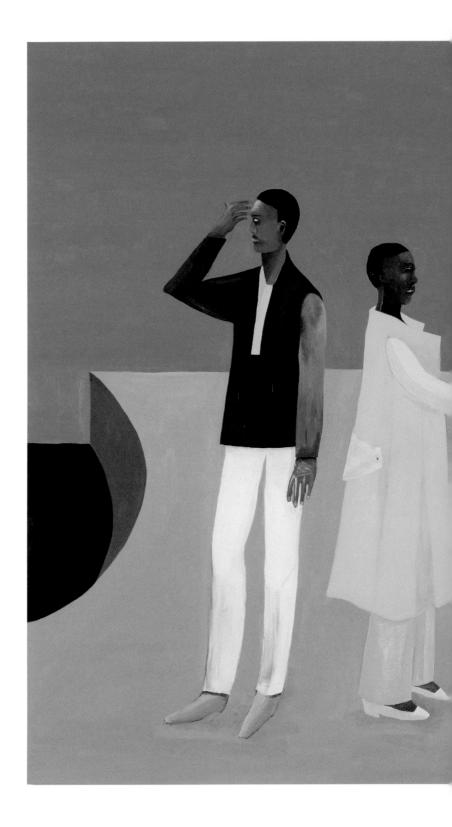

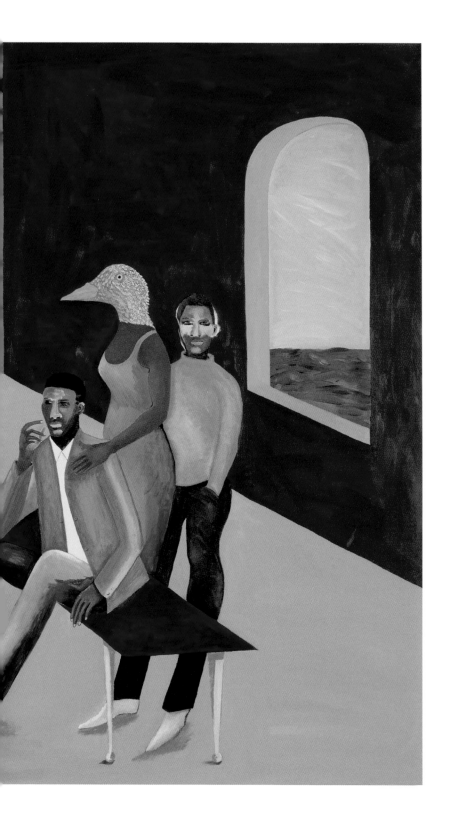

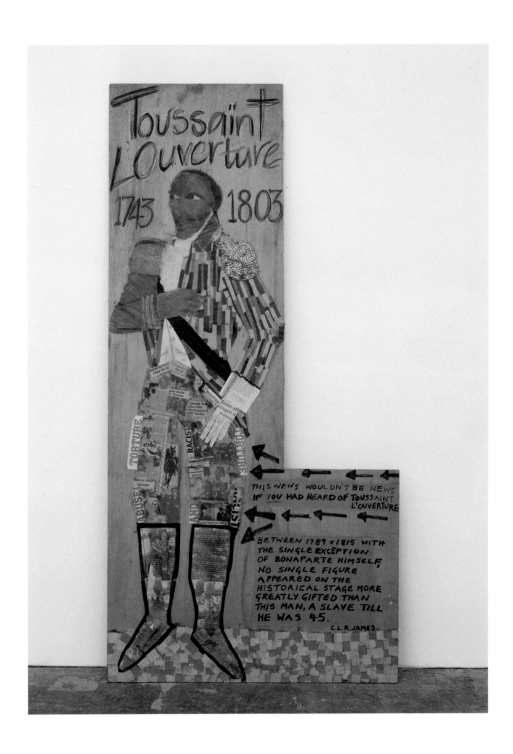

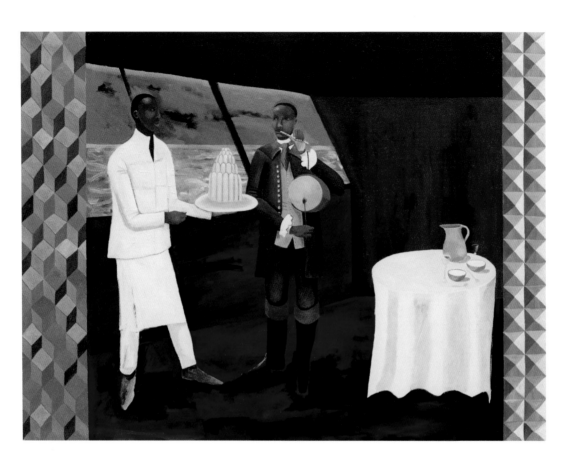

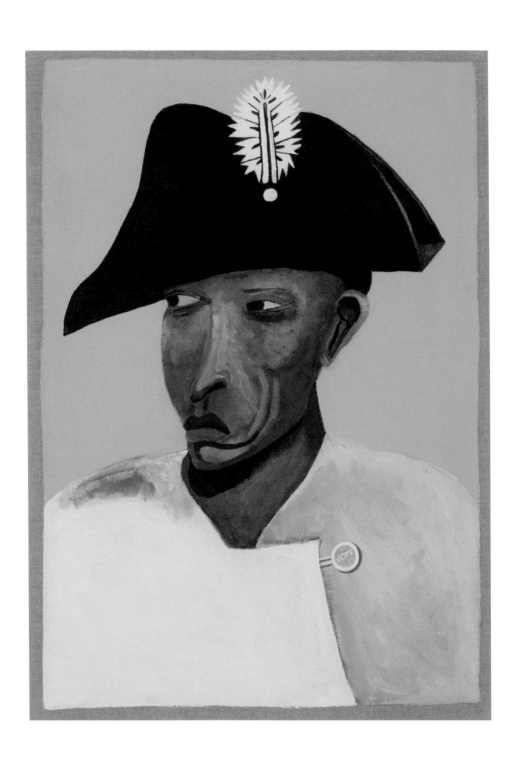

XVIII

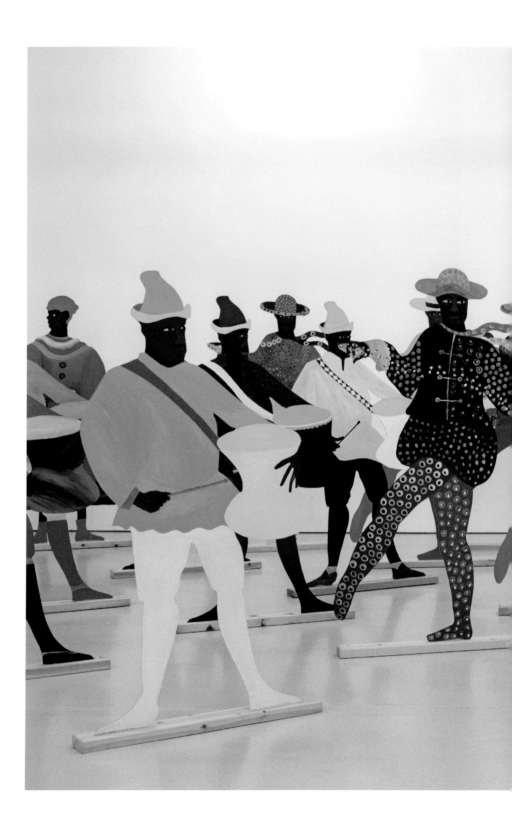

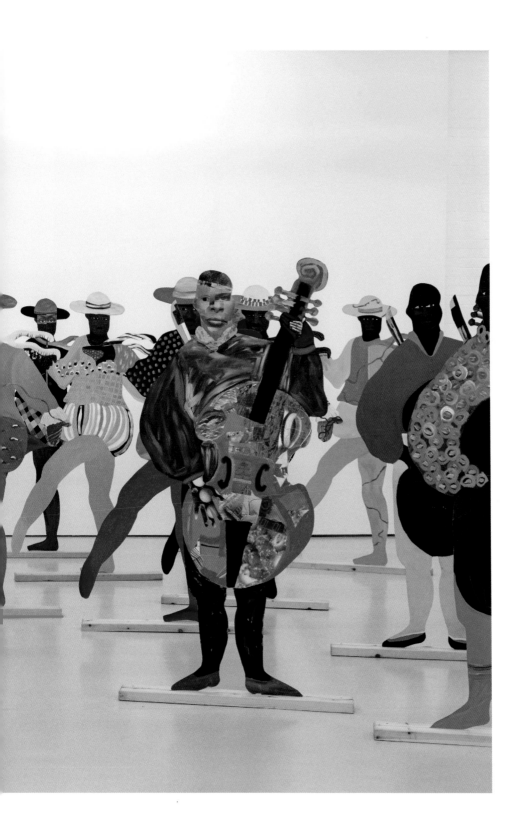

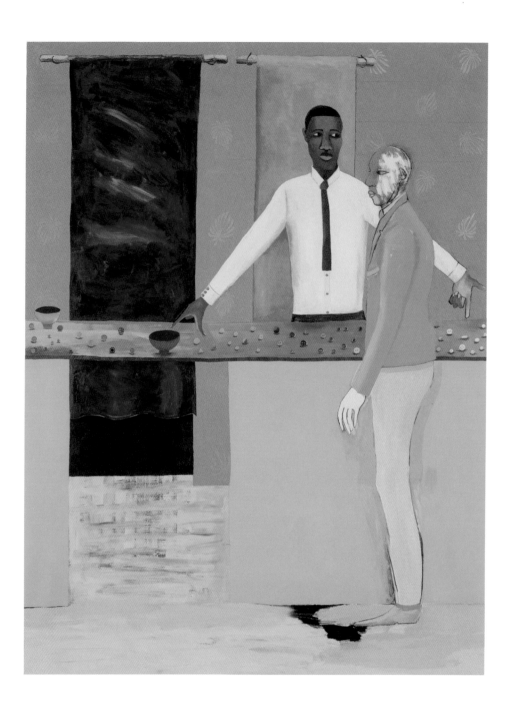

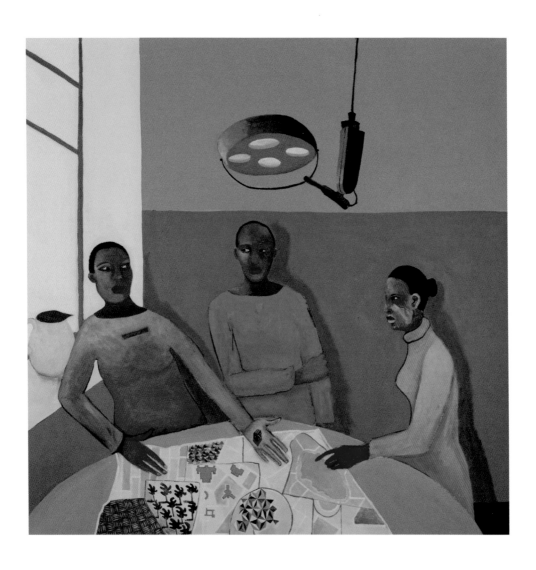

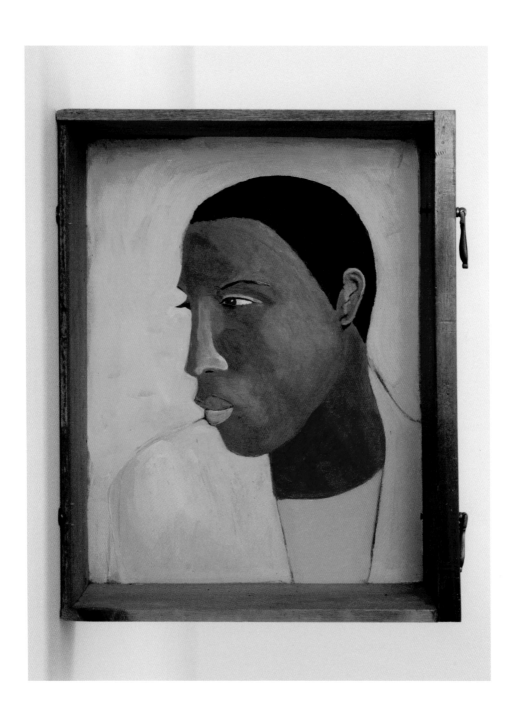

XXII

RAYMOND DE BORJA

SO FACTURE IS THE MATERIAL FACT OF JOY

It is the fifth of April 1976. As an alternative to concrete response, which can be violent, and to transcendent response, which can be detached, Agnes Martin speaks of an abstract response. 'We are in the midst of reality,' she says, 'responding with joy.'

It is the seventeenth of May 1961. For the *Group for Research on Everyday Life*, Guy Debord clicks on his tape recorder which begins to deliver his prerecorded lecture.

But while everyone agrees on the being of reality, Debord needs to insist on the existence of everyday life, despite the sociologists.

Can we say that this altering of our experience of a lecture is responding with joy?

In Agnes Martin, the experience of joy is elusive because it is rare.

In Guy Debord, we find life that is structured by the scarcity of free time.

It is everyday life which gives reality and joy a palpability. A sociality which renders the unlikely union of Agnes and Guy in a sentence: We are in everyday life responding with joy – an experience that is scarce and rare.

This sentence requires a studio where we can wait, or where we can walk –

A willed reception, a radical waiting; we wait for falling blue;

Or we walk up a fire exit because the rusting on its rails appears like a cloud of burnt sienna, a radiating color field, then we find a satellite dish. We break away from our dérive, each with the task of bringing back a microwave oven.

For elusiveness, attention.

For scarcity, choice and risk.

So Martin's *Gabriel* is attentively looking at the virtual from the actual, and seeing, for 78 minutes through the beach and the mountains, horizontal bands of color. While in Debord's *La société du spectacle*, it is montage after montage of text spliced to image that forms a spectacular whole.

We can trace a common thread of generosity running in these studios. When Agnes Martin speaks of joy, it is joy factured in everyday life.

An 'awareness

of the profound richness and energy abandoned in everyday life inseparable'

from an 'awareness
of the poverty of the dominant organization of this life.'

So we quote Guy Debord.

But Agnes cautions us on the experience of others: we are 'in reality at a stand-still, because their experience is in the past.'

Which is why we respond with the lyric,

and in choosing the lyric, live with a text long enough, attentively enough, to begin to imagine for it, more than this experience, a prosody, a text inscribed in present time.

This requires a studio, where we can cite and quote, that persists in the present. Citation as site, and facture as the material fact of joy.

Grids

to mark that we have located something which we cannot possess; that is not knowledge; we are happy.

Grids unquote.

For morning, for falling blue, for loving love

for earnestly pondering slight alterations of usual procedures

 the everyday right here *How*

is our life

BETWEEN THE MAKING OF THIS MOVE AND THIS MOVE

Then left to the quiet of gesture. The shoulders see to it that the arms see to it that the hands. The hands, the fingers. The fingers time, space, then intensity.

'And I don't know whether I can go back again to abstraction,' says Trisha Brown after working on Claudio Monteverdi's *L'Orfeo*.

The Monteverdi, whose *chorus of spirits* makes Trisha pace around her studio, asking herself 'what is a spirit, what is a spirit', makes her find a vocabulary of movement without

bone structure, that is smoke, intensity

draws forward the head
where the body, while, where the distance
between gesture and movement is a note

or a fullness of presence.

And the distance between gesture and writing is the sign
as the sign for itself.

Dear Jean, we are
lost in the repetition, a color,
or a phrase of movement

recalls to us *Écriture Rose* by Simon Hantaï –

which begins green,
begins black. Hegel: *In making its
inorganic nature organic
to himself*

and taking possession of it for himself. Looked at, however,

Ends in black. Maintains the missing.
And the quiet is the fold.

Where what is accomplished in writing
is the color rose.

It is after parting ways with surrealism that Simon Hantaï begins his work with folds, begins the search for 'an unremarkable painting'.

'The underpinning of my work is to create an architecture that is solid,' says Trisha Brown 'so the audience will know what the changes are.'

In working with Bach's *The Musical Offering*, Trisha returns to the question 'What is a theme?' takes a walk thinking 'what is a theme, what is a theme'.

It is fifteen years after withdrawing from the art scene that Simon begins work on *Travaux de lecture* as requested by his friend Jean-Luc

copying, re-copying, copying, re-copying Jean-Luc's and Jacques's

until an unreadable manuscript results on the stiffened and crumpled batiste.

Mailed to Jean-Luc as a gift in March 2000.

Word is where the work turns
is read as color is relation.

So the work
in the economy of the gift must be held in relation
may be word.

Silence whose rigor is a kind of sensuality
and whose sensuality is a line

Asked to put our arms around the work

The section of Trisha Brown's *Set and Reset* where she dances with Eva Karczag and her gestural movements are mirrored by Eva's balletic motion.

The shadow of the musculature on their backs
from the lighting design
of Robert Rauschenberg.

Dear Jean, we are chosen for how we sound. Dance means deixis as a fullness in the present.

Before Simon Hantaï's silence, some shorter silences, and several pliage works: *Études et blancs, Tabula* –

which Simon destroys, buries and, after his return from silence, unearths and makes into new work which he calls *Leftovers*.

There is a photograph of Trisha Brown performing *Watermotor* (shot by Babette Mangolte) where she seems to be moving simultaneously to her left and to her right.

'My father died in between the making of this move and this move,' Trisha finds herself saying in a performance of *Accumulation with Talking Plus Watermotor.*

In lieu of a biography, Simon Hantaï includes in the catalogue of his 1976 retrospective a photograph of a large unfolded painting and a grainy, black and white picture of his mother wearing a dark, creased, gridded tablier.

'And I don't know whether I can go back to abstraction again,' Trisha Brown says after working on *L'Orfeo.*

A HOUSE COLLAGED WITH PITCH CLASS SPACE

Daylight glosses the living room floors of M and Mme Leiseville at 27-29 rue Beaubourg.

Daylight at a doorless threshold, from several iterations of Les Halles, from the construction site of the Centre Pompidou.

Daylight at the rubble-edges of Gordon Matta-Clark's *Conical Intersect*.

Then daylight at the apex, collapses, of a person's cone of vision.

We expect the high-pitched ring that accompanies suddenly something bright

instead of silence annexed to shimmer, interior glow, found sounds, an audience pointing to the sun and a critique of modern housing.

Cones of vision and funnels of hearing emanate from an audience, transform the light-holes into points of articulation.

Construction sounds enter our gardens.

Passersby with their wobbly cones and funnels escape analysis.

The 'particular agony' that Tōru Takemitsu finds 'in the sound of the door someone closed' is our hearing in place of analysis.

We are when our geometric imagination meets social space, a schematic diagram of a house collaged with pitch class space.

The semi-circular incisions across floors, ceilings, and walls involve chisels, saws, hammers, and an extraordinary amount of sound.

'Gardens are constructions of space,' says Takemitsu, 'so really what I do is compose gardens with music.'

Gardens with construction sounds strain toward the present.

Perhaps, a light-split wall is how composition intersects construction as the immaterial spatially arranging,
or a movement where the phrase sustained by an oboe continues to the shō.

The moments after his dream, where Tōru begins to compose *A Flock Descends into the Pentagonal Garden.*

A shape that is a modulation, and not a modularity.

A morning, when we are, where construction is composition.

The shape that sound acquires from trusses, rubble, incision, this pastoral's dream content, our found ways of being, Dear Jean, the varied surfaces of our listenings, 'a lyrical cutting through'

suffused with light, where dream and labor intersect.

INSECT WOMAN
POLLY BARTON

ESSAY

I'm standing outside a convenience store in Shin-Ōkubo, dressed as a stag beetle.

For a while now, my friend M and I have been working on a film made up of various short snippets, stitched together to recreate the experience of flipping channels in a very strange hotel, or floating through the galaxy and tuning into different alien frequencies. Today we have been shooting footage for one such snippet: a karaoke video to a song by the artist Jun Togawa, called 'Mushi no onna' [Insect Woman]. M is a seasoned film-maker who has come up with most of the ideas for the various snippets, but this is one that I've dreamed up – an idea, in fact, that I've been wanting to realise for some time. Living in Japan, karaoke has become one of my favourite pastimes, and I've spent a lot of time watching karaoke videos – marvelling at the various features that define the genre and, particularly, at the peculiar brand of wistfulness that is a hallmark. Now we are trying to reproduce this wistfulness within an insect context, creating a karaoke video for a song I have become obsessed with. The video tells the story of a boy and a beetle who were once together but are now apart and pining for one another, each continually passing the other by without noticing.

To transform myself into a beetle, I have constructed a big, horned headdress out of cardboard, painted brown, with an open hole in the centre into which my face slots. M is wearing a purple sweatshirt and shorts, socks and sandals on his feet. He is also carrying a four-foot long insect-catching net, which I bought at a DIY shop where I live in Osaka and carried down on the bullet train to Tokyo. Travelling with it, wedging it into the overhead luggage rack, along with the oversized headdress wrapped up in a bin bag, earned me lots of strange glances.

What I love about filming with M is all the improvisation. We decide little in advance about the shots we want, tending instead just to turn up in a place together (we live in different cities) and let things happen. Tonight, we are wandering around late-night Shin-Ōkubo, a district of Tokyo with a large Korean community, filming one another. In the shots that need to include us both – a favourite one of mine features us using back to back pay-phones, oblivious to one another's presence – we have to find a suitable surface to rest the camera on, or set up the tripod. Shooting the film can be tiring and challenging, but it is also a cathartic experience in a way I wouldn't have anticipated. I am in my early 30s and living in Japan now for the second time, after an initial stint of teaching here at the age of 21. Some of me loves being here, and yet the pressure of being noticeably different from people around me and having that difference constantly reflected back at me is something I find fathomlessly tiring. I've always struggled with feelings of being strange, unacceptable, different, but now these perceptions feel like verifiable facts, and that's exhausting. It's a species of exhaustion that needs periodic release: that's what the karaoke is about, in part. But another, and arguably more targeted, form of release comes from dressing up and filming in this way – exaggerating and owning our weirdness, taking it out on the town, in a manner that feels liberating, even celebratory.

The improvisational nature of our filming process means it's hard to say conclusively when it's a wrap. In this case specifically, to judge when we're sure we've got enough decent footage for the 5 minutes and 29 seconds of Jun Togawa's song. But when we've been at it for over three hours, we can't think of any more shots we want. We're done, we say, let's say we're done, and we stop off at the convenience store – or combini, as they're commonly known here – to have a pee and buy a drink.

It's a big combini, set off from the main road with a car park, and sitting on the ground outside the entrance is a man who appears to be homeless. His clothes are rumpled, and there is a glass of sake perched in front of him on the concrete. As we make our way in, he glances up at me, and after a second, his face breaks open into a look of outright fear and pain. '*Kimoooooi*,' he says – *grooooooss*. He says it in a plaintive, drawn-out voice that makes him sound genuinely like he's about to cry.

My friend and I exchange a look and scurry inside the shop. Once among the racks of drinks and snacks, we start to laugh almost hysterically. As happens on so many occasions in Japan, I feel and think so many different things at once that I struggle to process my impressions.

I feel sad for the man and guilty for causing him discomfort. Appended to this guilt is the consciousness that the word kimoi, or some variation of it, is one that is often applied by other people to the homeless. I also feel a sense of surprise at the man's reaction, because disgust towards insects is something I encounter far less over here. Apart from the notable exception of the cockroach, which seems to be universally unloved and feared, the general attitude to insects registers differently in Japan than it did back home in the UK. Shinto, Japan's native religion, is animist in nature, and the innumerable kami, or deities, are powerfully connected to all aspects of nature; in Nara, a southwestern city near Osaka, a seventh-century miniature shrine dedicated to the tamamushi, or jewel beetle, was decorated by encrusting its surface with iridescent beetle wings. The other principal Japanese religion is Buddhism, where a sense of porousness between different types of beings can be found, too. This originates from the understanding that we as humans can, and frequently do, cease to be human and become other – specifically, that we can transition in and out of the insect realm through the cycle of reincarnation. This all stands at odds with the steadfast anthropocentrism running through the Judeo-Christian tradition and the sense of an untraversable difference between humans and other creatures, particularly those less humanlike in form.

I think of Patrick Lafcadio Hearn, a writer of Greek-Irish descent who picked up on this openness towards insects when he travelled to Japan in 1890, at the age of 39, and remained there for the rest of his life. He wrote that there was 'something spectral, something alarming in the very beauty of insects', and declared that, if he was made 'to hereafter live the life of an insect, I'm not sure the prospect would frighten me'.[1] In a series of essays, published under the title *Insect Literature* (1921), he collected translations of a selection of the numerous examples of Japanese haiku about insects. So we encounter, in his translation, poet Sakurai Baishitsu on the cicada (or sémi, as it is known in Japanese):

Yū-tsuyu no	Will the sémi
Kuchi ni iru made	continue to cry until
Naku semi ka?	night-dew fills its mouth?[2]

We also encounter the famous eighteenth-century female poet, Chiyo of Kaga, after the death of her small boy:

Tombō-tsuri!	Catching dragon-flies!
Kyō wa doko made	I wonder where he has
Itta yara!	gone today![3]

Finally, I think of Kobayashi Issa, known as one of the four great haiku masters, here in Robert Hass's translation:

Sumi no kumo	Don't worry, spiders,
Anji na susu wa	I keep house
Toranu zo yo	casually [4]

This tendency to lavish attention on insects and conceive of them as either channels for human sentiment or subjects of empathy in their own right is not the exclusive preserve of poets dating back hundreds of years. Again and again, I have noticed it pervading the attitudes of the people I have encountered in Japan: a lack of squeamishness I find very attractive. So when the man outside the convenience store calls me *grooooss*, I'm taken aback. I don't expect an impromptu haiku about the beauty of my beetle costume, but the intensity of his reaction surprises me. Has he confused me for a cockroach?

Alongside this surprise, there's a part of me that's thrilled by the man's revulsion, too. I didn't know this part was lurking until it raised its head, wouldn't have predicted this sense of defiant delight, but it announces its presence unequivocally – so unequivocally, in fact, that it points me to the reasons for my desire to dress up as a beetle in the first place. The reasons, also, behind my immoderate love of 'Insect Woman', the song we are making the video for, and the way that its singer, Togawa, plunges whole-heartedly into identifying herself with an insect. I haven't dressed up as an insect so that men will call me gross, exactly; the motivation feels more blurry than that. I want to mess around publicly with ideas of beauty and gender and age and disgust, and I want to do so through an invertebrate lens. Even if the impulse is convoluted, the proof of success feels remark-ably clear: as bad as I feel about it, this man's repulsion has validated that I've become an insect woman, just like Jun Togawa before me, and that is something I want to hold on to.

*

My affiliation with insects didn't exactly begin with my discovery of and fixation with Togawa during my 30s, but nor has it always been there; it feels contemporaneous with my first arrival in Japan in the early 2000s. Having travelled from London to the remote island of Sado, one of the many awakenings that I underwent was an entomological one. Suddenly, I became aware that insects could be not just noisy, unnerving and poten-tially perilous invasions upon my consciousness, but also presences of darting, quivering and ephemeral beauty. I was enamoured by the blood-red and indigo dragonflies hovering in my line of sight before zigzagging silently away, mesmerised by the jewel beetles lying on the road, outraged by the amount of noise that the cicadas made and thrown into utter confusion the first time I saw the great piles of their cast-off exoskeletons attached to tree trunks. All of these new additions to my personal insect roster seemed somehow like emissaries from another world. I suppose that their unfamiliarity helped in forming this impression, but it wasn't just that. There was something in their appearance and their movements that signalled the functioning of a different logic to the one I knew – a world that was iridescent and endlessly surprising. One May evening during my first year, I went with friends to a valley known for its firefly population. Watching its murky contours gradually come alive with green points of wavering light, I knew with absolute certainty that the world was

a magical place, and that I'd needed to get away from the country where I'd grown up in order to fully sense it.

Alongside this avenue of discovery, I was also fascinated by the way that insects made an appearance within consumer culture. In Japan, far more than in the UK, it was commonplace for young children to have a bug fixation, and this was reflected in what I saw around me. At DIY shops, they not only sold nets and carrying cases for capturing insects, but also displayed a wall of glass cages housing enormous live beetles for sale, that children would buy to keep as pets. These, I learned through talking to the parents of young sons, would be used by their owners to stage fights with their friends' beetle-pets. Suddenly all the iconography that I saw splashed across colouring books, pencil cases and kids' t-shirts, with beetles rearing up in fighting poses like robots and superheroes, made sense. I found myself drawn ineluctably to the aesthetic of it all.

At the same time, it didn't escape me that insects, as they were refracted within the culture, were a clearly gendered and child-specific phenomenon. It was only the boys' summer kimonos that were dotted with stag beetles, only the boys who bought insects from the DIY stores and kept them in cages, or who went to the park to hunt for bugs. When I bought badges with insects on and wore them, people looked at me strangely, laughed nervously. This disjunct between my age and my gender, and the insects to which I felt magnetised, wasn't a cause for distress on my part – mostly, I suppose, because there were so many ways that I failed to match up to ideas about what adult femininity consisted of in Japan that it seemed ludicrous to even try. In fact, in the beginning, I found my inability to live up to feminine standards liberating. There on the island, I was so other, and I flouted the requirements for what a person should be so holistically, that I didn't feel the grip of gendered expectations until my second, longer, stint living there.

Yet it was only years later, upon encountering Jun Togawa, the Insect Woman, that it fully occurred to me that this disjunct could open up new possibilities for ways of being in the world.

*

Jun Togawa is a Japanese new wave singer who recorded her first solo album, *Tamahime-sama* [Princess Tamahime] in 1984. She had made her debut as a singer two years prior with a band called Guernica, in an album produced by musical visionary and Yellow Magic Orchestra member Haruomi Hosono. He collaborated on *Princess Tamahime*, too, singing in the chorus and writing one of the songs.

Providing this kind of factual exposition of Togawa is easy enough; what is far harder is attempting to summarise what she stands for, aside from a kind of semiotic chaos. Her multiplicity is exhibited most notably in her live performances, where she cycles between dressing as a miko (a shrine maiden understood historically as a shaman), a princess in fuchsia, a primary schooler, a man in sunglasses and a superhero called Barbara Sexeroid. It isn't just her attire, either; even within the bounds of a single costume, she seems to shape-shift, depending on what particular facial expression she is pulling at that second. Drawing influence from Andean folk songs and classical repertoire, her vocals veer between operatic vibrato, childlike hymnals and violent yelling. Her lyrics are often littered with body parts and excreta, as well as psychological and philosophical terminology. In one of her greatest hits, 'Suki suki daisuki' [Love you love you LOVE YOU] (1985), she sings of 'a direct perception of anti-

nihilism' and 'latent infantile violent tendencies'. At a time when the first wave of idol culture was cresting, and seemingly every other female in pop dressed in pastels, wore a perma-smile and sang exclusively of romance, Togawa offered an alternative vision of what a woman in music could be: deranged, heroic, kaleidoscopic.

In a promotional video from the 1980s, Togawa informs us that her debut album is about menstruation – in her words, 'taking menstruation as the starting point for an exploration of eros'. But, if the album is ostensibly about periods, it's also oozing with insects. The cover, for a start, is a multiple-exposure photograph of Togawa wearing dragonfly wings; where the dragonfly figures overlap, they are cast into darkness. The image reminds me of the oneiric photograms made during the 1920s by photographer and Bauhaus professor László Moholy-Nagy; the two share a blurred, drifting quality that demonstrates, better than any high-res image could, how a photograph is a single moment plucked from the flow of time and light. Togawa's multiple-exposure photo inserts the motif of the insect within this realm of shifting ephemerality, where all permanency is turned on its head, and where a four-winged dragonfly would be sovereign.

The third track on *Princess Tamahime* is titled 'Konchūgun' [Beetle Army] and tells the story of an invading troop of insects, from the perspective of one of its members: 'I'm a beetle, an invertebrate / Compound eyes, no brain / Insides shrouded in chitin / Never experienced rationality.' As the song progresses, the actions of the insects described in the bridge progress in grammatical form from description – 'Crawling along the streets / Clinging on to buildings' – to imperative, delivered in the manner of an army commander: 'Blot out the sky! Take over the station!' Here, and throughout the album, Togawa toys with concepts of otherness and empathy: not just singing about beetles, in a way that would be unheard of for the other female singers of her time, who invariably sang of romance and romance only, but doing so from the beetles' perspective, aligning herself with them in a way that seems calculated to summon in its listener both alarm and a reevaluation of where they fall on the us-and-them divide. Only this time, articulated via entomology.

The standout insect paean in *Princess Tamahime* is its final song, 'Insect Woman': the song for which I made the video. It tells the story of a woman who pines for her lover for so long that she becomes a cicada chrysalis, set to the tune of 'Pachelbel's Canon'. The opening refrain to the canon rings out in a plaintive pizzicato, and then comes the voice, high and sudden as a clarinet:

Gekkō no shiroki hayashi de	In the white of the moonlit forest
ki no ne horeba	dig at the roots of the tree and
semi no sanagi no ikutsumo	out come the cicada chrysalises
detekishi	one after another
aa aa	ahh ahh
sore wa anata o omoisugite	that is what I have become
kawarihateta watashi no sugata	after wanting you for too long

Somehow – and maybe this has something to do with my comprehending Japanese but not being a native speaker – I hear the first word, 'moonlight' (gekkō) and a confusion takes place in my mind between medium and meaning, so that Togawa's piercing voice becomes a single ray of moonlight, soft, sharp and secret. As with so much of Togawa's oeuvre, the song seems to stage a war between parody and earnestness

and emerges from this conflict on a higher level: truer and more vibrant than either.

Here, once again, the insect is not just topic or motif, but an identity claimed:

> By the time that you finally get to noticing me
> this girl who has become a caramel-bellied insect
> will have strange grasses growing from her
> stems of sadness extending from her caramel back

Differently to 'Beetle Army', what emanates from both the lyrics and from Togawa's delivery, is the sense that this cicada isn't just one in an endless cycle of costume identities. It seems to have the ring of a truer, more permanent guise.

<p style="text-align:center">*</p>

There are various ways of reading Togawa's venture into insecthood. Probably the most ready-to-hand of these, certainly for a Western listener, is that it marks a deliberate venture inside transgressive territory. In her songs, performances and conversations, Togawa persistently goes to places that other female artists won't and don't go – menstruation, for one, but also sweat, urine, eyeballs, insects, cum.

A second interpretation might pull in precisely the opposite direction: the insect occurs in Togawa's oeuvre as a symbol of purity. This reading gains traction from the fact that the insect Togawa finds herself becoming, in her opus of unrequited longing, is the cicada, a being whose purity has been multiply noted. In his piece 'Sémi' (1900), Lafcadio Hearn quotes the account of 'The Five Virtues of the Cicada' by the celebrated third-century Chinese scholar, known in Japanese literature as Riku-Un:

> II. —It eats nothing belonging to earth and drinks only dew. This proves its cleanliness, purity, propriety.
> III. —It always appears at a certain fixed time. This proves its fidelity, sincerity, truthfulness.[5]

Hearn then goes on to note that there is much overlap between this and the account of the Greek lyric poet Anacreon 'written twenty-four hundred years ago':

> We deem thee happy, O Cicada, because, having drunk, like a king, only a little dew, thou dost chirrup on the tops of trees. [...] And old age does not consume thee. O thou gifted one – earth-born, song-loving, free from pain, having flesh without blood – thou art nearly equal to the Gods.[6]

We could thus see Togawa's transformation, at least within the bounds of 'Insect Woman', as borrowing the purity of the cicada to give expression to the extremity of her feelings: an unwavering devotion that cannot be manifested in the human body anymore, and has to take on a form 'nearly equal to the Gods'.

And then, there is a third way of comprehending what lures Togawa towards the insect realm, a broader and more complex reading, which transcends both of these analyses even as it incorporates them: an understanding of her insect fixation that might sound arcane when spelled out,

but which I feel that I'm guided to intuitively, for the simple reason that I feel it in myself as well. The insect as a new home, apart from the constrictions of the human body; the insect as an escape from the confines of the other identities forced onto her: young woman, pop star, romantic object. It is still the carapace of an identity, but it is a roomier, more comfortable one. It is still a site of performance, but importantly, it is one where performativity is recognised. She is not expected to be a natural insect, and so she can inhabit the role freely, without the spectre of naturalness hanging over her. In this reading, it isn't a coincidence that 'Insect Woman' is the song that feels the most ethereal of all Togawa's work. It transcends the transgressive, the provocative, and comes from a place of need.

*

In 1984, the same year that Togawa released *Princess Tamahime*, she published a compendium of photos, lyrics, short stories and autobiographical essays under the title *Jueki susuru watashi wa mushi no onna* [I am a Sap-Drinking Insect Woman]. The first of her essays – the first piece of writing in the book, in fact – opens with Togawa describing what a 'lucky baby' she was, for narrowly escaping Thalidomide poisoning and a fire that ravaged the hospital in which she was born on the day after her mother was discharged. She then goes on to give a portrayal of her less-than-lucky childhood – she was a milk-guzzling, sturdily built, sincere and well-meaning child, and starting school came as a shock. It turned out that nobody else was as artless as she was, and it wasn't long before she was comprehensively made fun of and bullied, to the point that she came to resent her parents for not teaching her to be more worldly wise. She went on to develop obsessive-compulsive disorder and pined after the other boy in the school who also suffered with it.

There is something both dreadful and thrilling about reading Togawa's writing: the way her terse, Shirley Jackson-like prose seems to combine a blithe lack of guile with a foreboding darkness always perched just around the corner. And so, as she describes a brief period of excitement and happiness at being a pubescent girl – apparently freed for a little while from the traumas of earlier childhood – the reader begins to feel a kind of morbid dread. From around her fifth year in primary school, Togawa says, her mother gave her nylon pants to wear, and these pants played a major role in shaping her pre-teen experience. Whenever there were health checks or similar occasions where she'd strip to her underwear in front of others, the girls in her class would tell her how grown up she was for wearing pants like that, and she felt herself to be a supremely sexy creature. And really, for a pubescent child, she writes, there is nothing better in the world than to feel yourself as sexy. 'But then one day,' she continues, 'something bad happened. I was groped by someone in the park, and the next morning, while the shock of that had still not worn off, I got my first period. I suddenly began to hate the idea of growing up, and of getting older.' After divulging how, for a while, nightmares and flashbacks to the groping incident kept her awake at night, Togawa says: 'When my second period came, I felt like I'd come down a path from which there was no return. And I decided to find a way home.'[7]

What Togawa says about her childhood resonates deeply with me. I too was sturdy and well behaved, and being around others who weren't as guileless as I was came as a shock. Particularly Togawa's description of suddenly being shaken from safety by the spectre of impending

'womanhood' reawakens memories inside me – not of events or sights or sounds but of feelings and impressions of the world, that seemed at the time not just hard to articulate, but made of the wrong sort of stuff entirely to ever allow their proper articulation. I wasn't molested in a park the day before my period came, but I can remember with great clarity the time when being sexy went from a fun game among girlfriends to being a very serious game, at which I, as a prospective woman, was suddenly required to throw my life at. More than that: it was a game that was now supposed to constitute the overarching majority of who I was, a game that was going to claim my personhood. Even as a pubescent girl I knew that, and I hated it, and though I didn't put it to myself in those words, I wanted a way home more than anything.

And so, the interpretation that presses itself on me with some urgency is that for Togawa, finding a way home meant becoming very specifically the person, the performer, that she was – the insect woman that she is. That in performing, playing dress up, constantly oscillating between different images, and somehow finding, amid those oscillations, the space to be free, she hit upon some alchemical formula whereby she had solved the impossible paradox of becoming a woman and remaining herself. She had found the solution, not in any cracking-a-mathematical-proof way, nor with any succinct technique or simple quotable formula, but through a series of transitory experiments that together added up to something like a methodology – a methodology as personhood. I don't think it made her happy – it feels hard, reading through her various essays, to believe that she has ever been happy for very long – but I think it did in some way take her home. And paradoxically, that homecoming assumed completion when she exited the human form entirely, and became cicada.

*

During the beginning of my first stint in Japan, around the same period that my insect feelings were coming into bloom, I developed a tremendous crush on an American boy. We were both part of the cohort of 10 English teachers who moved to the same island at the same time; we were both utterly new there, although he had taken Japanese as his minor at college, spoke a bit of the language, and generally knew a lot more about the country than I did. I remember talking with him about our respective reasons for being drawn to the culture and him telling me of a short story that he'd read at university, that described in depth a young boy and a girl standing facing one another and the play of the red and green light from their lanterns spilt on each other's torsos. It was such a simple story, he said, in the way he had of speaking that was overly earnest but somehow still genuine, and also beautiful. Listening to him narrate the tale, I felt – much like I did on that May evening when I'd gone out to the valley to watch the fireflies, in fact – that even if it was by total fluke, I had ended up in the sort of place I had wanted to be for a long time, where magic happened as a matter of course, and people weren't embarrassed to name it. Even stronger was another feeling: the sense that I wanted to be part of that story for him, whatever on earth that meant. I wanted to be spoken about with such wistfulness and simplicity; I wanted to be something about which he felt so certain. Maybe it was as simple as wanting to be something beautiful to him – but not beautiful in the tricksy, devious way that I sensed he saw adult female beauty. Beautiful like a child, or a lantern. Beautiful like a person.

A whole 15 years later, by now having settled back in the UK, I discover the origin of this story by accident. A young man whom I know professionally emails me in response to something that I've written, and while explaining his own feelings about Japan, he mentions a story from Yasunari Kawabata's *Palm-of-the-Hand Stories* (1920) called 'The Grasshopper and the Bell Cricket'. Looking it up, I find that this is the very story the American had spoken about 15 years earlier, in his room on the island – the story of a children's insect hunt, observed by an older narrator, in which a boy finds what he thinks is a grasshopper and presents it to a girl. Yet when the insect is passed to her, it transpires that it is not a grasshopper, but a bell cricket. The denouement is a scene where the two children's names, which they have cut into their homemade paper lanterns, are, unbeknownst to them, cast upon one another's torsos:

> In the faint greenish light that fell on the girl's breast, wasn't the name 'Fujio' clearly discernible? [...] The girl's lantern, which dangled loosely from her wrist, did not project its pattern so clearly, but still one could make out, in a trembling patch of red on the boy's waist, the name 'Kiyoko'.[8]

Kawabata's storytelling is such that we do not need to know before reading that a bell cricket is rarer or more valued than a grasshopper – the setup conveys that information for us. Yet after reading it, I look up the sound of a bell cricket and find myself watching a YouTube video called 'The voice of Japanese bell cricket', which shows two of the insects sitting in a plastic tub with holes punched in the top, along with some chunks of cucumber. I am no expert when it comes to insect sounds, but its chirruping has a special, almost unearthly quality to it: knowing this makes the children's reaction more comprehensible.

In any case, just as my American friend said, the Kawabata story is an incredibly simple but incredibly beautiful one. And yet when I arrive at the end, I find an abrupt swerve into a gendered, and therefore markedly adult, perspective, which knocks me off balance. Throughout the story, the girl and the boy's interaction is portrayed quite evenly by the narrator, and I feel a jolt when, in the final passage, the narrator switches to addressing the insect-catcher boy directly:

> Fujio! Even when you have become a young man, laugh with pleasure at a girl's delight when, told that it's a grasshopper, she is given a bell cricket [...] Probably you will find a girl like a grasshopper whom you think is a bell cricket.
>
> And finally, to your clouded, wounded heart, even a true bell cricket will seem like a grasshopper. Should that day come, when it seems to you that the world is only full of grasshoppers, I will think it a pity that you have no way to remember tonight's play of light, when your name was written in green by your beautiful lantern on a girl's breast.[9]

I understand Kawabata's narrative decision, of course. The narrator is male, and it makes sense in the cultural context from which Kawabata was writing that such a narrator would identify only with the boy and not the girl. When he talks to Fujio he is, of course, talking to himself, in a way that he couldn't be were he speaking to Kiyoko. I also know that it is precisely this of-courseness which gets under my skin, brings up an itchy sense of claustrophobia. I want the story to stay as it was –

not entirely free of gender, but free at least of these thick, stark lines of separation that the last paragraphs draw.

Yet the sharp division between the worlds of childhood and maturity also brings into focus a commonality between Kawabata and Togawa: although the two approach the insect from different angles, it symbolises for both of them some form of innocence. Specifically, an innocence that precedes a full awareness of gendered relationships, the demands of patriarchy and the schisms that follow. In Togawa, at least, the innocence is not overly romanticised. Maybe it is a kind of innocence that is reached for because of all that has been tainted and ruined before it – all the expectations and crushed hopes that are part of being human, woman, girl. It is a trauma-informed innocence, a place of refuge and refusal.

'To stay human is to break a limitation', writes Anne Carson. 'Like it if you can. Like it if you dare.'[10] If Togawa's transition to insect marks a dissociation from her human form, it would appear to be a disassociation that, perversely, allows her to retain the very qualities we might call the most human: tenderness, sentience and sincerity. In the song 'Insect Woman', it is the pain of invisibility and frustrated longing that effects Togawa's transformation into a cicada, but the place she reaches is one of transcendence and, we sense, of peace. Her emotions might not have changed, but now she is in a form where it is no longer a threat to feel them. It was the longing for a taste of this peace myself – peace from all the nebulous, disquieting feelings of not being enough – that had compelled me to follow in her footsteps. To dress up as a beetle and film a karaoke video for her song, unconsciously attempting to forge some indelible tie between us.

Thinking back now on how it felt to walk around Tokyo in that cardboard headdress, it seems to me I really did get a taste of what it was like to be something else. That something was winged and guileless and permitted to be so, and it could sit out in the open air without being molested or pinned to any particular set of meanings:

Gekkō mo itetsuku mori de,	In the forest where even the moonlight freezes
Jueki susuru watashi wa mushi no onna	I am a sap-drinking insect woman

1 Lafcadio Hearn, 'Gaki' in *Insect Literature* (The Swan River Press, 2020) p. 258.

2 Sakurai Baishitsu, tr. Lafcadio Hearn, quoted in *Insect Literature* (The Swan River Press, 2020), p. 25.

3 Fukuda Chiyo-ni, tr. Lafcadio Hearn, quoted in *Insect Literature* (The Swan River Press, 2020), p. 258.

4 Kobayashi Issa, tr. Robert Hass, https://100.best-poems.net/selected-haiku-issa.html

5 Hearn, 'Sémi' in *Insect Literature*, p. 102.

6 *Ibid.*, p. 103.

7 Togawa Jun, *Jueki susuru, watashi wa mushi no onna* [I am a Sap-Drinking Insect Woman] (Keibunsha, 1984) pp. 14–22.

8 Yasunari Kawabata, 'The Grasshopper and the Bell Cricket', tr. Lane Dunlop and J. Martin Holman, https://www.picciolettabarca.com/posts/the-grasshopper-and-the-bell-cricket

9 *Idem.*

10 Anne Carson, *The Beauty of the Husband* (Jonathan Cape, 2001) p. iii.

INTERVIEW IRENOSEN OKOJIE

Irenosen Okojie's first novel *Butterfly Fish* (2015) follows Joy, a photographer in London who inherits a cursed brass head and her grandfather's diary after the sudden death of her mother. Joy begins to discover a far more complex and tragic family history than she could ever have imagined – and keeps catching glimpses of a young Black woman who looks strangely familiar in the background of her photographs. Okojie's writing twists and shifts the world as we know it, opening up realms of exhilarating and sometimes terrifying uncertainty. Her work is dizzyingly rich with symbolism, metaphor and startling narrative turns, undergirded by a deep understanding of human frailty and empathy for her characters.

Okojie's darkly funny, tender and surprising short story collection, *Speak Gigantular* (2016), features two ghosts trapped on the London Underground, a young woman with epilepsy determined to solve the disappearance of her neighbour and an altruistic bank robber dressed as a big yellow bird. Characters faced with challenging situations like unemployment, grief or incarceration find themselves plunged into bizarre but revelatory experiences, including being rescued by statues or enlisting a helpful crocodile to eat disappointing men. In her second collection *Nudibranch* (2019), we meet characters ranging from a woman farmer raising a small boy who is part of a lethal secret experiment, a famous musician caught in an obsessive love affair with a possible murderer and a Black acrobat in nineteenth-century Prussia. 'Grace Jones', a story from *Nudibranch* that won the 2020 AKO Caine Prize for African Writing, introduces a young Grace Jones impersonator working at a raucous party; over the course of the evening, the reader slowly comes to understand how the death of her entire family in a terrible fire continues to emotionally sever her from other people.

Okojie's family come from the city of Uromi in Edo State, Benin, a part of Nigeria which once formed the flourishing royal capital of the Edo Kingdom, a rich historical lineage that has inspired her writing. Born in Nigeria, she moved to England aged eight and attended school in Norfolk and London. Okojie is a polymath: in addition to writing prose, she works in film, theatre, visual art and poetry. As well as coordinating numerous theatre projects, Okojie is the creator of *Black Joy* (2019), a short film on the importance of Black creativity and pleasure in film, music and literature for BBC Ideas. She was awarded an MBE for her services to literature in June 2021.

Okojie is a warm, erudite and expansive conversationalist, with a wry sense of humour. She was so enjoyable to talk to that I didn't notice over two hours had passed, and the interview only concluded at the request of her pet beagle, Gogo, who needed to be let outside. LEON CRAIG

THE WHITE REVIEW I recently had the pleasure of re-reading *Speak Gigantular* and *Nudibranch*. Both crackle with magic, and I noticed that they both also open with very short stories. 'Gunk', in *Speak Gigantular*, is a nihilistic, defiant pep talk to a heartbroken man alone in the city, instructing him, 'Son, this is the skin I'm leaving you with / This is how to wear it comfortably. / This is how to camouflage when you need to.' Meanwhile, 'Logarithm' in *Nudibranch* conjures an enigmatic, flickering world with a simple formula: 'Here is a crease. Here is a murmur.' When you were writing and ordering the collections, did they feel like incantations to you?

IRENOSEN OKOJIE I like that way of phrasing it, 'incantations', because the word has a spiritual element, which speaks to the intentions behind my stories. In both 'Gunk' and 'Logarithm', I wanted to set the tone for the world that is going to come – like saying 'this is an Irenosen Okojie collection, these are the rules.' Even though they are probably quite jarring for the reader at first, I think by the time they finish the collection, they can see the connection between 'Logarithm' and the other stories in *Nudibranch*. Similarly, with 'Gunk', there are themes like otherness and race, masculinity, femininity and motherhood. By the end, the reader gets a sense that, actually, the first story was a way of grounding the collection. Certainly with 'Logarithm', it feels very spiritual, and it's very much a stream of consciousness piece. It's been interesting working with editors in terms of how they want to shape the collection, what should go first and what shouldn't.

TWR Can you describe your relationship with editors and being edited? You write such unique stories, and often the plots go in unexpected directions but their visionary quality is always clear.

IO I have to have an editor that firstly has an appreciation for my work – who understands that my writing is really layered and dense. Sometimes with short stories, editors expect them to be quite clean, but my stories are the opposite of that. There's so much going on. I like to have the freedom to be able to feverishly write the first draft, and I never worry about editing the pieces initially, or even the second time around, because I think that can disrupt the flow of the writing. I'm somebody who is very loose and intuitive in terms of how I structure my stories. I like to leave space for things to come to me. Being able to play, being able to experiment and to go where the characters lead me, makes the process much more exciting. With *Nudibranch*, I submitted all the stories together, so the editors weren't just looking at the individual stories, but the collection as a whole – whether certain stories worked together, whether one or two stories need to be there to make the collection feel more cohesive. I think, from an editor's perspective, it's about tidying it up and reining me in – keeping the wildness of the writing, but also making it cohesive for a reader to follow. I want my writing to leave you with images and themes to grapple with, so the reader asks: 'What have I just read? Why does this image disturb me? Do I have sympathy for this character?' I'm trying to interrogate readers' expectations, around Black characters and Black women in particular. There's been such a lack of representation, unfortunately, there is also a particular expectation of what stories Black women writers are supposed to tell and how far we're supposed to go. I just completely ignore all of that. I'm not writing to a prescription of what a Black, African-British woman writer should be. So an editor has to bear all of that in mind and not be intimidated by that as well.

TWR The reining-in thing is partly true, but as an editor myself, I also think of editing as giving permission. When I'm working with writers, particularly those who are writing about elements of their identities that have been marginalised, one of the most joyful parts of that work is saying, 'No, be the fullest version of yourself and let your characters be the fullest versions of themselves on the page.'

IO I remember when I got the first round of feedback from the wonderful Rukhsana Yasmin, who edited my novel *Butterfly Fish*. At that stage, I was still a bit sensitive about having my work edited, because it's a journey, as they say, it's such a vulnerable thing. You feel so exposed. Initially I couldn't make sense of the edits, but I was advised to sit with them, and I went away and processed the suggestions, there were things that I thought were brilliant, because I would not have thought of taking that direction myself. Then there were other suggestions that I didn't feel were quite right, and I think you always have to go back to your intention as a writer, because it's a collaborative process, and there's a trust that develops. The process of working with an editor should make a work absolutely sing. It should make the work even better

than when you initially submitted it. It's something that I've grown to appreciate. There's a nurturing that goes on, a blossoming – a sense of permission, as you say, to fully step into yourself.

TWR When I read *Butterfly Fish*, there were points when I gasped, because of the intensity of the main character Joy's grief for her dead mother. I actually made a loud noise when I learnt Joy had lost her arm after drunkenly jumping under a tube train. It's so visceral – the reader recoils and then is drawn back into the story. In your short stories, too, there are characters who have terrible things happen to them: abduction, assault, bereavement. Joy's bad luck feels very relentless. What was it like to write these sections?

IO The reason why I'm so comfortable writing about dark things is because I've had so many traumatic things happen in my life. Writing has been a place to transform those experiences, and that's why a lot of my work is about transformation, people who are on the cusp of some sort of change. For years, Joy and the other characters in *Butterfly Fish* were speaking to me. I'd be walking down the street and feeling what they were thinking and feeling. Enmeshment happens between the reality of the author and the imagined world that they are creating, and I get so deeply engrossed in that process. I go through the spectrum of experiences with the characters, across their narrative arcs. Joy is a character that went through a lot, so by the time I got to write her darker parts, I felt like I could do her justice. Even though the novel had an imaginative, slightly otherworldly feel to it, my own traumatic experiences made me feel that I could ground the story. I wanted for the reader to be transported, but also to feel the reality. I found Joy's character intense to write, and I think that shows on the page. As a writer, you can feel when I'm excited, you can feel when I'm feverish, and you can feel when I'm completely being experimental.

TWR Novels typically involve durational relationships with a set cast of characters. Did you find that switching from the novel form to writing short stories allowed you to more fully explore the breadth of human experiences that interest you?

IO I spent a feverish two years in my 20s writing *Speak Gigantular*, while taking a break from a first draft of *Butterfly Fish*. I needed to do some work on the novel, but I was struggling. At the same time, I didn't want to stop writing. Then I read Denis

Johnson's *Jesus' Son* (1992), a set of interconnected stories about drug addiction, which I found free-wheeling and potent. There are moments of surrealism in the stories, alongside very real insights into what it means to have an addiction and how it affects the people around you. I didn't know that short story collections were capable of doing that, and that collection changed me as a writer. It gave me permission to be even more daring. And through the process of writing *Speak Gigantular*, I realised that I was an experimental writer, that I am somebody that likes to pull and push the boundaries, to see what can come from that, and what can come from work that isn't easily labelled.

TWR Did you feel a similar sense of freedom to experiment when you returned to *Butterfly Fish* after having begun work on the stories in *Speak Gigantular*?

IO Writing short stories is like using the other side of your brain. I love the novel form as well, but it's such a long game, and you have to keep finding ways to stay excited about it. I always say the middle is the danger zone. When I'm writing a novel, I have all this excitement in the beginning, and it propels me forward, and then I get to the middle and I'm like, how am I going to apply all this? I talk to other writers, who also still have that issue, even after writing their fifth or sixth book. That feeling never goes away, because each book is its own animal, it has its own internal rhythms, it has its own kind of memory and way of life. So you have to create all of that from scratch. Just because you did that before, doesn't mean that you can do exactly the same thing for the next one. I think that's part of the challenge, but also part of the joy. And part of the way you keep it exciting.

TWR Was it difficult to get such experimental work into the hands of readers at the beginning of your career, and has getting published changed the process of writing for you?

IO Fulfilment as a writer is so important; we have to find ways to calibrate ourselves. *Speak Gigantular* was such a raw collection – it was literally me finding my voice. By the time I wrote *Nudibranch*, I was at a difficult point in my life, and I wrote those stories with a real sense of urgency. I think it's an even weirder collection than *Speak Gigantular* in terms of the ideas. For writers who are more audacious and experimental, it can be a

challenge to get picked up, and *Speak Gigantular* was published by an independent publishing house. Sometimes publishers can lack the vision, or the imagination, to know what to do with you or find an audience for you. But I think it's also to do with how Black writers are seen. A white version of me probably would have had less trouble getting published, because it's a given that you can have that freedom, that range. All it takes is one editor who gets your vision, and backs you – and it makes me think of all the Black writers and writers of colour, who will have not found that editor, all the lost work that we'll never see. Having *Speak Gigantular* published gave me the confidence to feel like I can sit and just think, and that's important for any writer. I think it's important to have artistic innovation recognised, especially as a Black British woman. There can be so many ways to be diminished both systemically and in personal contexts. I poured my heart into *Speak Gigantular* and *Nudibranch*. I hope they continue to speak to readers in years to come.

TWR Often your characters are shown worrying about money and work and how they're going to pay the rent – which is still quite rare in contemporary fiction. I find that refreshing, because often I read books and wonder, 'How is this person paying for their lifestyle?'
IO I'm glad you say that because I want that element of realness in the stories. I've been negotiating those things in my own life. How do I make art and pay the bills? Art doesn't pay well, so you have to find ways to be creative about that, to survive. We have to negotiate those things, and I think it's important to show that. Even though a lot of my work is quite surreal, it is surrounded by these bits of reality, like getting a job, or going from one job to another.

TWR The verisimilitude of your stories also comes through in the racial politics of your writing. Often, in the really surreal stories, the narrator will be a Black woman, or a person of colour, and it won't necessarily be a story about race, but their race will still be something that's a presence in the story and influences their interactions with other people.
IO Absolutely. I want to present people of colour in contexts that readers don't necessarily expect. It's about being seen. Within my stories, racial politics might have an influence on the lives of my characters, but it may not be the main thing. I want my characters to be fully dimensional; I want to show the different experiences and the multitudes of Blackness. There's a story in *Nudibranch*, 'Kookaburra Sweet', about a woman who becomes what she eats. She's a Black woman, and you know that by the time you get to the second or third page of the story, but there are other things about her that are just as important as that Blackness. She went to Australia and tried to have some sort of journalistic career, and it failed woefully. She sort of fell in love, and that failed woefully, too, and she had to return to the UK. She's essentially really spirited, and she's grappling with everything that's happening to her. But there's also this magical element in terms of what she is eating. On her way home, she has a conversation at the airport with an Aboriginal man who gives her some liquorice that she keeps for later. It's not clear if he's real or an apparition, but then, when she is back in London, she has the liquorice sweet and we see a transformation happen where she becomes what she eats. There is an element of Black women being sacrificial in some way. I'm not hitting you over the head with it, but it's there if you read the story. There are layers and there are ways that you can incorporate the political.

TWR Do you ever feel pigeonholed by an expectation that you should foreground political topics in your writing?
IO That's been my frustration with non-fiction, which I have written for *The Guardian* and *The Observer* – which was great, but it was always particularly around race. If I pitched anything else, they just wouldn't be interested in it, and I found that very frustrating. Give us the room: we're not just experts about our race, we are experts in other things as well. Because Black people have to deal with that racial element, we have to be incredibly creative about how we survive in the world – which makes me an expert in other areas. So let me write about those things. Since I wasn't being given the space to do that in non-fiction, I was even more passionate about doing it in my fiction, which is why I think that there is this sort of feverish quality about stories like 'Kookaburra Sweet'.

TWR There is a protean quality to your writing, particularly in your use of metaphor. In 'Grace Jones' you write: 'There was a building that remained a husk; a blackened charcoal carcass

gutted from the inside out. The carcass leaned against the heavens in protest at its losses, at its snatched internal sky tainted with the fingerprints of one last daily procession, rituals of the living.' There are so many moments, like these, where the world in your stories shifts into metaphor, becomes hallucinogenic.

IO It's wonderful that you pick up on the poetical aspect, because poetry really was like fuel for me when I first started writing and still is now. I would read poetry every morning really early, to feed me and open up my brain, and to give me the permission to play with language, because I find what poets do really fascinating. I would read people like the Jamaican-American poet and activist June Jordan [1936–2002], who was such a radical artist in her time. Her work was so daring and political, but also experimental. I read her work to make me feel like I can go on. I also started writing poetry as a form of practice – not any poetry that I've published or shown to people but just for myself, to experiment and play with language, and that has inevitably seeped into the writing. Within poetry there is a practice of creating imagery, honing it, making it shift, so it can be malleable, even elusive. I'm fascinated by all the different things that you can do with imagery, how it can sit in the body, how it can stay with people. If I'm not working on fiction, even when I'm not working on books, I'm always writing poems for myself. I might write 10 to 12 poems a day, first thing in the morning. They're not massively long, but I just have so many images in my head and poems feel like the right space for them. And sometimes in those images, there might be a story. There is this part of me that actively seeks imagery. I like to write and then go and see Surrealist work – blistering stuff like the paintings of Leonora Carrington. I love Lynette Yiadom-Boakye's paintings, too. They're gifts. Her renderings of Black people in moments of contemplation or reverie are tremendous. She creates spaces of restoration where you see us just being. That's so rare.

TWR Your love of visual art makes me think about the antique cursed brass head in *Butterfly Fish* with its 'high, proud forehead, its broad nose [and] defiant expression', and the role it plays in driving the action forward. The novel traces the history of the brass head, once a gift to a princess named Adesua in eighteenth-century Benin, later a bribe to Joy's grandfather Peter in 1950s Nigeria

and finally Joy's inheritance. I remember very clearly seeing images of the Benin Bronzes for the first time at age 17, and being hit by the full magnitude of the evil of the Benin Punitive Expedition of 1897, in which the British sacked and looted Benin City. Is the head based on a particular piece of art? Is there a particular reason you wanted to focus on an artefact from Benin?

IO The head came from being a kid in Nigeria, and seeing those kind of artefacts in my grandmother's home, my uncle's home, and having an appreciation for that kind of art – and then also seeing artworks like the Benin Bronzes in the British Museum, knowing the history behind that, and being really frustrated about it. So writing *Butterfly Fish* was a kind of reclaiming of my history, my family's history in Benin. I have a direct and really strong connection to that place, because it's where I'm from, and my dad told me stories about Benin and the Benin Kingdom as a kid. In Africa, we had amazing kingdoms with a really flourishing society, incredible architecture, incredible art, and it was so brilliant that when the British came and pillaged it all, they didn't quite believe that Black people were capable of designing stuff with such depth of thought and intricacy. They completely looted it all. There was a real sense for me of wanting to make that history visible. And I loved the idea of having an artefact that would connect history, and connect familial history. So often, Black history gets taught, especially in the UK, as only being about slavery, and that really frustrates me, because there's so much Black history that isn't about slavery. And those histories can be really empowering and might give young Black people a sense of strength in themselves, enable them to take courage and gain confidence from the amazing things that have happened in history.

TWR Did you grow up speaking any other languages apart from English? Has that influenced your work in any way?

IO When I was living in Nigeria, I grew up absorbing a lot of different languages and hearing Pidgin English as well. When I moved to England, I lost it somewhat. But years later, when I went back to Nigeria, it was like a memory coming back. When I went to Aké Arts and Book Festival in Ogun State, Nigeria in 2015, when *Butterfly Fish* came out, I was able to jump right into speaking Pidgin again. Being an immigrant, or being the

child of immigrants, you carry other languages within you, and that affects your work. Perhaps that's also part of why I like to play with language so much, why I'm so determined to interrogate language and bend it and twist it in terms of images. I have a desire to seek language within language, to move it from some of the places that people are comfortable with it being.

TWR During our conversation, you've mentioned often feeling like an outsider wherever you go, whether in Britain, Nigeria or elsewhere. There are a lot of stories in *Nudibranch* and *Speak Gigantular* which draw on ideas about demons, ghosts and gods visiting the human world. The titular story of *Nudibranch* features a devouring goddess visiting a festival of love in search of eunuchs to feed on, and there are two ghosts stuck in the London Underground in the story 'Walk with Sleep'. Do you feel more kinship with the otherworldly presences, or the humans who are visited by them?

IO It depends on the day; I do feel like a person from another world or dimension sometimes. I remember, when I first came to England, dancing in the rain. We lived in this block of flats, with a drive around it, and I was dancing in the rain and all the neighbours were just watching this little Black girl, eight years old. My mother found this really funny, but I think it was a way of me trying to connect. I remember that I felt like I wasn't quite in my body. I felt like I had travelled somewhere else, that was what the feeling of movement and dance did for me. I felt like I had another kind of power. I also think it's true for writers that we have access to other spaces that aren't necessarily on display. Some days when I'm feeling really fed up and frustrated and angry about certain things, I'm very much of this earth. And then there are times I'm able to see things in the everyday that feel like rifts, that feel otherworldly. Like running into somebody who speaks your language on the bus – I remember that happening. I was so happy because I don't often meet people from where I'm from in Nigeria. There's a lot of Yoruba people, there's a lot of Igbo people. But you don't come across a lot of people from Edo, Benin and particularly not the village my father's from. I happened to be on the bus one day. I went to the top and I could hear this man on the phone, speaking my language, which I hadn't spoken for years. And something in me just opened up, every part of my body was listening

to this man's conversation. I went up to him and we had this random conversation. To me, it felt spiritual that it happened, because that day I was feeling down. It gave me a sense of self, a sense of connection that I needed that day.

TWR There is so much existential range in your writing, from the murderous time travelling monks of 'Filamo', to the grind of searching for work and everything in between. I wonder what you think about the possibility of there being more to our lives than can readily be perceived?

IO When things like that happen, I do think that there's a connection to the other world. My younger sister has epilepsy and so that means that she has seizures, and she's on medication to manage it. Every time she has seizures and she comes to, it takes her a couple of days to recover. I always tell her that she's gone somewhere else and come back, that she's come back with more information, and how that information manifests will reveal itself in time. So I see her as a traveller, and we're really close anyway, but we're able to connect even more, because we have this kind of understanding between us about her condition. Hopefully I've explained it to her in a way that she can own with it with a sense of confidence and not be ashamed about it, because there's a power to it. For me, that is spiritual. There are places in Africa where they would say somebody like her has been taken over by a demon. These things happen, unfortunately, but I wanted to reframe it for her. To get to the revelation, to be able to forge your way through a difficult context, sometimes that can feel like an awakening. I love those moments, which is why they're in my stories, why they happen to characters who are navigating the drudgery of the everyday.

TWR There are points in a lot of the stories where you delve into the characters' internal landscapes and explore how the strength of an emotion can influence the perceptions of reality. Are you especially interested in the tricks of the subconscious?

IO I think we've all had moments where we're feeling down in our own company, and everything is upended. It might be because of a drink, or some other vice. For me, it's about bringing what's underneath, simmering away, to the fore and letting it have legs, sometimes letting it run riot. As a writer, I keep my eyes open. Not just when

I'm inebriated. It's not pretty, sometimes it's dark and it's horrible. In 'Cornutopia', one of the stories in *Nudibranch*, I talk about this woman in pain, who had this horrible thing happen to her. It devastated her relationship with her then-partner, but they've reconfigured it into a really lovely friendship. I take you through the things that are in her subconscious and still actively affecting her. We see her go to a drug trial to have something done about this pain. Among the questions I wanted to explore with that story are: How does pain manifest itself? How do we measure it? What does it look like? Can we ever really get rid of it? Is it just about coming to terms with it? In that story in particular, I'm interrogating things that are lying dormant in the subconscious.

TWR A lot of people, particularly women, particularly women of colour, particularly Black women, are ignored by doctors and other medical professionals when they say that they're experiencing really terrible pain. In 'Cornutopia', much of the agony is in the protagonist's head, but it's not all in her head. The physical pain is real as well.
IO I was conscious of having heard stories from other Black women about going to the hospital and having their symptoms minimised or just dismissed. But I was also thinking about complexity and light and shade because there's a lot of surreal projection happening in the piece. I'm also really interested in spaces that are supposed to be safe not being safe, and I think hospitals are a great example of that. There are lots of great doctors and nurses who are incredible and who do an amazing job, but we also know the stories about people who exploit those positions, and people who become power hungry or macabre in those situations, who take advantage of innocent people. We know the stories of Black people having been put through medical trials that stain the history of medicine.

TWR In their novel *Freshwater* (2018), Akwaeke Emezi demonstrates that received – white, Western – ideas about mental ill health, or very extreme emotional experiences, are often not the whole truth. Emezi's reframing of the world really came back to me when reading 'Cornutopia', and also in another of your stories, 'Daishuku'. One could give a very basic description of Daishuku as a story about a man with a degenerative neurological disorder. But it's not just that, his experience is

real to him, and you can't compress it into a tidy diagnosis.
IO Memory is really interesting to me, the fact that memory can be really deceptive, every time you remember something, it's slightly different. You can actually conjure a memory that isn't entirely real, but has elements that feel familiar, and I was interested in the role memories can play in sustaining somebody. In the story, Daishuku has this sweet love for his dead wife Mae. He has Alzheimer's, and because of this he's still looking for her – everywhere he goes. We encounter Daishuku as a downtrodden homeless character, but that's not the only way he's shown. Daishuku is many things: he is a man, he is homeless, and he is struggling to carve out an existence. There are people on the fringes who are battling all sorts of things that we don't know about when we pass them on the underpass or at the station. 'Daishuku' operates on several different levels. One reading of the story could be, 'This man is having to deal with this Alzheimer's that has taken its toll.' But it's also a love story, and it's about different iterations of the self, right down to him as a sperm and what he's like as a sperm, which comes at the end of the story. Structure is something that I'm constantly looking to play with, but it happens intuitively, as I'm writing. It kind of bubbles up, I have the loose idea, and then it all comes to me.

TWR I also want to ask you about 'Alysm', your story about contracting Long Covid that was featured in the anthology *Disturbing the Body: An Anthology of Misbehaving Female Bodies* (2020). I'm curious about whether you feel that experience had impacted your writing and particularly how you write about the body.
IO I contracted Covid in March 2020. It was really, really tough. At the time I was struggling to breathe for up to eight hours a day, and there was nothing the health service could do for me. To keep myself occupied during isolation I started writing a story, 'Rosheen', which had been commissioned for an anthology titled *Hag* (2020). The story was a reinterpretation of an old folktale. I would get so tired, and I would have to take breaks then come back to it, but I felt like it kept me going. I kept saying to myself, 'If I'm still breathing tomorrow, I can do another bit of the story, if I'm still alive tomorrow.' It sounds really messed up to say, but this is how it felt. So I worked on that story, I'm really

proud of it, considering how it was forged. Then I
got asked to contribute to another anthology called
Disturbing the Body. The body is something that fas-
cinates me – the things that we carry in it, the way
the body processes time, illness, memory and loss.
All of that is written on the body, I think you can
feel it. When the commission came up, I thought
it was the perfect opportunity to write about my
experience of Covid, even though I was scared to
write it, because I thought I might re-traumatise
myself. But it all needed to go somewhere because
I was still carrying the terror that I went through.
My god it was so lonely. I think it was the loneliest
I've ever been. The cruelty of the illness is that
there's a lack of physical touch for the people who
have it, because you could infect somebody. So, at
the point when you need support, you're denied it.
I wanted to be able to put all of that into the
writing: the fear, the desire to not infect anybody.
I was so conscious that I didn't want my family to
suffer, I didn't want them to see me struggling to
breathe, because I knew that that would just undo
them. But I was really grateful to still be alive, and
I felt like I needed to write, because a lot of the
stories in the news are about death. They're not
about people who have survived.

TWR I have one last question, about the new
novel that you're working on. It's titled *Curandera*,
which is Spanish for a person who cures and heals.
What are you able to tell me about it?
IO It's very different to *Butterfly Fish*. I'm
exploring friendship and shamanism, and
I'm fascinated by the different ways that healing
manifests in different cultures. There have been
delays with the novel, because of catching Covid,
and also because writing three books back to back
is joyful and demanding. It's good to have time
to replenish, to sit with an idea so there's space
for the work to develop fully rather than being
rushed. Having gone through this experience,
I feel like I'm returning to the book with a sense
of direction and a depth that I didn't have before
– a larger understanding of how one can regenerate
oneself. Of course I wouldn't have wanted to get
Covid. Who would? But we have to learn from
the experiences that we go through. As a writer,
it would be remiss not to.

L. C.,
May 2021

POLLY BARTON is a translator of Japanese literature and non-fiction, based in Bristol. Her full-length translations include *Where the Wild Ladies Are* by Matsuda Aoko (Tilted Axis Press, 2020), *There's No Such Thing as an Easy Job* by Kikuko Tsumura (Bloomsbury Publishing, 2020), and *Spring Garden* by Tomoka Shibasaki (Pushkin Press, 2017). Her non-fiction debut, *Fifty Sounds* (2021), is out with Fitzcarraldo Editions.

RZ BASCHIR lives in London and is currently working on her first short story collection. She won The White Review Short Story Prize 2021, sponsored by RCW.

ZACH BLAS is an artist, filmmaker, writer and Assistant Professor of Visual Studies in the Daniels Faculty of Architecture, Landscape, and Design at the University of Toronto. His practice spans moving image, computation, theory, performance and science fiction. Recent and forthcoming exhibitions include 'British Art Show 9' (2022); 'Positions #6: Bodywork' at the Van Abbemuseum (2020); 'Uncanny Valley: Being Human in the Age of AI' at the de Young Museum (2020); 'The Body Electric' at the Walker Art Center (2019); the 2018 Gwangju Biennale and the 68th Berlin International Film Festival. His artist monograph *Unknown Ideals* will be published in 2022 with Edith-Russ-Haus für Medienkunst and Sternberg Press.

RAYMOND DE BORJA is the author of *they day daze* (High Chair, 2012). His recent work appears or is forthcoming in *Big Other, Black Sun Lit, Cambridge Literary Review, Heavy Feather Review, Jacket2, OmniVerse* and elsewhere.

LEON CRAIG's writing has been published in the *TLS, The London Magazine, The Mechanics' Institute Review* and elsewhere. She has work forthcoming in *Cunning Folk* and the anthology *Queer Life. Queer Love* (Muswell Press, 2021). Her short story collection, *Parallel Hells*, will be published by Sceptre in February 2022.

ZARA DINNEN is author of *The Digital Banal* (Columbia University Press, 2018) and lecturer at Queen Mary, University of London.

JAMES GIDDINGS was born in Johannesburg, South Africa and now lives in Sheffield. His debut pamphlet *Everything is Scripted* won Templar Poetry's Pamphlet & Collection Award in 2016.

LILI HAMLYN's work has appeared in the *TLS*, the *Oxonian Review, IRIS* magazine and is upcoming in *The Yale Review*. She lives in Brooklyn.

LUBAINA HIMID (b. 1954, Zanzibar) lives and works in Preston, UK, and is Professor of Contemporary Art at the University of Central Lancashire. She is the winner of the 2017 Turner Prize. Himid has exhibited extensively in the UK and abroad. Significant solo exhibitions include 'Lubaina Himid', Tate Modern, London (2021); 'Spotlights', Tate Britain, London (2019); 'Lubaina Himid', CAPC Bordeaux, France (2019); 'Work From Underneath', New Museum, New York (2019); 'Our Kisses are Petals', BALTIC Centre for Contemporary Art, Gateshead (2018); and 'Navigation Charts', Spike Island, Bristol (2017). Selected group exhibitions include 'Mixing It Up: Painting Today', Hayward Gallery, London; 'Invisible Narratives 2', Yamamoto Keiko Rochaix, London; and 'Unsettled Objects', Sharjah Art Foundation, Sharjah (all 2021).

SHANE JONES is an American writer living in upstate New York. His novels include: *Light Boxes* (Penguin Books, 2010), *Daniel Fights a Hurricane* (Penguin Books, 2012), *Crystal Eaters* (Two Dollar Radio, 2014), and most recently, *Vincent and Alice and Alice* (Tyrant Books, 2019).

REBECCA LIU is a commissioning editor at *The Guardian*'s *Saturday* magazine and staff writer at *Another Gaze*.

IRENOSEN OKOJIE is a Nigerian British author whose experimental works create vivid narratives that play with form and language. Her debut novel *Butterfly Fish* (Jacaranda Books, 2015), and short story collections *Speak Gigantular* (Jacaranda Books, 2016) and *Nudibranch* (Dialogue Books, 2019), have won and been shortlisted for multiple awards. A fellow and Vice-Chair of the Royal Society of Literature, Okojie is the winner of the 2020 AKO Caine Prize for her story, 'Grace Jones'. She was awarded an MBE for services to literature in 2021.

EUGENE OSTASHEVSKY is the author of, most recently, *The Pirate Who Does Not Know the Value of Pi* (New York Review of Books, 2017), a poetry book about pirate-parrot communication.

MUI POOPOKSAKUL is a lawyer-turned-translator with a special interest in contemporary Thai literature. She has translated two story collections and a chapbook by Prabda Yoon and a story collection and a novel by Duanwad Pimwana. Currently, she is translating Saneh Sangsuk's novel, tentatively titled *The Understory*, the work excerpted in this issue. She lives in Berlin, Germany.

SANEH SANGSUK, known in Thailand by his pen name Dan-arun Saengthong, has authored a dozen books, including five novels and three story collections. His work has been translated into French, Italian and Spanish, among other languages. Sangsuk has won all of Thailand's highest literary accolades and has also been named a Chevalier de l'Ordre des Arts et des Lettres by the French government. The novel excerpted in this issue, forthcoming from Deep Vellum in 2023, will be his first publication in the US. Sangsuk lives in his native province of Phetchaburi, Thailand, where many of his tales are set.

MARIA STEPANOVA is a Russian poet and the author of the poetry collection *War of the Beasts and the Animals* and the novel *In Memory of Memory*, both translated by Sasha Dugdale and published in 2021. *In Memory of Memory* was recently shortlisted for the International Booker Prize.

DREW THOMPSON is an educator, writer and an independent curator, who specialises in African and Black Diaspora visual and material culture.

ALOK VAID-MENON is the author of *Beyond the Gender Binary* (Penguin Workshop, 2020) and *Femme in Public* (2017). Their poetic challenge to the gender binary is internationally renowned.

OCEAN VUONG is the author of the novel *On Earth We're Briefly Gorgeous* (Vintage, 2019). A recipient of a 2019 MacArthur 'Genius Grant', he is also the author of the critically acclaimed poetry collection, *Night Sky with Exit Wounds* (Jonathan Cape, 2017). A Poetry Foundation Ruth Lilly and Dorothy Sargent Rosenberg fellow, his honours include fellowships from the Lannan Foundation, the Civitella Ranieri Foundation and the Elizabeth George Foundation, and awards from the Academy of American Poets and the Pushcart Prize.

KANDACE SIOBHAN WALKER is a writer and filmmaker from Wales and elsewhere. She lives and loves in South London. Her work has appeared in *bath magg*, *The Guardian* and *The Good Journal*, among others. Her debut poetry pamphlet will be published by Bad Betty Press in 2022. She won The White Review Poet's Prize 2020, in partnership with CHEERIO.

PLATES